THE ART-ARCHITECTURE COMPLEX

THE
ART-ARCHITECTURE
COMPLEX

HAL FOSTER

VERSO
London • New York

This publication is made possible in part by the Barr Ferree
Foundation Fund for Publications, Princeton University

First published by Verso 2011
© Hal Foster 2011

1 3 5 7 9 10 8 6 4 2

Verso
UK: 6 Meard Street, London W1F 0EG
US: 20 Jay Street, Suite 1010, Brooklyn, NY 11201
www.versobooks.com

Verso is the imprint of New Left Books

ISBN-13: 978-1-84467-689-7

British Library Cataloguing in Publication Data
A catalogue record for this book is available from the British Library

Library of Congress Cataloging-in-Publication Data
A catalog record for this book is available from the Library of Congress

Typeset by Hewer Text UK Ltd, Edinburgh
Printed in Singapore by the Tien Wah Press

CONTENTS

PREFACE

Over the last fifty years, many artists opened painting, sculpture, and film to the architectural space around them, and during the same period many architects became involved in visual art. Sometimes a collaboration, sometimes a competition, this encounter is now a primary site of image-making and space-shaping in our cultural economy. Only in part is the importance of this conjunction due to the increased prominence of art museums; it involves the identity of many other institutions, as corporations and governments turn to the art-architecture connection in order to attract business and to brand cities with arts centers, festivals, and the like. Often where art and architecture converge is also where questions about new materials, technologies, and media come into focus; this, too, makes the connection an urgent one to probe.

I begin with an overview of the role of image and surface in architecture from the moment of Pop art to the present, and conclude with a conversation with a sculptor who has long advanced a different approach to building, one that relates material to structure and body to site. A leitmotif of the book, this division has become a battle-line between practices in both art and architecture today. Within this frame are three sections of three chapters each, which explore central

aspects of the art-architecture complex. The first section considers three "global styles"—the design practices of Richard Rogers, Norman Foster, and Renzo Piano—which might be to our postindustrial configuration of modernity what the "international styles" of Walter Gropius, Le Corbusier, and Mies van der Rohe were to the industrial arrangement—signal expressions that are at once pragmatic, utopian, and ideological in force. If modernity has a look today, Rogers, Foster, and Piano are among its master designers.[1]

The second section turns to architects for whom art was a key point of departure: Zaha Hadid, Diller Scofidio + Renfro, and a group of designers informed by Minimalism, including Jacques Herzog and Pierre de Meuron. Not long ago, a near prerequisite for vanguard architecture was an engagement with theory; lately it has become an acquaintance with art. The connection is often significant, at least in a strategic way: Hadid launched her career with a return to Russian Suprematism and Constructivism, and Diller Scofidio + Renfro began their practice with a fusion of architecture with Conceptual, performance, feminist, and appropriation art. With designers influenced by Minimalism, the reciprocity of art and architecture is no less fundamental; just as Minimalists opened the art object to its architectural condition, so have these architects acquired a Minimalist sensitivity to surface and shape. As might be expected, recent developments in museum design come to the fore in this section.

All these involvements have altered not only the relationship between art and architecture, but also the character of such mediums as painting, sculpture, and film. The third section considers these transformations. "Sculpture is what you back into when you back up to see a painting," Barnett Newman quipped in the 1950s, in the heyday of painting as the paragon of all modernist art. If sculpture is dismissed here, architecture is not even mentioned, yet a decade later it would be impossible to avoid. The critical role of architecture in the recent repositioning of the arts is a central topic in the third section, which surveys the sculptures of Richard Serra, the films of Anthony McCall, and the installations of Dan Flavin and others (including Donald Judd, Robert Irwin, and James Turrell). Like sculpture, other mediums have crossed over into the space of architecture, and in my reckoning the results are not always positive.[2]

One theme that recurs in the book is modernity, skeptical though I am of the notion. In our time, the sociologist Ulrich Beck has argued, modernity has become reflexive, concerned to retool its own infrastructure, and some of the projects discussed here do involve the conversion of old industrial sites to suit a postindustrial economy of culture and entertainment, service and sport.[3] Recent art is hardly a passive object in this makeover; sometimes its expanded dimensions alone have prompted the transformation of disused warehouses and factories into galleries and museums, and in the process a few depressed working-class areas were reborn as stylish art-tourist destinations. Surely, by this point, the pretense that the cultural is separate from the economic is finished; one characteristic of contemporary capitalism is the commingling of the two, which underlies not only the prominence of museums but also the refashioning of such institutions to serve an "experience economy."[4] What relation do contemporary art and architecture have to a greater culture that prizes experiential intensity? Do their own intensities counter this larger one? Sublimate it? Cover for it somehow? Such questions also recur in what follows.

New materials and techniques play a role in contemporary design that is aesthetic as well as functional. Like the International Style, the global styles of Rogers, Foster, Piano, and others often feature heroic engineering, and once again technology is seen as a virtue, a power, in its own right, as though it were a fetish to ward away the unsavory aspects of the very modernity of which it is a part. (This new Prometheanism was bucked up, not knocked back, by the attacks of September 11: tall buildings in iconic shapes were thought to inspire moral uplift, not to mention financial interest and political support. Who can forget the phallic cry of "Build them higher than before!"?) Contemporary materials and techniques tend to be light, and this lightness, another leitmotif of this book, has affected art as well as architecture. In particular it has forced a revaluation of the old values of material integrity and structural transparency, the vicissitudes of which I also consider here. An essential ideologeme of modernity today, lightness has supported an abstraction beyond any seen in modernism—one said to be in tune with the abstraction of cybernetic spaces and financial systems. Yet this lightness comes with a conundrum of its

own, for how is modernity to be represented thereby? If the machine age had its distinctive iconography, what is ours?

Even as Rogers, Foster, and Piano refuse the decorative symbolism of postmodern architecture (which is now discredited in any case), they offer muted allusions that sometimes have civic resonances (this is especially true of Rogers). At the same time, they re-signify some architectural types in ways that also have public implications (think of the airport terminals of Foster and the art museums of Piano). According to Anthony Vidler, the modern period produced three architectural typologies.[5] The first, developed in the Enlightenment, proposed a natural basis for neoclassical architecture, with the mythical model of the "primitive hut" made up of classical columns hewn from tree trunks. The second, advanced by Le Corbusier and others in support of the International Style, reworked these references to natural and classical worlds in terms of the machine. A third typology, important to postmodern architecture as defined by Aldo Rossi, Léon Krier, and others, turned away from industrial models and toward the building types of the traditional city. With these global styles we might glimpse a fourth typology. Like the others, it retains a relation to the natural (now thoroughly acculturated as "green design") as well as to the classical (this is most refined in Piano): technology is again central (particularly with Foster), and the civic is still considered (again, particularly with Rogers). Yet what is most characteristic of global style is its "banal cosmopolitanism": even as its signal buildings respond to local conditions and global demands at once, they often do so in a manner that produces an image of the local for circulation to the global. (A familiar example is the "Bird's Nest" stadium by Herzog and de Meuron used as the default logo of the 2008 Beijing Olympics.)

Imageability, then, is another theme of this book (especially in the second section), and here the architecture-art connection is explicit. One positive development is that some work is able to carve out spaces, within conditions of spectacle, for experiences that are not scripted or even expected. Another is that some work is able to site its structures in ways that resist any easy consumption as image-events. Imageability remains a tricky business, though, especially when it

comes to recent designs of art museums. Some of these buildings are so performative or sculptural that artists might feel late to the party, collaborators after the fact. Others make such a strong claim on our visual interest that they might compete in a register that artists like to claim as their own—the visual. Architects have every right to oper- *Why* ate in these arenas, of course, but sometimes in doing so they might neglect other matters (program, function, structure, space . . .) that they address more effectively than artists. These confusions, too, are considered in what follows.

Lest I jump my own gun, let me mention just one more concern (especially in the third section): the question of artistic medium. Debate on this subject long stalled over the opposition between a modernist ideal of "specificity" and a postmodernist strategy of "hybridity," yet these positions mirrored each other, as both sides assumed that mediums have fixed natures, with artists encouraged either to disclose them or to disturb them somehow. My understanding diverges from such accounts. In the first instance, mediums are social conventions-cum-contracts with technical substrates; they are defined and redefined, within works of art, in a differential process of both analogy with other mediums and distinction from them—a process that occurs in a cultural field that, vectored by economic and political forces, is also subject to continual redefinition.[6] Thus sculpture as practiced by Serra is a distinctive language, but one that partakes of aspects of painting and architecture (for example, its framing of sites) even as it articulates its differences from them (for example, its refusal of the imagistic). So, too, film as practiced by McCall seeks to be autonomous, yet it implicates drawing, photography, sculpture, and architecture in that search. This question of medium is not an academic one, for an important struggle is waged between practices like these concerned with embodiment and emplacement and a spectacle culture that aims to dissolve all such awareness. The dialectic of postwar art, I suggest here, has produced not only a move from pictorial illusion into actual space, but also a refashioning of space *as* illusion writ large, with important ramifications for architecture, too.

Although many artists and architects privilege phenomenological experience, they often offer the near-reverse: "experience" handed

back to us as "atmosphere" or "affect"—that is, as environments that confuse the actual with the virtual, or feelings that are hardly our own yet interpellate us nonetheless.[7] In the guise of our activation, some work even tends to subdue us, for the more it opts for special effects, the less it engages us as active viewers. In this way the phenomenological reflexivity of "seeing oneself see" approaches its opposite: a space (an installation, a building) that seems to do the perceiving for us. This is a new version of the old problem of fetishization, for it takes our thoughts and sensations, processes them as images and effects, and delivers them back to us for our appreciative amazement. This book is written in support of practices that insist on the sensuous particularity of experience in the here-and-now and that resist the stunned subjectivity and arrested sociality supported by spectacle.

I have used terms like "encounter" and "connection" to describe the recent relationship between art and architecture, so why opt for the semi-sinister "complex" in the title? I mean the word in three ways. The first is simply to designate the many ensembles where art and architecture are juxtaposed and/or combined, sometimes with art in (what was once considered) the space of architecture, sometimes with architecture in (what was once considered) the place of art. Such ensembles might be the rule in traditions in the West and elsewhere, and the modernist moment of a relative separation of the arts the exception. I also intend "complex" to indicate how the capitalist subsumption of the cultural into the economic often prompts the repurposing of such art-architecture combinations as points of attraction and/or sites of display. Although the "art-architecture complex" is hardly as ominous as the "military-industrial complex" (or its present incarnation, the "military-entertainment complex"), it, too, warrants our vigilance. Lastly, I mean "complex" almost in the diagnostic sense of a blockage or a syndrome—one that is difficult to identify as such, let alone overcome, precisely because it appears so intrinsic, so natural, to cultural operations today. Yet, as any neurotic secretly knows, a complex disables far more activities than it enables.[8]

Like its predecessor, *Design and Crime*, this is a book of cultural criticism as much as art and architectural criticism. It seeks a way between journalistic commentary and insider theorizing; it is not

about the latest trends, nor is it post-critical in posture.[9] I under-stand the fatigue that many feel with the negativity of critique, its presumption of authority, its sheer out-of-date-ness in a world-that-couldn't-care-less, but it still beats the shallowness of flip opinion and the passivity of cynical reason, not to mention the other options on offer. (In lieu of criticality comes what exactly—beauty? affect? celebration? any other pills to pop?) One sometimes becomes a critic or a historian for the same reason that one often becomes an artist or an architect—out of a discontent with the status quo and a desire for alternatives. There are no alternatives without critique.

My thanks go to Sebastian Budgen, Mark Martin, and Bob Bharma at Verso for their commitment, and to Mary-Kay Wilmers and Paul Myerscough, my editors at the *London Review of Books* (where preliminary versions of Chapters 2, 3, and 4 appeared), as well as Tim Griffin and Don McMahon, my editors at *Artforum* (where prelimi-nary versions of Chapters 1, 5, and 6 appeared), for their support. I am also grateful to Stan Allen, Tiffany Bell, Yve-Alain Bois, Benjamin Buchloh, Richard Gluckman, Richard Serra, Anthony Vidler, Sarah Whiting, and Charles Wright for spirited conversations about some of these topics over the years. Thanks are due, too, to Ryan Reineck for his work on the illustrations, and to Julian Rose for his reading of the manuscript (if intellectual exchange is a potlatch, I am in his debt). Sandy Tait attended this book with her special grace.

ONE

IMAGE-BUILDING

We associate Pop with music, fashion, art, and many other things, but not architecture, and yet Pop was bound up with architectural debates from first to last. The very idea of Pop—that is, of a direct engagement with mass culture as it was transformed by consumer capitalism after World War II—was first floated in the early 1950s by the Independent Group (IG) in London, a motley collection of young artists and art critics such as Richard Hamilton and Lawrence Alloway, who were guided by young architects and architectural historians such as Alison and Peter Smithson and Reyner Banham. Elaborated by American artists a decade later, the Pop idea was again brought into architectural discussion, especially by Robert Venturi and Denise Scott Brown, where it came to serve as a discursive support for the postmodern design of the Venturis, Michael Graves, Charles Moore, Robert Stern, and others in the 1980s, all of whom featured images that were somehow commercial or historical in origin, or both. More generally, the primary precondition of Pop was a gradual reconfiguration of cultural space, demanded by consumer capitalism, in which structure, surface, and symbol were combined in new ways.[1] That mixed space is still with us, and so a Pop dimension persists in contemporary architecture, too.

In the early 1950s Britain remained in a state of economic austerity that made the consumerist world appear seductive to emergent Pop artists there, while a decade later this landscape was already second nature for American artists. Common to both groups, however, was the sense that consumerism had changed not only the look of things but the nature of appearance as such, and all Pop art found its principal subject here—in the heightened visuality of a display world, in the charged iconicity of personalities and products (of people *as* products and vice versa).[2] The consumerist superficiality of signs and seriality of objects affected architecture and urbanism as well as painting and sculpture. Accordingly, in *Theory and Design in the First Machine Age* (1960) Banham imagined a Pop architecture as a radical updating of modern design under the changed conditions of a "Second Machine Age" in which "imageability" became the primary criterion.[3] Twelve years later, in *Learning from Las Vegas* (1972), Venturi and Scott Brown advocated a Pop architecture that would return this imageability to the built environment from which it arose. However, for the Venturis, this imageability was more commercial than technological, and it was advanced not to update modern design but to displace it; it was here, then, that Pop began to be refashioned in terms of the postmodern.[4] In some ways the first age of Pop can be framed by these two moments—between the retooling of modern architecture urged by Banham on the one hand and the founding of postmodern architecture prepared by the Venturis on the other; but, again, it has an afterlife that extends to the present. It is this story that I sketch here.

In November 1956, just a few months after the fabled "This is Tomorrow" exhibition in London first brought the Pop idea to public attention, Alison and Peter Smithson published a short essay that included this little prose-poem: "[Walter] Gropius wrote a book on grain silos, Le Corbusier one on aeroplanes, and Charlotte Perriand brought a new object to the office every morning; but today we collect ads."[5] Modern designers like Gropius, Corb, and Perriand were hardly naïve about mass media; the point here is polemical, not historical: *they*, the old protagonists of modern design, were cued by functional things, while *we*, the new celebrants of Pop culture, look to "the throw-away object and the pop-package" for inspiration. This was done partly in delight, and partly in desperation: "Today we are being edged out of

our traditional role [as form-givers] by the new phenomenon of the popular arts—advertising," the Smithsons continued. "We must somehow get the measure of this intervention if we are to match its powerful and exciting impulses with our own."[6] This anxious thrill drove the entire IG, and architectural minds led the way. "We have already entered the Second Machine Age," Banham wrote four years later in *Theory and Design*, "and can look back on the First as a period of the past."[7] In this landmark study, conceived as a dissertation in the heyday of the IG, he, too, insisted on a historical distance from modern masters (including architectural historians like Nikolaus Pevsner, his advisor at the Courtauld Institute, and Sigfried Giedion, author of the classic account of modern archiecture, *Space, Time, and Architecture* [1941]). Banham challenged the functionalist and/or rationalist assumptions of these figures (that form must follow function and/or technique) and recovered other imperatives neglected by them. In doing so he advocated a Futurist imaging of technology in Expressionist terms—that is, in forms that were often sculptural and sometimes gestural—as the prime motive of advanced design not only in the First Machine Age but in the Second Machine (or First Pop) Age as well. Far from academic, his revision of architectural priorities also reclaimed an "aesthetic of expendability," first proposed in Futurism, for this Pop Age, where "standards hitched to permanency" were no longer so relevant.[8] More than any other figure, Banham moved design discourse away from a modernist syntax of abstract forms toward a Pop idiom of mediated images.[9] If architecture was adequately to express this world—where the dreams of the austere 1950s were about to become the products of the consumerist 1960s—it had to "match the design of expendabilia in functional and aesthetic performance": it had to go Pop.[10]

What did this mean in practice? Initially Banham supported the Brutalist architecture represented by the Smithsons and James Stirling, who pushed given materials and exposed structures to a "bloody-minded" extreme. "Brutalism tries to face up to a mass production society," the Smithsons wrote in 1957, "and drag a rough poetry out of the confused and powerful forces which are at work."[11] This insistence on the "as found" sounds Pop, to be sure, but the "poetry" of Brutalism was too "rough" for it to serve for long as the signal style of the sleek Pop Age, and in fact the most Pop project by

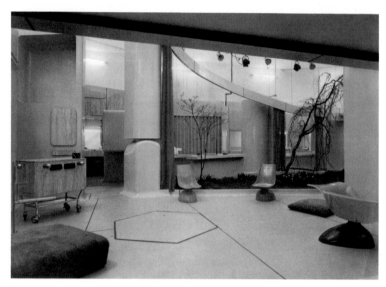

Alison and Peter Smithson, The House of the Future, 1955–56.

the Smithsons, the House of the Future (1955–56), is also the most alien to their work as a whole. Commissioned by the *Daily Mail* to suggest the suburban habitat to come, this model house was replete with gadgets devised by sponsors (for example, a shower-blowdryer-sunlamp), but its curvy plasticity was inspired by the sci-fi movie imagery of the time as much as by any imperative to translate new technologies into architectural form.

As the Swinging Sixties unfolded in London, Banham looked to the young architects of Archigram—Warren Chalk, Peter Cook, Dennis Crompton, David Greene, Ron Herron, and Michael Webb—to carry forward the Pop project of imageability and expendability. According to Banham, Archigram (1961–76) took "the capsule, the rocket, the bathyscope, the Zipark [and] the handy-pak" as its models, and celebrated technology as a "visually wild rich mess of piping and wiring and struts and cat-walks."[12] Influenced by Buckminster Fuller, its projects might appear functionalist—the Plug-In City (1964) proposed an immense framework in which parts might be changed according to need or desire—but, finally, with its "rounded corners, hip, gay, synthetic colours [and] pop-culture props," Archigram was

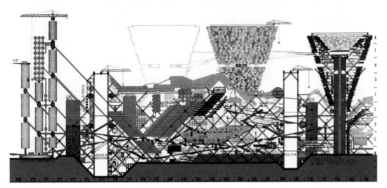

Peter Cook, *Plug-In City, Section, Max Pressure Area*, 1964. Photo ©
Archigram. Courtesy of Archigram Archives.

"in the image business," and its schemes answered to fantasy above
all.[13] Like the Fun Palace (1961–67) conceived by Cedric Price for
the Theatre Workshop of Joan Littlewood, Plug-In City offered "an
image-starved world a new vision of the city of the future, a city of
components . . . plugged into networks and grids."[14] Yet, unlike the
Price project, almost all Archigram schemes were unrealizable—luck-
ily so, perhaps, for these robotic mega-structures sometimes look like
inhuman systems run amok.

For Banham it was imperative that Pop design not only express
contemporary technologies but also elaborate them into new modes
of existence. Here lies the great difference between Banham and the
Venturis.[15] Again, Banham sought to update the Expressionist imper-
ative of modern form-making vis-à-vis a Futurist commitment to
modern technology, while the Venturis shunned both expressive and
technophilic tendencies; in fact they opposed any prolongation of
the modern movement along these lines. For Banham contemporary
architecture was not modern enough, while for the Venturis it had
become disconnected from both society and history precisely through
its commitment to a modernity that was abstract and amnesiac in
nature. According to the Venturis, modern design lacked "inclusion
and allusion"—inclusion of popular taste and allusion to architec-
tural tradition—a failure that stemmed above all from its rejection of
ornamental "symbolism" in favor of formal "expressionism."[16] To

right this wrong, they argued, the modern paradigm of the "duck," in which the form expresses the building almost sculpturally, must cede to the postmodern model of the "decorated shed," a building with "a rhetorical front and conventional behind," where "space and structure are directly at the service of program, and ornament is applied independently of them."[17] "The duck is the special building that *is* a symbol," the Venturis wrote in a famous definition; "the decorated shed is the conventional shelter that *applies* symbols."[18]

To be sure, the Venturis also endorsed Pop imageability: "We came to the automobile-oriented commercial architecture of urban sprawl as our source for a civic and residential architecture of meaning, viable now, as the turn-of-the-century industrial vocabulary was viable for a Modern architecture of space and industrial technology 40 years ago."[19] Yet in doing so they accepted—not only as a given but as a desideratum—the identification of the "civic" with the "commercial," and thus they took the strip and the suburb, however "ugly and ordinary," not only as normative but as exemplary. "Architecture in this landscape becomes symbol in space rather than form in space," the Venturis declared. "The big sign and the little building is the rule of Route 66."[20] Given this rule, *Learning from Las Vegas* could then conflate corporate trademarks with public symbols: "The familiar Shell and Gulf signs stand out like friendly beacons in a foreign land."[21] It could also conclude that only a scenographic architecture (i.e. one that foregrounds a façade of signs) might "make connections among many elements, far apart and seen fast."[22] In this way the Venturis translated important insights into this "new spatial order" into bald affirmations of "the brutal auto landscape of great distances and high speeds."[23] This move naturalized a landscape that was anything but natural; more, it instrumentalized a sensorium of distraction, as they urged architects to design for "a captive, somewhat fearful, but partly inattentive audience, whose vision is filtered and directed forward."[24] As one result, the old Miesian motto of modernist elegance in architecture—"less is more"—became a new mandate of postmodern overload in design: "less is a bore."[25]

In the call for architecture to "enhance what is there," the Venturis cited Pop art as a key inspiration, in particular the photo-books of Ed Ruscha such as *Every Building on the Sunset Strip* (1966).[26] Yet this

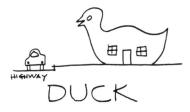

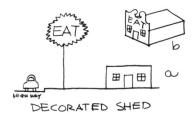

Illustration from Robert Venturi, Denise Scott Brown
and Steven Izenour, *Learning from Las Vegas* (1972).
Courtesy of Venturi, Scott Brown and Associates, Inc.

is a partial understanding of Pop, one cleansed of its dark side, such
as the culture of death in consumerist America exposed by Warhol in
his 1963 silkscreens of car wrecks and botulism victims. Even Ruscha
hardly endorsed the new autoscape: his photo-books underscore its
null aspect, without human presence (let alone social interaction), or
document its space as so much gridded real estate, or both.[27] A more
salient guide to *Learning from Las Vegas* was the developer Morris
Lapidus, whom the Venturis quote as follows: "People are looking
for illusions ... Where do they find this world of the illusions? ...
Do they study it in school? Do they go to museums? Do they travel to
Europe? Only one place—the movies. They go to the movies. The hell
with everything else."[28] However ambivalently, Pop art worked to
explore this new regime of social inscription, this new symbolic order
of surface and screen. The postmodernism prepared by the Venturis
was placed largely in its service—in effect, to update its built environ-
ment. One might find a moment of democracy in this commercialism,
or even a moment of critique in this cynicism, but it is likely to be a
projection.

By this point, then, the Pop rejection of elitism became a postmodern manipulation of populism. While many Pop artists practiced an "ironism of affirmation"—an attitude, inspired by Marcel Duchamp, that Richard Hamilton once defined as a "peculiar mixture of reverence and cynicism"—most postmodern architects practiced an affirmation of irony: as the Venturis put it, "Irony may be the tool with which to confront and combine divergent values in architecture for a pluralist society."[29] In principle this strategy sounds fitting; in practice, however, the "double-functioning" of postmodern design— "allusion" to architectural tradition for the initiated, "inclusion" of commercial iconography for everyone else—served as a double-coding of cultural cues that reaffirmed class lines even as it seemed to cross them. This deceptive populism only became dominant in political culture a decade later, under Ronald Reagan, as did the neoconservative equation of political freedom with free markets also anticipated in *Learning from Las Vegas*. In this way, the recouping of Pop as the postmodern did constitute an avant-garde, but it was an avant-garde of most use to the Right. With commercial images thus cycled back to the built environment from which they arose, Pop became tautological in the postmodern: rather than a challenge to official culture, it was that culture, or at least its setting (as the corporate skylines of countless cities still attest).

Yet this narrative is too neat, and its conclusion too final. There were alternative elaborations of Pop design, such as the visionary proposals of the Florentine collective Superstudio (1966–78), the antic happenings of the San Francisco–Houston group Ant Farm (1968–78), and other schemes by related groups in France and elsewhere. Both Superstudio (Adolfo Natalini and Cristiano Toraldo di Francia) and Ant Farm (Chip Lord, Doug Michels, Hudson Marquez, and Curtis Schreier) were inspired by the technological dimension of Pop design, as manifest in the geodesic domes of Fuller and the inflatable forms of Archigram. Yet, changed by the political events associated with 1968, they also wanted to turn this aspect of Pop against its consumerist dimension. By this point, then, the two sides of Pop, Banhamite and Venturian, were developed enough to be played against each other.

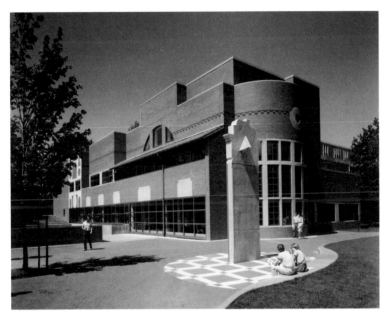

Venturi, Scott Brown and Associates, Wu Hall, Princeton University, 1983.
Courtesy of Venturi, Scott Brown and Associates, Inc.

In 1968 Fuller proposed a massive dome for midtown Manhattan—a utopian project that also suggested a dystopian foreboding of cataclysmic pollution, even of nuclear holocaust, to come. Again, this dystopian shadow is sometimes sensed in the sci-fi imagery of Archigram, with its "Armageddon overtones of survivaltechnology."[30] Superstudio took this utopian-dystopian slippage to the limit: its *Continuous Monument* (1969), a project of visionary architecture as Conceptual art, imagined the capitalist city swept clean of commodities and reconciled with nature—but at the cost of a ubiquitous grid that, however beautiful in its purity, is monstrous in its totality. Also inspired by Fuller and Archigram, the Ant Farmers were Merry Pranksters by comparison, pledged as they were to Bay Area counter-culture rather than to tabula-rasa transformation. Yet their performances and videos, which somehow combine anti-consumerist impulses with spectacular effects, also pushed Pop design back toward art.

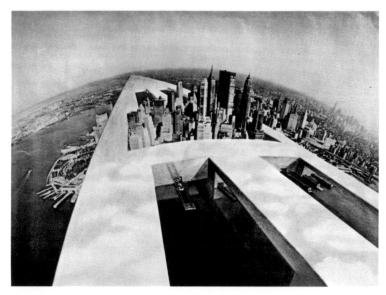

Superstudio, *Continuous Monument, New York*, 1969.

This is most evident in two famous pieces—*Cadillac Ranch* (1974), where Ant Farm partially buried ten old Cadillacs, nose down in a row like upside-down rockets, on a farm near Armarillo, Texas, and *Media Burn* (1975), where, in a perverse replay of the JFK assassination, they drove a customized Cadillac at full speed through a pyramid of televisions set ablaze at the Cow Palace in San Francisco. Today both works read in part as parodies of the teachings of *Learning from Las Vegas*.

Pop design after the classic moment of Pop was not confined to visionary concepts and sensational happenings—that is, to paper architecture and art events. In fact its emblematic instance might be the familiar Centre Pompidou (1971–77), designed by Richard Rogers and Renzo Piano, which is at once technological (or Banhamite) and popular (or Venturian) in effect. These two main strands of Pop design have persisted in other ways as well. Indeed, they can be detected, albeit transformed, in two of the greatest stars in the architectural firmament of the last thirty years: Rem Koolhaas and Frank Gehry.

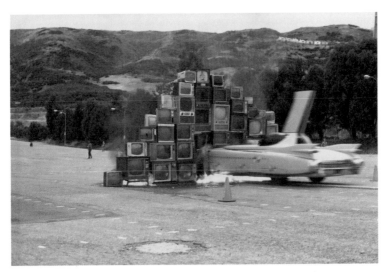

Ant Farm, *Media Burn*, Cow Palace, San Francisco, July 4, 1975. Photo ©
John F. Turner. University of California, Berkeley Art Museum and Pacific
Film Archive.

Koolhaas could not help but be influenced by Archigram, trained
as he was at the Architectural Association in London at a time, the
late 1960s, when Chalk, Crompton, and Herron all taught there.
Certainly his first book, *Delirious New York* (1978), a "retrospec-
tive manifesto" for the urban density of Manhattan that was also a
riposte to the celebration of suburban signage-sprawl in *Learning
from Las Vegas*, advanced such Archigram themes as the "Technology
of the Fantastic."[31] Yet Koolhaas played down this connection
and, in a strategic swerve around Archigram, cited modernist prec-
edents instead, Le Corbusier and Salvador Dalí above all. Critical
of both figures, he nonetheless combined these opposites—Corb the
Purist form-giver (and manifesto-maker), Dalí the Surrealist desire-
purveyor (and media-celebrity)—in a lively compound that triggered
his own success, first as a writer and then as a designer.[32] Yet the
Pop imaging of new technology *à la* Archigram, cut with a Brutalist
attention to rough materials and exposed structures, still guided
Koolhaas.

Koolhaas borrowed from Dalí his "paranoid-critical method," a Pop strategy *avant la lettre* which "promises that, through conceptual recycling, the worn, consumed contents of the world can be recharged or enriched like uranium."[33] In a way that echoes both Banham and the Venturis, Koolhaas turned this device of a "systematic overestimation of what exists" into his own way of working: his office has often produced its designs through an exacerbation of one architectural element or type, and does so to this day. For example, in the public library in Seattle (1999–2004) and the CCTV (China Central Television) complex in Beijing (2004–08), Koolhaas retooled the old skyscraper, the hero-type of *Delirious New York*. In Seattle the glass-and-steel grid of the Miesian tower is sliced into five large levels (four above grade), stepped into cantilevered overhangs, and faceted like a prism at its corners; as it follows these twists and turns, the light-blue metal grid is transformed into different diagonals and diamonds. The result is a powerful image, second only to the Space Needle (1962) as Pop emblem of the city, that is not a fixed image at all, for it changes at every angle and from every point of view. The image is also not arbitrary: the building uses its site, an uneven slope in downtown Seattle, to ground its forms, which renders them less sculptural and less subjective than they might otherwise appear. More importantly, the profile is motivated by the program, especially in the penultimate level that contains a great spiral of ramped bookshelves. The Cubistic skin as a whole wraps the different functions of the building, which serves as its own diagrammatic representation.

The idea of building as Pop sign is problematic, yet at least in Seattle the sign is placed in the service of a civic institution. The CCTV in Beijing is a different matter. It, too, transforms the Miesian tower into a "bent skyscraper," here an immense faceted arch, and it, too, is motivated by the program, which combines "the entire process of TV-making"—administration and offices, news and broadcasting, program production and services—into one structure of "interconnected activities."[34] Moreover, like the Seattle diamond, the CCTV arch is both a technological innovation and an "instant icon," and in this respect it is also connected to Pop, at once Banhamite and Venturian in its lineage.[35] Yet, unlike the Seattle library, this

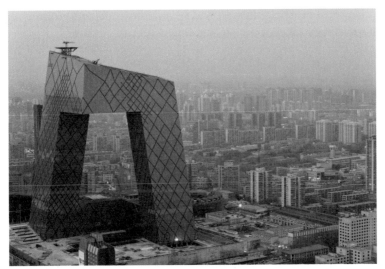

OMA, Rem Koolhaas and Ole Scheeren, CCTV Building, Beijing, 2004–08.
Photo © Iwan Baan.

building-sign is overwhelming in its sense of scale and underwhelm-
ing in its sense of site, and one can hardly see it as civic (if anything,
it reads as a triumphal arch dedicated to the state).

Like Koolhaas, Gehry has steered mostly clear of architectural
labels. Influenced by the Austrian emigré Richard Neutra (who was
long active in Los Angeles), he first turned a modernist idiom into an
LA vernacular, mostly in domestic architecture, through an innova-
tive use of cheap materials associated with commercial building (for
example, exposed plywood, corrugated metal siding, chain-link fenc-
ing, and asphalt), as in his own celebrated home in Santa Monica
(1977–78/1991–92). However, this gritty style was soon succeeded
by an imagistic one, as in his Chiat/Day Building in Venice (1985–
91), where, in collaboration with Claes Oldenburg and Coosje van
Bruggen, Gehry designed giant binoculars for the entrance of this
advertising agency. At stake in this stylistic shift is the difference
between an inventive use of common materials, as in his house, and
a manipulative use of mass signs, as in the Chiat/Day Building—or
indeed the Aerospace Hall (1982–84), also in LA, where a fighter jet
is attached to the façade. The first path can bring elite design back in

touch with everyday culture, and renew an architectural form with a social spirit; the second tends to ingratiate architecture to a public projected as a mass consumer. For the most part Gehry followed the second path into stardom in the 1990s, and the present status of the celebrity designer, the architect as Pop figure, is in no small measure a by-product of his fame.

Along the way Gehry seemed to transcend the Venturian opposition of modern structure and postmodern ornament, formal duck and decorated shed, architecture as monument and architecture as sign, but in fact he collapsed the two categories. This occurred first, almost programmatically, in his huge Fish Sculpture at the Olympic Village in Barcelona in 1992—a trellis hung over arched ribs that is equal parts duck and shed, both all structure and all surface, with no functional interior. The Fish also marked his initial use of CATIA, or "computer-aided three-dimensional interactive application." Because CATIA permits the modeling of non-repetitive surfaces and supports, of different exterior panels and interior armatures, it allowed Gehry to privilege shape and skin, the overall configuration, above all else: hence the non-Euclidean curves, swirls, and blobs that became his signature gestures in the 1990s, most famously in the Guggenheim Bilbao (1991–97), and perhaps most egregiously in the Experience Music Project (1995–2000) in Seattle, whose six blobs clad in different metals have little apparent relation to the many interior display-stations dedicated to popular music. In Bilbao Gehry moved to make the Guggenheim legible through an allusion to a splintered ship; in Seattle he compensated with an allusion to a smashed guitar (a broken fret lies over two of the blobs). Yet neither image works even as a Pop version of sited connection (Bilbao as an old port, Seattle as the home of Jimi Hendrix and Grunge music), for one cannot read them at ground level. In fact one can see them in this way only in media reproduction, which is a primary site of such architecture in any case.

On the one hand, then, Gehry buildings remain modern ducks inasmuch as they privilege formal expression above all; on the other hand, they also remain decorated sheds inasmuch as they often break down into fronts and backs, with interiors disconnected from exteriors in a way that sometimes results in dead spaces and cul-de-

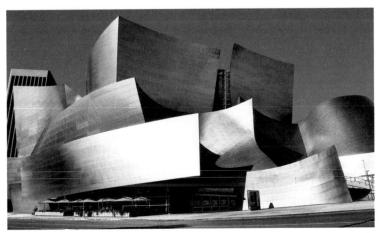

Frank Gehry, Walt Disney Concert Hall, Los Angeles, 1987–2003. Courtesy of
Gehry Partners, LLP.

sacs in-between (this is especially true of his Walt Disney Concert
Hall in LA [1987–2003]).[36] But the chief effect of this combination
of duck and shed is the promotion of the quasi-abstract building as
Pop sign or media logo. And, on this score, Gehry is hardly alone:
there is a whole flock of "decorated ducks" that combine the willful
monumentality of modern architecture with the faux-populist iconic-
ity of postmodern design.

In some cases, the duck has become the decoration; that is, the
form of the building serves as the sign, and sometimes at a scale
that dominates the setting, as the Guggenheim Bilbao dominates
its surroundings. In other cases the decorated shed has become the
duck; that is, the surface of the building is elaborated, with the aid of
high-tech materials manipulated by digital means, into idiosyncratic
shapes and mediated envelopes. The first tendency exceeds the ambi-
tion of the Venturis, who wanted only to reconcile architecture to its
given context via signs, not to have it become a sign that overwhelms
its context (the latter is also a "Bilbao effect," one not often acknowl-
edged).[37] The second tendency exceeds the ambition of Banham, who
wanted only to relate architecture to contemporary technology and
media, not to have it become a "mediated envelope" or "datascape"
subsidiary to them.[38] Today decorated ducks come in a wide variety

of plumage, yet even as the stylistic appearance is varied, the logic of effect is often much the same. And, despite the attacks of September 2001 and the crash of September 2008, it remains a winning formula for museums and companies, cities and states, indeed for any corporate entity that desires to be perceived, through an instant icon, as a global player.[39] For them, and perforce for us, it is still—it is ever more—a Pop world.

PART I
GLOBAL STYLES

TWO

POP CIVICS

In 1971 one of the architectural surprises of the last century occurred: two young designers, neither French, won the most important commission in Paris since World War II, the design for the Centre Pompidou, and they became famous overnight. The two—a thirty-eight-year-old Englishman named Richard Rogers and a thirty-five-year-old Italian named Renzo Piano—designed an exuberant building that delighted some and outraged others: a glass box supported by a structure of steel and concrete, each façade a playful grid of prefabricated columns and diagonal braces, with a transparent escalator tube that snakes up the front, and other service tubes, picked out in primary colors, that run up the other sides. Imagined as a cross between the British Museum and Times Square updated for the information age, the Beaubourg was immediately popular (it still has more than 7 million visitors a year); plopped down in a broad piazza, it was also populist (Rogers calls it "a people's center, a university of the street").[1] Yet the project was contradictory as well: a Pop building designed by two progressive architects for a bureaucratic state in honor of a conservative politician (the Gaullist Georges Pompidou), a cultural center pitched as "a catalyst for urban regeneration" (240) that assisted in the further erasure of Les Halles

Centre Pompidou, Paris, 1971–77. Photo © Renzo Piano Building Workshop.

and the gradual gentrification of the Marais. Such tensions have run through the subsequent careers of both Rogers and Piano, who have long identified with the Left even as they have benefited from the patronage of the Center and the Right.[2]

Although young by architectural standards in 1971, Rogers had several years of practice behind him. A graduate of the Architectural Association in London, he attended Yale in 1961–62 with Norman Foster, with whom he partnered, along with their spouses Su Brumwell and Wendy Cheeseman, until 1967. Difficult though it is to believe today, "Team 4" disbanded for lack of work, but not before they completed a breakthrough structure for Reliance Controls in Swindon (in southwest England), which the architectural writer Kenneth Powell describes as "neither a factory nor an office building nor a research station but a combination of all three" (20). The first of many "flexible sheds" that Rogers has designed over the years, the Reliance Controls Factory owed much to the elegant simplicity of

the Case Study Houses in Southern California, especially the famous Eames House of 1949. Yet Rogers was also open to the new Pop and high-tech ideas of the 1960s. In 1968, for example, he conceived a mass-produced house made up of yellow panels zipped together and set atop legs that could be adjusted, and so positioned (in principle) almost anywhere. Displayed at the 1969 Ideal Home exhibition in London, the Zip-Up House was, in its high-tech optimism, one part Buckminster Fuller and, in its snappy material and speedy process, one part Archigram (this group had already proposed a sci-fi pod with robotic legs in 1963). However, unlike Fuller and Archigram, Rogers was willing to moderate his schemes in order to get them executed; in the same years, for instance, he built a home for his parents in Wimbledon that combined the Pop modularity of the Zip-Up House with the refined pragmatism of the Eames House. Yet even when large commissions appeared, Richard Rogers Partnership (RRP, now Rogers Stirk Harbour and Partners) continued to experiment with modular designs in search of an economical architecture that was also inventive. Over the years, such schemes have included a mobile hospital for rural use, a diner conceived as an industrial product, an exhibition structure that is a giant system of shelves (a project presented by means of a Meccano model), and an apartment high-rise in which almost everything can emerge from a kit of prefabricated parts.

Given projects like the Reliance Control Factory and the Zip-Up House, the Beaubourg did not come out of the blue; nevertheless, as one of the few prominent Pop and high-tech buildings to see the light of day, it was received as a manifesto. First, it made clear the renewed importance of innovative engineering for contemporary architecture (Rogers and Piano were assisted by the great Irish engineer Peter Rice, who often consulted for RRP thereafter). Second, it offered one response to the open question of what postindustrial design might look like: "Most of us want it to look like *something*," Reyner Banham once remarked in a discussion of Archigram; "we don't want form to follow function into oblivion."[3] In this regard the Beaubourg was not as far-out as the "clip-on" and "plug-in" idiom of Archigram, with its "visually wild rich mess of piping and wiring and struts and cat-walks," but Rogers and Piano did convey the

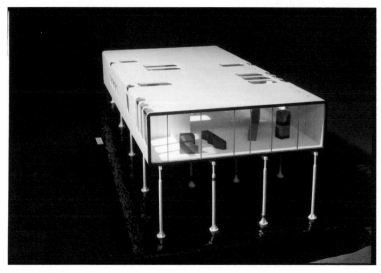

Zip-Up House, 1968.

unlikely mix of the communitarian and the consumerist that came to pervade much 1970s culture.[4] Third, and more specific to Rogers, the Beaubourg demonstrated the advantage of mechanical services pushed to the outside of the structure—as a means not only to free up the interior space (at almost fifty meters deep, the open floors of the Beaubourg allow for diverse uses) but also to animate the building as a whole (there is an echo of Futurism here: one thinks of the power stations imagined by Antonio Sant'Elia, with whom Rogers was impressed as a student).[5] In a way, the service tubes function as a contemporary form of ornament—they give the Beaubourg both detail and scale—and the movement of people across the piazza into the ground floor and up the escalator not only enlivens the center but connects it to the city as well. (The favored form of architectural imagery at RRP might well be "the mass ornament" of the occupants of its buildings—in circulation, in meetings, and so on.)[6]

These are all idea-devices that recur in RRP designs. In effect Rogers presents a threefold motivation of advanced technology in the Beaubourg that continues in work to the present. In the first instance new technologies serve to engineer new kinds of open space, a priority

that underscores his commitment to the innovations of modern architecture. Yet the trappings of these technologies are also put to use as ornament, which also speaks to his attention to the motivations of postmodern design. Finally, in the reconciliation of such demands RRP is able to speak to conflictual interests (again, communitarian and commercial, public and private)—a reconciliation that can also be read as a compromise.

After the Beaubourg, Rogers parted with Piano (amicably, as he had done with Foster), and more projects came his way, some from the business establishment. In 1978 no less an institution than Lloyd's of London selected Rogers to design its main building for insurance trading. The program called for a vast space, dubbed "The Room," whose functions could expand and contract with trade volume, and Rogers responded with a full-height atrium surrounded by galleries connected by escalators and lifts. Here again services are moved to the exterior, with stairs located in corner towers—the first appearance of this signature feature of the practice. Along with the atrium arch, these stair towers lend a Gothic touch to the Pop look of Lloyd's; at the same time the stainless-steel cladding connotes high-tech. Although Lloyd's lacks the populist dimension of the Beaubourg, the fact that a building with Pop-Goth and high-tech attributes could appear at all in the conservative City was a surprise—a provocative one for some.

Lloyd's established the language that RRP would go on to develop in different ways: an abundance of glazing, services on the outside when appropriate, with stairs and lifts often placed in towers, all done in such a way that interiors might be made as open, and exteriors as animated, as possible. The exteriors of its buildings do not express the interiors in a functionalist way; rather, the office strives to manifest the logic of its designs in a rationalist manner, often through an explicit hierarchy of elements. (Powell suggests that Louis Kahn, who thought in terms of "served" and "servant" spaces, influenced Rogers here, which again speaks to his modern affinities.) For example, RRP uses colors more often than most offices, yet it does so less for Pop effect than for design clarity: it applies its colors rigorously, and usually in order to articulate different services or sections. Although, as the Beaubourg showed early on, Rogers is responsive to the expectations of the capitalist world of mass culture, he also

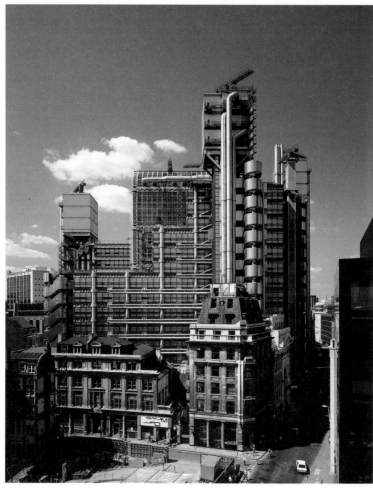

Lloyd's of London, 1978–86. Photo © Eamonn O'Mahony.

believes that architecture must offer a formal order that might miti-
gate the distractive clutter of that world.

Lloyd's was completed in 1986, at a time when conservative calls
for the so-called contextualism of postmodern design were strong,
and soon enough Rogers was drawn into the fray, sometimes with
the Prince of Wales as an antagonist.[7] Perhaps these skirmishes
impeded further large-office commissions in the London area in the

1980s; in any case, they returned in the boom years of the 1990s and the 2000s. Among these buildings are Channel 4 Television Headquarters near Victoria Station (1990–94); 88 Wood St (1993–99) and Lloyd's Register (1993–2000) in the City; Broadwick House in Soho (1996–2002); Waterside, the corporate headquarters of Marks & Spencer, in Paddington Basin (1999–2004); Chiswick Park, a business park in West London (1999–2010); and still other projects are in the works. Most of these buildings are cleanly designed and smartly engineered, and each has a flourish of its own—the bridge entrance and the concave front of Channel 4, for example, or the curved roof of Broadwick House. Yet these are more variations than innovations in the established RRP language: again, much glazing, cladding in steel or aluminum when necessary, exterior services and stair towers when possible, and color accents for articulation.

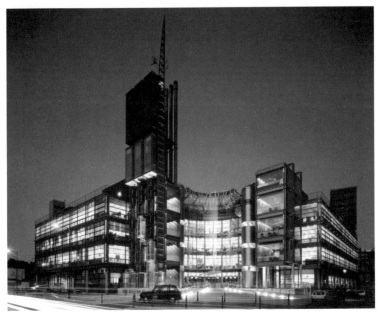

Channel 4 Television Headquarters, London, 1990–94. Photo © Richard Bryant / Arcaid.co.uk.

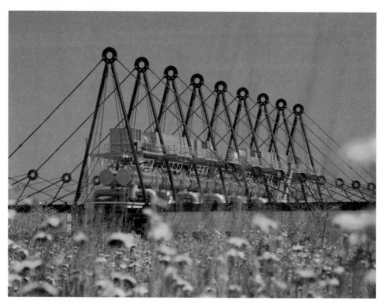

Patscentre, Princeton, 1982–85.

As might be expected, it was industry, both old and new, that really warmed to the rationality of RRP designs, and such projects also followed on the Beaubourg. In 1979 Rogers designed a center for Fleetguard in Quimper (western France); though a relatively heavy industry (it makes engine filters), Fleetguard received a rather light construction: a long box supported by slender columns that extend though the roof and are stayed by thin cables, with columns and cables painted red. Again designed with the aid of Peter Rice, this steel-mast structure became another signature device of RRP—its most prominent appearance is at the Millenium Dome (1996–99)—but it is not just a stylistic feature: as the stair towers open up interior spaces, so do the mast structures augment interior spans. The result is a functional flexibility that has suited high-tech enterprises as well, such as INMOS Microprocessor Factory in Newport (south Wales) and Patscentre near Princeton (New Jersey), which RRP designed in the early 1980s. These, too, are big sheds supported by steel masts, uniformly colored, that allow for broad spaces mostly free of columns. With much prefabrication and construction off-site, such

structures can be built economically and rapidly. Lightness, flexibility, economy, efficiency: these are architectural values, but most companies are pleased to be associated with them as well. In other words, there is an abstract symbolism at work here, and other clients have partaken of it, too (for example, RRP has also adapted its shed type for various academic projects, as with its resource center for Thames Valley University [1993–96]). In all these instances technology serves as both the driver of the spatial arrangement and the source of the iconic power of the building.

As RRP executed these big jobs, it attracted still bigger ones, such as transportation facilities, dockland developments, and master plans. Among its major works in the first category are Terminal 5 at Heathrow (1989–2008), Transbay Terminal in San Francisco (1998–2010), and Barajas Airport in Madrid (1996–2005). Although the primary innovator in this architectural type is Norman Foster—as we will see in the next chapter, his single-level terminal at Stansted established a new model—RRP has contributed as well, and its shed structure finds its apotheosis in such terminals. At Heathrow, RRP

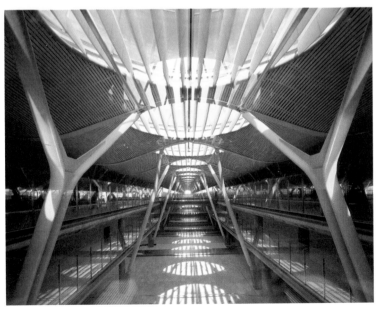

Barajas Airport, Madrid, 1996–2005. Photo © Amparo Garrido.

used giant tree columns to hold up its broad open terminal; at Madrid many such columns support the long wings of the terminal under a great canopy, colored Spanish red and yellow, whose curves guide travelers like so many waves. (Such neo-Baroque shapes are in fashion in architecture—they serve as one badge of high-tech know-how and style—but Rogers has limited them mostly to roofs.) In other words, both terminals are designed as symbolic gateways as well as practical ones; "like London's great railway stations of the past," Mike Davies, a longtime Rogers partner, remarks, "Terminal 5 has a civic role to play."

This civic role is important to RRP, and I will query it in this chapter; for the moment it might simply be noted that the office also claims it for its dockland projects and master plans. Over the years RRP has produced schemes for parts of Florence (where Rogers was born), Berlin, Paris, Lisbon, Shanghai, Singapore, and east Manchester, among other cities. But much of its planning has focused on London and environs, with schemes for Paternoster Square (the prince helped to dash this one), Greenwich Peninsula, Bankside, Wembley, and Lower Lea Valley (involving the Olympics master plan); and the same is true for its dock projects, which have included the Royal Albert Docks, Silvertown Docks, and Convoys Wharf. Not all RRP proposals for the public realm are on target: its scheme for the National Gallery extension (1982) foisted its own new idiom—part Beaubourg, part Lloyd's—on a program and a site not well suited to it. Yet others are inspired, such as the Coin Street Development (1979–83), which proposed that Waterloo station be connected to the City with a lofted arcade and a footbridge across the Thames (fitted with pontoons to support various amenities), and the "London as it could be" project (1986), which argued for a long park along the Embankment as well as a new route from Waterloo station across the river to Trafalgar Square. This kind of will-to-plan is often rejected as a will-to-power, yet it is needed today more than ever, especially as the industrial infrastructure of modern metropolises crumbles and the urban catastrophe of climate change looms (RRP has long studied both problems), and certainly American cities have fallen behind on this score (even at the level of individual buildings, the most innovative designs have lately appeared in smaller

cities like Seattle and Cincinnati). In any case, commitment to planning has often led Rogers into the political arena: he campaigned for Labor in the 1992 general election; he was appointed chair of the Urban Task Force after Tony Blair won in 1997; and he has advised design-friendly mayors of Barcelona (Pasqual Maragall, 1982–97) and London (Ken Livingstone, 2000–08) through architectural transformations of their cities.

Of course, proposed projects are one thing, executed ones quite another, and on this score the major public buildings designed by RRP have tended to appear farther afield. A few are law courts, such as the European Court of Human Rights in Strasbourg (1989–95), which consists of two circular chambers with two long tails for offices and chambers along the River Ill, and the Bordeaux Law Courts (1992–98), a glazed shed with a curvy canopy, under which sit seven courtrooms modeled in the vague shape of wine flasks (unusually for RRP, they are clad in cedar, which reinforces the association) with tops that pierce the roof. Clearly, like other celebrated offices, RRP benefited from the post-1989 push to use architecture to develop institutional images for the "new Europe" (I mean the early, optimistic version of this figure, not the divisive, debt-ridden one on stage since the 2008 crash)—a program in which cities and regions also participated eagerly. On this front Rogers is seduced by the dubious analogy between architectural transparency and political transparency (Foster and Piano are, too—even more so). Thus all the glass at the Bordeaux Law Courts is meant to suggest "the accessibility of the French judicial system" (284); similarly, the National Assembly of Wales (1999–2005) on Cardiff Bay, with its glazed shed under a wavy roof, "seeks to embody democratic values of openness and participation" (319). Yet the structures that house the assembly here—two curvy cones which, as at Bordeaux, pierce the roof—conjure up other associations far more readily: sailboats, church spires, and sorcerer hats à la Harry Potter.

The wine flasks at Bordeaux and the sail spires at Cardiff point to an important question in contemporary architecture: What is the relation between its civic role and its iconic power? Often today iconic buildings are asked almost to stand in for the civic realm, sometimes with

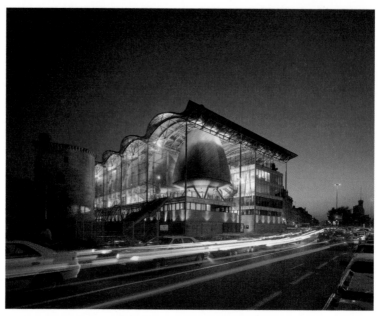

Bordeaux Law Courts, 1992–98. Photo © Christian Richters.

the effect that they then displace whatever residues of this realm might be left, as if imagistic promotion were all that citizens can safely expect from politicians and designers today. Rogers, like Foster and Piano (with whom he will always be triangulated), emerged in the interregnum between the engineered abstraction of modern architecture and the decorative historicism of postmodern architecture. In different ways all three designers have refined the former and refused the latter, and for the most part they have fought shy of the sculptural iconicity of contemporaries like Frank Gehry and Santiago Calatrava. However, like these other architects, Rogers and company are also asked to brand their clients distinctively. For example, RRP was commissioned to design a bridge for Glasgow meant to be an "icon for the city," one that would mark its desired metamorphosis from old industrial center to "European business and cultural capital" (354). The scheme, a ramped promenade that bends dramatically on the horizontal across the River Clyde, evokes a wing, a fin, and a fishnet all at once; here, in effect, an old building-type of function and labor became a new

spectacular symbol of leisure and display. Announced in 2003, it was abandoned as a bridge too far three years later.

Such abstract symbolism can be effective, but it can also be inflated; the Millennium Dome qualifies as one such balloon, and it is a colossal one. With its twelve 100-meter masts (twelve as in twelve hours, months, and constellations), "the ultimate inspiration for the Dome," Mike Davies tells us, "was a great sky, a cosmos under which all events take place" (298). RRP remains proud of this structure, and certainly the office cannot be blamed for its financial problems and confused contents

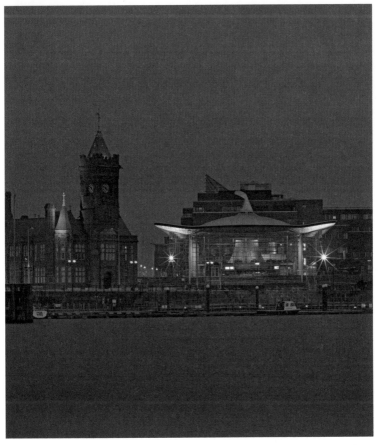

National Assembly of Wales, Cardiff, 1999–2005. Photo © Richard Bryant / Arcaid.co.uk.

(from its initial smorgasbord of "Millennium Experience" exhibits to its current status as an O2 entertainment complex), but the cosmic association is grandiose, and most people regard the Dome as a white elephant. The RRP contribution to the World Trade Center site was to be a different animal. One tower in a proposed group of four (the others were to be designed by David Childs, Foster, and Fumihiko Maki), the RRP scheme sends mixed messages, with glass façades that extend beyond the rooftop as well as steel cross-braces that support the tower in case its columns collapse in the event of an attack. On the one hand, RRP offers a suggestion of transparency, even of spirituality, which responds to the contradictory rhetoric of American freedom and perpetual funeral that has pervaded Ground Zero discussions since 9/11; on the other hand, it presents an image of security, even of armored defense against the world, also strong in post-9/11 talk. This contradiction comes with the site, and it is compounded by a master plan that mixes office buildings, a transportation hub, retail stores, anodyne cultural centers, and a huge memorial. What designer could make sense of that pseudo-civic realm?

Millennium Dome, London, 1996–99. Photo © Grant Smith / View.

For the most part RRP has worked seriously on the question of civic architecture in a consumerist age, and its responses are usually well considered—no more manipulative, on the level of image, than the Bordeaux flasks or the Cardiff spires. Yet here the contradictions that first emerged with the Beaubourg return. Rogers has acknowledged our mass-cultural society with the Pop and high-tech aspects of his architecture (in a sense, RRP holds together the Banhamite and Venturian lineages of Pop traced in the first chapter); at the same time he insists on a humanist notion of the city as "meeting-place." The rationalism of RRP designs can be severe; at the same time the office is renowned for its sociability (it is structured as a non-profit, with the salaries of its senior partners pegged to those of its youngest employees; it is active in charities; and the famous River Café, run by Ruth Rogers, began as the office canteen). Finally, RRP steams ahead with huge developments; at the same time it rightly promotes the sustainability of architecture and the regeneration of cities. RRP works well with such contradictions, but is that an expression of strength or a function of compromise—or both? To design a public space is not, *ipso facto*, to work for the public good, and to offer an iconic building is not, *ipso facto*, to play a civic role. Indeed, it might be that the controversies with the prince, over the Millennium Dome, the Heathrow Terminal, and so on, have the most use-value in this regard: they demonstrate a society that is more antagonistic than RRP otherwise allows.

CRYSTAL PALACES

Has any contemporary architect signed as many cityscapes as Norman Foster? Perhaps none since Christopher Wren has affected the London skyline so dramatically, from the Swiss Re tower in the City to the Wembley Stadium arch to the north. Born in 1935, Foster has a right to be immodest, and he does punctuate his accounts of his buildings with adjectives like "first" and "largest," and verbs like "reinvent" and "redefine."[1] Moreover, like his colleagues Richard Rogers and Renzo Piano, Foster is the subject of recent multi-volume publications, as if to outdo the massive tomes produced for such famous peers as Frank Gehry and Rem Koolhaas, whose large offices are cottage industries compared to his.

For Foster is also "Foster + Partners," a practice of some 1,000 people in some twenty-two offices. The list of its works runs for pages, and most have been realized: seven banks, nine bridges, eight civic designs (such as the transformation of Trafalgar Square), ten conference centers, thirty-eight arts halls, twenty-eight buildings for education and health, ten for government, fourteen for industry, twelve for retail, thirty-five for leisure and sport, thirty for residences, thirty-nine master plans (from fairs to entire cities), sixteen mixed-use developments, sixty-five offices (for example, Hearst Tower in

Swiss Re, London, 1997–2004.

Manhattan, 2000–06), twenty-eight product and furniture models, nine research complexes, and twenty-four transport systems (from private yachts to train terminals, metro stations, and airports)—and the numbers grow each year.[2] Like some of its clients, "Foster" is

international in its reach; indeed, many corporations and governments are smaller operations.[3] Yet for all the varied work over the last fifty years, the practice has remained mostly coherent in style and consistent in quality. Technologically advanced, spatially expansive, and formally refined, its designs are abstractly rational to the point of cool objectivity, yet somehow distinctive, relatively easy to identify, nonetheless; along with Rogers and Piano, Foster has achieved a global style. No wonder corporate and political leaders seek out this stylish office: there is a mirroring of self-images, at once technocratic and innovative, that suits client and firm alike.

"Foster" offers an architecture of great panache, with sleek surfaces, usually of metal and glass, luminous spaces, often open in plan, and suave profiles that can also serve as media logos for a company or a state. As a result, high-tech and high-design corporations are drawn to the practice: recent commissions include a European headquarters in Chertsey (southeast England) for Electronic Arts, which devises computer games, and a complex in Woking (also southeast) for McLaren Technology, which develops Formula 1 racing cars; both buildings feature glass façades whose elegant curves stick in the mind. That "Foster" is able to design efficient structures that are also media-friendly is proven: Renault uses its center in Swindon (1980–82, in the southwest), with its yellow exoskeleton of piers, cables, and canopies, as the backdrop for its UK advertisements, and the *Financial Times* has adopted the Commerzbank Headquarters in Frankfurt (1991–98), a towering wedge in white and grays, as its emblem of the city.

In this business of architecture as brand, other famous designers have relied on idiosyncratic forms that brand them as well: to make buildings stand out from often dismal surroundings, Gehry has used neo-Baroque twists, Koolhaas Cubistic folds, and Zaha Hadid Futurist vectors. In comparison, "Foster" favors relatively restrained geometries, however expanded they might be; its two colossal airports in China, for example, are little more than two arrows laid out point-to-point in plan. Such structures read almost as Gestalts or given forms; for the practice this graphic simplicity is all about clarity of program, whereby one might move from taxi or train through checkpoints to plane as though by a natural

Commerzbank Headquarters, Frankfurt, 1991–98.

progression. Even when "Foster" employs irregular volumes—ovoid and elliptical ones sometimes appear, such as the pinecone of the City Hall in London (1998–2002) or the cocoon of the Sage Music Centre in Gateshead (1997–2004)—they are just odd enough to be distinctive, and even then we cannot quite say, for example, whether

the Swiss Re (1997–2004) is a gherkin, a bullet, or a (Freudian) cigar. This abstract symbolism is less explicit than the kitschy images of postmodern architecture yet more declarative than the semiotic gestures of deconstructivist design (*à la* Peter Eisenman, say). All that is certain about this ambiguous abstraction is that it conveys a great faith in advanced technology and international business alike. In the end it is this dual enterprise, which is also abstract and ambiguous in its workings, that the symbolism of such buildings suits and celebrates.

Indeed, "Foster" exudes a heady air of refined efficiency that almost any corporation or government would want to assume as its own. The office stresses ecologically sensitive systems as much as technologically advanced designs: clearly it wishes to be seen as both green and clean, which, apart from actual benefits, is good public relations for all concerned. A further attraction is that the copious glass in a typical "Foster" design (not so green, this) suggests a transparency that might be associated with the political or administrative workings of

City Hall, London, 1998–2002.

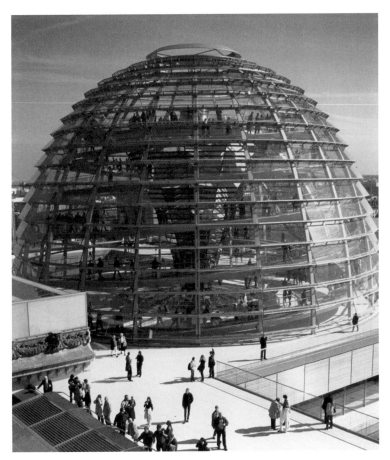

Reichstag, New German Parliament, Berlin, 1992–99.

the client—though, as suggested, these workings can be quite opaque. (This is the gambit of the glass dome-cum-observation deck conceived for the refurbished Reichstag in Berlin [1992–99]: it is thought meaningful that German citizens might glimpse their representatives from on high, as though this might nudge the politicians toward accountability.) Moreover, for all its image flair, a primary draw of "Foster" is that it is able to offer a wide array of design services, apparently at any site or scale. A key term for its director is "integration," that is, the capacity to produce a total design, from an elegant door-handle

to a great high-rise, from a private residence for a Japanese art collector to a massive bridge in southwest France. "Design for me is all encompassing," Foster states (6); and we should take him at his word, for his practice comprehends entire disciplines: architecture, engineering, urbanism, landscape design, product modeling, materials research . . .[4]

At the same time "Foster" does not want to be dismissed as too corporate, with decisions made by committee, or too technocratic, with designs produced by computer, and so the presentation of the office highlights the artistry of Foster the man. Almost every project is published with a sketch or two in his hand, which purports to be the original vision for each scheme. (It is a funny twist: while many artists no longer appeal to the inspired nature of the drawing, many architects still insist on it. They have traded on the old legend of the artist as visionary image-maker—a compensatory myth that continues to circulate with great currency, despite its persistent demystification in postmodernist art and poststructuralist theory alike.) Moreover, Foster asserts a logic of autonomous development that is usually associated with artistic practice more than architectural production. "A number of themes and concerns . . . have guided us consistently over the years," he writes, as if momentarily free of context and client alike, and then goes on to trace a pattern of internal "reinvention" of building types (6).

His breakthrough came forty years ago, with the headquarters in Ipswich for the insurance company Willis Faber & Dumas (1970–75; now "Grade One" listed, it cannot be altered). Here three banks of escalators rise from the ground floor, through an open plan, to a restaurant and a garden on the roof, with all elements (including a pool) intended to democratize the workplace. Yet the signature of the building is its pristine wall of dark glass, reflective by day and transparent at night, which curves with the street line: this early interest in spectacular effects has persisted to the present—and perhaps for "Foster," as certainly for many commentators on architecture, the spectacular is a good-enough substitute for the democratic. (As we saw in prior chapters, this is a trend from the Venturis to Gehry, and it is active in Rogers, too.) In any case, according to Foster, Willis Faber "reinvented" the office building, and he sees the Hongkong

& Shanghai Bank (1979–86), the Commerzbank, and the Swiss Re as successive elaborations of this type at the scale of the high-rise. In these buildings, services and circulation systems are pushed to the perimeter (as often with Rogers), so that the office floors remain relatively open, and lofty atria trimmed with greenery become possible. "What was once avant-garde," we are told, "has entered the mainstream" (92). The second part is certainly right: such floral atria are now commonplace, but often they appear less as public "gardens in the sky" than as corporate shows of power.

Sometimes a "reinvention" moves from one building type to another. The Sainsbury Centre for Visual Arts in Norwich (1974–78), another early design, also features a "single unified space," which the practice has "re-explored" in other cultural centers (7). Yet, for Foster, the most significant expression of such space has occurred in three airports: Stansted (1981–91), Hong Kong (1992–98), and Beijing (2003–07). Again, all are open in plan, laid out clearly on a primary level, whose modular canopy guides passengers readily to planes— a model, Foster underscores, since taken up by airports worldwide.

Willis Faber & Dumas Headquarters, Ipswich, 1970–75.

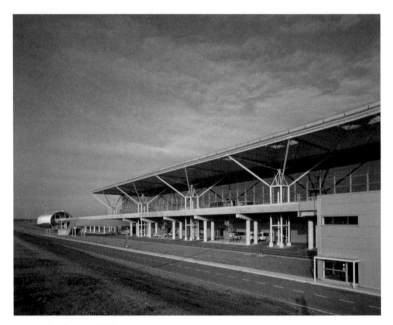

Stansted Airport, 1981–91.

(Incidentally, a measure of the technical capacity of the office is that the Beijing airport measures over a million square meters, handles as many as 50 million passengers per year, and was completed in time for the 2008 Olympics.) "With Stansted," Foster writes, "we took the accepted concept of the airport and literally turned it upside-down" (7). That is, service systems are placed underground, where train transport is also found, not overhead, which leaves the roof free to be a light canopy—another signature device, and one not restricted to any one building type.

In fact unified spaces and light ceilings (most often in glass) abound in "Foster" designs. In renovations of historic buildings, another specialty of the practice, they are used to enclose the extant structure; this is the case, for example, at the Reichstag, the Great Court at the British Museum (1994–2000), and another large court-yard at the Smithsonian Institution in Washington (2004–07). The basic strategy of these designs is to reinstate selected features of the original structure, add circulation systems and amenities, and then

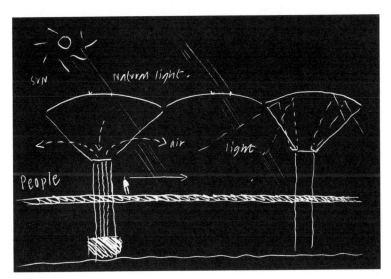

Drawing for Stansted Airport.

to cover the whole with a dramatic glass top. By these means, Foster argues, "new architecture can be the catalyst for the revitalization of old buildings": "The Reichstag has become a 'living museum' of German history," he claims, and "the Great Court is a new kind of civic space—a cultural plaza—that has pioneered patterns of social use hitherto unknown within this or any other museum" (12, 14). Yet what sort of civic space is projected here, and what sort of social use solicited? For all the reanimation, real or apparent, of either institution, the original structure is treated as a museological object: it is literally put under glass like an old artifact polished up. This combination of historical building and contemporary attraction can tend toward spectacle: a political assembly becomes a spectator-sport at the Reichstag, a distinguished museum becomes its own marvelous display at the British Museum. Is this space civic or touristic, one of social use or mass distraction—or is the distinction now quite blurred?

"Foster" might be more effective when its juxtapositions of old and new are more abrupt, as with the Carré d'Art, a discrete structure opposite the preserved Roman temple in Nimes (1984–93), or a wing

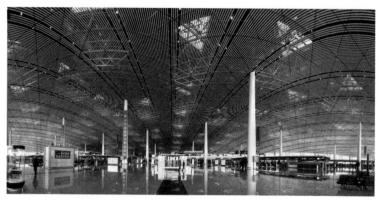

Beijing Airport, 2003–07.

of the Joslyn Art Museum in Omaha (1992–94), which doubles the Art Deco original nicely. Perhaps the best in this genre, the Sackler Galleries at the Royal Academy of Arts (1985–91), is also the most intrusive; the new spaces are carved right into the old museum, and they do enliven it. Yet this kind of collision has its limits, too. In the Hearst building in Manhattan "Foster" plunged a diamond-gridded glass tower of forty-two

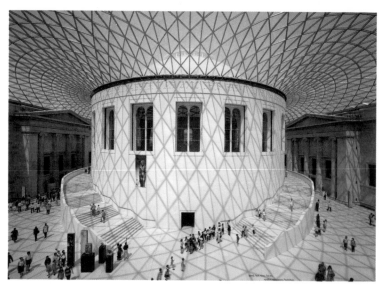

Great Court at the British Museum, London, 1994–2000.

stories into the original structure, a low Art Deco stone block on Fifty-Eighth Street and Eighth Avenue, and, far from "floating weight-lessly," the tower looks as though it has crash-landed. Here, rather than the "Mozart of modernism" (as Paul Goldberger proclaimed in the *New Yorker* regarding the project), he is its Steven Spielberg.

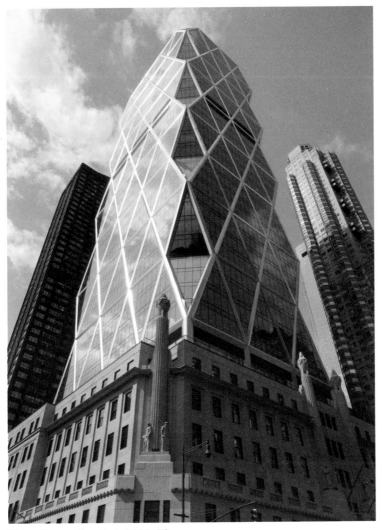

Hearst Tower, New York, 2000–06.

Like history, nature is also sometimes put under glass by "Foster," literally so in the National Botanic Garden of Wales (1995–2000), which is "the largest single-span glasshouse in the world" (158). As one might expect from the practice, the technology is superb: an immaculate glazing system allows the glass roof to curve in two directions at once, with panes that open and close automatically as the climate demands. Yet what does such a project convey about the status of nature in the "Foster" universe? The office contains a "Sustainability Forum" that investigates new green materials, products, and techniques, and implements them when appropriate: 90 percent of the steel in its Hearst Tower is recycled, for example, and the renovated Reichstag was designed to run an energy surplus. This concern with sustainability is praiseworthy in a world where buildings consume more energy, and emit more carbon dioxide, than either transport or industry. So, too, the practice has long advocated the progressive mixing of postindustrial industries, green areas, and residential developments, as in its plan for the German city Duisburg. There are "no technological barriers to sustainable development," Foster concludes, "only ones of political will" (15).

The bravado of this assertion is telling. The practice is capable of Promethean interventions into the landscape: for its Hongkong

Great Glass House, National Botanic Garden, Carmarthenshire, Wales, 1995–2000.

airport a 100-meter peak was flattened, and 200 million cubic meters of rock moved. By the same token, however, nature is abstracted in the "Foster" universe: it has become "ecology," "sustainability," a set of synthetic materials and energy protocols—that is, a fully acculturated category. "Foster" frames this acculturation in benign (sometimes Zen) terms, and insists, rightly, on "holistic thinking" when it comes to "sustainable strategies" (14), yet sometimes the holistic slips into the totalistic. Certainly the dialectic of modernity has shown that the prospect of a nature humanized can flip into the reality of a world technologized, and there are indications of this condition already within the "Foster" oeuvre. For example, in 1989 a Japanese corporation asked the office to imagine a satellite extension of Tokyo (this particular topos of visionary architecture runs back at least to the Metabolists in Japan in the 1960s), and its scheme is very sci-fi. A diamond-gridded cone of 170 stories set two kilometers out in Tokyo Bay, "Millennium Tower" recalls, all at once, the Eiffel Tower, the utopian projects of Russian Constructivism (one visualization even includes a zeppelin labeled "Green Visitors"), the dark Deco city of *Metropolis*, and the gigantic geodesic dome that Buckminster Fuller (a longtime Foster friend) once proposed for midtown Manhattan. In short, Millennium Tower conjures up a total world designed by a brilliant technocrat.

In such "Foster" designs, both history and nature appear abstracted, even sublimated, and the same might be said of industry. In the background of these projects one often senses the early jewel of industrial structures, the Crystal Palace produced by Joseph Paxton for the Great Exhibition in London in 1851 (names like "Great Glass House" and "Great Court" also point to this precedent). With its efficient construction in industrial iron and glass, its bold reformulation of architecture through engineering, its technological rationalism and social optimism, the Crystal Palace lies deep in the "Foster" DNA: again and again its transparent structure, unified spaces, and undecorated surfaces show through "Foster" designs, and not only in the nearly 50 conference centers and arts halls conceived by the office. (Incidentally, these traits alone suggest that "Foster" has little to do with the scenographic preoccupations of postmodern architecture,

though, as suggested, the office finds other ways to communicate.) The Crystal Palace was the confident projection of an industrial Britain still on the rise; against the historical odds, "Foster" attempts a similar projection for a postindustrial Britain, which might be one reason the director is embraced by his countrymen (as Lord Norman of the Thames Bank, no less): as one gazes up at his grand buildings in his homeland, the Empire does appear to live on.

At times "Foster" plays with our threshold-condition between industrial and postindustrial orders: at the Sage Gateshead, for example, the bulge of the music hall, representative of an entertainment economy, echoes the arc of the old suspension bridge nearby, emblem of another economy altogether, but this echo also smoothes over whatever tension might exist between the two. This smoothening is also evident in the other types left over from the industrial era—bridge, tower, train station, underground, airport, department store, and office building—at which the practice excels. With the application of advanced materials and techniques, they, too, appear heightened and lightened—again, sublimated—and this holds for the values that accompany them as well. Functionality, rationality, efficiency, flexibility, transparency: they seem pushed to a new level, and altered in the process, as if they had become emblematic values in their own right.[5]

Consider transparency. Again, like its modern predecessors, "Foster" suggests an analogy between architectural and political openness, not only at the Reichstag but also at City Hall. ("It expresses the transparency and accessibility of the democratic process," we are told; "Londoners see the Assembly at work" [188].) Yet the analogy is shaky from the start, and, when applied to the Singapore Supreme Court (2000–05)—"Foster" touts the "dignity, transparency, and openness" of its design (34)—it seems absurd given the track record of that government in general. How can architects continue to sell this line? Or, more saliently, why do we continue to buy it? Is it out of a sentimental attachment to the old virtues of transparency, and the wistful hope that appearing so will make it so? In any case, such transparency is subject to different interpretations: open office spaces might appear nonhierarchical and democratic to the architect or even to the boss, but panoptical and oppressive to the employees. Then,

too, as suggested, what once seemed transparent can now appear spectacular, whereby light and glass no longer signify civic accountability so much as mass attraction. Already, with its glass curtain wall for Willis Faber, "Foster" favored dramatic effects, and this fascination continues through the Reichstag, whose cupola serves as an observation deck by day and a "beacon" by night (182). So, too, the popular Millennium Bridge in London is described as a "ribbon of steel by day" and "a blade of light at night" (204): both a place for viewing and a view of its own, this pedestrian way is a platform for a citizenry imagined as twenty-four-hour spectator-people. In this manner an exhibitionist streak runs through "Foster," and other prominent practices today as well (Herzog and de Meuron come to mind). A spectacle society invites it, of course, and these architects can hardly be blamed for the society—but must they comply so brilliantly with its problematic desires?[6]

At issue here is a key ideological dimension of contemporary architecture. Consider how modern architecture of the early twentieth century—the white, abstract, rectilinear variety of Adolf Loos and Le Corbusier—captured the look of the modern. Such architecture still appears modern when almost nothing else of the period does— not the cars, the clothes, or the people.[7] "Foster," I want to suggest, approximates a similar feat for the look of modernity today: perhaps more persuasively than any other office, it delivers an architectural image of a present that wishes to appear advanced. Of course, the very attempt is underwritten by the new-economy clients that the practice attracts—high-tech companies, mega-corporations, banks from Europe to Asia, governments of many sorts—but they are attracted for this reason, too (again, there is a mirroring of images). Now, as with Le Corbusier et al., this look of the modern is not merely a look; it is an affirmation of an entire ethos: if Corb imaged modernity as clean functionality, with architecture as a "machine for living in," "Foster" updates this image with sophisticated materials, sustainable systems, and inspired schemes, which, again, it offers as values in their own right. In doing so, the office looks back not only to the 1920s but also to the 1960s, that is, to its own point of origin—the late modernism, inflected by Mies van der Rohe, that is associated with powerhouse firms like Skidmore, Owings and Merrill (in the

glory days of Gordon Bunshaft), architects like Minoru Yamasaki (of World Trade Towers fame), and designers like Bucky Fuller. Of course, like the 1920s, the 1960s were a moment of technological transformation that generated many visionary proposals—proposals for sleek megastructures among them, most of which could not be executed at the time. Today, however, these projections are no longer so outlandish; in fact "Foster" has realized its own versions of some of them.

One aspect of this look of modernity today is found in the signature element of the "Foster" practice: its diamond grids of glazed glass, "the diagrid." Although other architects have used it (as Koolhaas did in the Seattle Public Library), the diagrid is an architectural meme for "Foster": once one looks for it in the work, it appears everywhere. It is a structural unit, but it also serves as an ideological form—one that signals technocratic optimism above all else (in this respect it recalls the prime instance of the diagrid in modern architecture, the famous Glass Pavilion designed by Bruno Taut for the 1914 Werkbund Exhibition in Cologne). At times in "Foster" this optimism takes on a tinge of faith (as it did for Taut), literally so in its design for a Palace of Peace and Reconciliation (2004–06) in Kazakhstan. A pyramid, clad in stone, whose apex is made up of stained-glass diagrids, this palace is the venue for the "Congress of Leaders of World and Traditional Religions."[8] Koolhaas once suggested that the architectural modernity of Manhattan was driven by a passionate dialectic of two forms that often appeared in its World Fairs—the pylon and the sphere— the first of which attracts us with its height, the second of which welcomes us with its breadth.[9] In a sense the "Foster" diagrid is a miniature grandchild of this pair: it can be used in towers (as in Millennium Tower), for it can rise high, as well as in centers and halls (as in the Great Court), for it can also curve and enclose. Yet the diagrid is not a surefire device, for it produces problems of its own, especially ones of scale. Expanded in size, it can threaten to go on forever, as it nearly does in the "Foster" scheme for the World Trade Center, in which a tower of extended diagrids was to top out at 500 meters. So, too, not extended enough, it can appear oddly truncated, as it does in the Hearst Tower.

Palace of Peace and Reconciliation, Kazakhstan, 2004–06.

The World Trade Center scheme is especially telling in this regard. As much as any other candidate for the site, "Foster" appeared to be in synch with the popular (that is to say, the imperial) call to build the towers "higher than before." Such is its faith in modernity that "Foster" did not alter its design profile after 9/11. Indeed, for all its sensitivity to ecology, "Foster" does not seem much affected by any disaster, natural or manmade; history, too, appears abstracted in its work. In the post-9/11 world this unshakable confidence is welcomed by the shaky powers that be, and, like Santiago Calatrava and a few others, "Foster" delivers it: the office offers moral uplift in beautiful forms at a grand scale. Go, new millennium, "Foster" seems to proclaim with each new project. Go, modernity.

LIGHT MODERNITY

A tension runs through the work of acclaimed Italian architect Renzo Piano. Born in 1937 to a Genoese family of prominent builders, he has long stressed his commitment to craft—to the particularities of material and making—and, though his firm has multiple offices with international projects, it is still called Renzo Piano Building Workshop.[1] On the other hand, Piano burst into public view with the Centre Pompidou (1971–77), which, designed with Richard Rogers, is the most celebrated of the high-tech megastructures of the period, and today he is also associated with such large urban schemes as the redevelopment of the old harbor in Genoa (1985–1992) and Potsdamer Platz in Berlin (1992–98), as well as such massive infra-structural projects as Kansai International Airport (1988–94), for which an entire island was engineered into being in the Bay of Osaka (no less than 6,000 workers labored over three years).

Another version of this tension is that, despite the persona of the modest craftsman, Piano is the favored architect of many high-class institutions, cultural, academic, and corporate. Among his buildings in the first category are the Menil Collection in Houston (1982–87), an exquisite museum that distinguished the more classi-cal Piano from the more Pop Rogers; the Beyeler Museum in Basel

Kansai International Airport, 1988–94. Photo © Kawatetsu.

(1991–97) and the Nasher Sculpture Center in Dallas (1999–2003), two more elegant temples devoted to private art collections; the Niccolò Paganini Auditorium in Parma (1997–2001) and the Parco della Musica in Rome (1994–2002), the former a converted factory, the latter an original complex of three lead-clad auditoria; the Paul Klee Museum in Bern (1999–2006) and the Morgan Library extension in New York (2000–06); new wings for the High Museum in Atlanta (1999–2005), the Los Angeles County Museum of Art (2003–08), and the Art Institute of Chicago (1999–2009); and still to come, among other such projects, are makeovers of the Isabella Stewart Gardner Museum in Boston and the Kimbell Art Museum in Fort Worth, as well as an annex for the Whitney Museum of American Art in New York. So, too, in the academic category Piano has schemes under-way for such universities as Columbia, Harvard, and Michigan. His fifty-two-story tower for the *New York Times* on Fortieth Street and

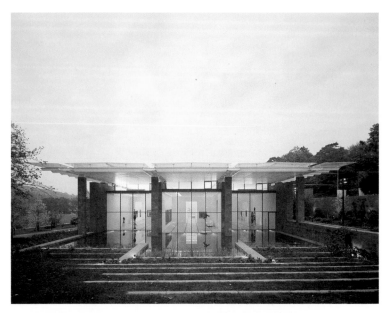

Beyeler Museum, Basel, 1991–97. Photo © Christian Richters.

Eighth Avenue was completed in 2007, and his California Academy of Sciences in San Francisco, which boasts an undulating roof with turf and skylights, was finished in 2008—and these are just two of his many corporate-institutional jobs of late. That Piano has four major projects in Manhattan alone—a new campus for Columbia to come uptown, the *Times* tower and the Morgan complex completed in midtown, and a satellite for the Whitney to appear in Chelsea—is extraordinary: When was the last time one office had so many important pieces on the Monopoly board? Even his London Bridge Tower—if built, this 305-meter glass spire will be the tallest office building in Europe—looks like a World Trade Center scheme that, fed up with the delay in Lower Manhattan, moved from the Hudson to the Thames.

Clearly, Renzo Piano Building Workshop delivers a design profile that speaks to different elites; in this respect its success, if not its size, recalls that of Skidmore, Owings and Merrill in the postwar heyday of late modern architecture as a dominant establishment style. What is it that makes Piano so attractive? Much of his allure lies precisely

New York Times Building, 2000–07. Photo © Michel Denance.

in his ability to mediate the tension between the local craft of building and the global enterprise of big business. Piano does so, on the one hand, through a refined use of materials (sometimes as traditional as wood and stone), which helps to ground his buildings in particular sites, and, on the other hand, through a suave display of engineering (often in light metals and ceramics), which serves to associate his designs with the contemporary world of advanced technology.

These poles of the practice were already present in its beginnings: in the middle to late 1960s Piano worked briefly in Philadelphia for the American architect Louis Kahn, long celebrated for his tactile and tectonic expression of materials, as well as in London with the Polish engineer Zygmunt Makowski, who was innovative in structures and skins supported by their own tension. Another key mentor was the French designer Jean Prouvé, with whom the peripatetic Piano studied in Paris. From his sculptural collaborations with Constantin Brancusi, through his furniture designs, to his modular schemes for colonial housing, Prouvé was adept at smooth combinations of the traditional and the technological—he possessed the kind of finesse now associated with Piano—and, as a member of the jury

that awarded the Pompidou commission, Prouvé was instrumental to Piano in other ways, too. Finally, it was on the Pompidou project that Piano first worked closely with the Irish engineer Peter Rice of Ove Arup & Partners.[2] In fact, after Piano and Rogers separated in 1978, Piano teamed with Rice, and, though they parted in 1981, Rice consulted for the office until his untimely death in 1992.

With such influences and interests, Piano was in the thick of progressive architecture in the 1960s and 1970s, during which time he experimented with temporary structures, exhibition spaces, and free-plan housing. In his embrace of clean design and smart engineering, Piano was associated not only with Rogers but with Norman Foster (with whom Rogers partnered before he teamed with Piano). All three young architects sought a way beyond modern architecture that would both realize its economic efficiencies and extend its technical advances. To this end they were inspired by the more visionary engineering of Buckminster Fuller as well as by the more practical Californian modernism of Richard Neutra, Charles and Ray Eames, and other designers of the Case Study Houses in Los Angeles. However, by the late 1970s Piano, Rogers, and Foster had diverged. Piano was never so Pop as Rogers nor so high-tech as Foster, and his signature device came to differ as well: whereas Rogers continues to experiment with circulation systems pushed to the exterior (as at the Pompidou), and Foster with great spans of open space (as at the Stansted terminal), Piano is still guided by his distinctive notion of "the piece."

"The piece" is a repeated component of a building, often a structural element such as a joint or a truss, which Piano exposes to view in a way that offers a sense of the construction of the whole; to this extent it seems to partake of the modernist principle of tectonic transparency. Even when the piece is more about appearance than about structure, it still lends a specific character to the building, which it often helps to scale vis-à-vis the site, too. The exemplary instances in the Piano oeuvre are the modular trusses and leaves (in cast iron and ferro-cement) that comprise the roof of the Menil Collection. Key to the special quality of this celebrated museum, these elements do several things at once: they allow us to see into its structural support and to sense its spatial ordering, they filter the strong light

Menil Collection, Houston, 1982–87. Photo © Richard Bryant.

of Houston into its galleries, and they cover the colonnade of its exterior, which in turn connects the building to its setting—to both the large verandas typical of Southern homes and the Greek Revival style favored in civic structures in the United States. For architectural writer Patrick Buchanan, this use of the piece is characteristic

of Piano in general, whose "art" he sees as one of "fitting in" and
"fitting together."[3] However, other examples of the piece—from the
massive cast-steel braces on the façades of the Pompidou to the light
ceramic scrims on the sides of the *Times* tower—might not seem so
fitting: the Pompidou ties are so big as to be brutal, while the *Times*
tubes are so fine as to be precious (especially in the gritty context of
Forty-Second Street).[4] Nevertheless, in these instances, too, the pieces
lend the buildings either a tectonic clarity or a tactile quality that
they would not otherwise possess. And sometimes the piece has a
metaphoric significance as well: for example, the eighty-three-meter
arches that support the curved roof of the Kansai terminal serve to
underscore the experience at hand, that of winged flight, but do so in
a way that is not too manipulative.

Like any device, however, the piece has its weaknesses, as even
advocates of Piano acknowledge. Due to his insistence on these
exposed components, "the complexity" of his buildings tends to
"come from the skin," architectural writer Philip Jodidio admits,
and they are "usually far more distinctive in section than in plan,"
Buchanan adds—which is to suggest that the articulation of space
and/or the development of program sometimes appears secondary in
Piano.[5] If this is a liability, it might be due to the very facility with
which he reconciles two preoccupations that are often at odds—a
concern with structure, pronounced in modern architecture, and a
concern with surface, paramount in postmodern architecture. For
better or worse, Piano suggests a third way: an evocation of struc-
ture on the surface of his buildings, that is, in effect, an evocation
of structure as skin or decoration—and sometimes, given his close
attention to light effects, as atmosphere, too.[6] But then in these cases
it is not clear how tectonic, or even functional, such "structure" is;
as Buchanan suggests, Piano sometimes treats technology as a leit-
motif. One thinks immediately of the famous I-beams that Mies van
der Rohe applied to the façades of his Seagram Building (1958) in
New York (among other buildings), which are not structural at all.
Piano is inclined to this kind of Miesian finesse, in which architec-
tural transparency seems to be affirmed, only to be made a little faux.

Here, the device of the piece appears in a new light. For Buchanan,
these components are often possessed of "a sense of aliveness"

that "elicits empathetic identification"; they are "almost ... beings in themselves."[7] This response is quite different from the rational understanding usually associated with architectural transparency; in fact it is close to fetishization, understood as the investment of an inanimate thing with an animate presence or power. As frequently in fetishization, a rhetoric of the natural, especially of the natural charged with the technological, follows: for Buchanan, Piano has created an "organic architecture," and among the pieces of evidence offered are the leaf motif of the Menil Collection, the toroidal shape of the Kansai terminal ("the torus is the most common geometrical figure found in nature"), and the sail forms that recur in his work (an avid sailor, Piano has designed two cruise ships and four sailboats).[8] Of course, architectural discourse is steeped in natural analogies (witness the old myth that the first building was a "primitive hut" with proto-classical columns derived from tree trunks), and these analogies have always served not only to naturalize architectural form but to idealize it as well. The modern master of such rhetoric is Le Corbusier, who argued that certain products of industry had developed as if by natural selection—a claim that made them appear necessary, too—and liked to compare luxury machines of the time with the Parthenon (his example was a Delage sports car). Similarly, Buchanan sees "natural evolution" at work in the Piano pieces, which are also said to combine "the efficiency of a machine and the integrity of the organism," and an abstracted classicism runs through his work from the Menil Collection through the Morgan Library and beyond.[9]

"The lesson of the machine lies in the pure relationship of cause and effect," Le Corbusier wrote in *Decorative Art of Today* (1925). "Purity, economy, the reach of wisdom. A new desire: an aesthetic of purity, of precision, of expressive relationships setting in motion the mathematical mechanisms of our spirit: a spectacle and a cosmogony."[10] There is little here that does not speak to Piano: often in his architecture, too, the principle of transparency shades into "an aesthetic of purity," in which a fusion of the organic, the mechanical, and the classical is essayed, and "technology" is indeed treated as a "leitmotif." In *Decorative Art* Le Corbusier looked to the machine as the austere basis of a new kind of ornament, one that would differ from the stylish compromises with industrial production offered by

Art Deco. Yet his own fusion of the organic, the mechanical, and the classical also worked to reconcile—to gloss over—the contradictory demands of the technological and the traditional. This note of an Architecture Deco is present in Piano as well, perhaps because, like Le Corbusier, he, too, operates at a time when such contradictory demands are especially insistent—not only between local building and global business, but also between traditional materials and digital techniques. Here his connection to Prouvé is again pertinent, as is his affinity for Brancusi (Piano designed the Brancusi Atelier adjacent to the Pompidou)—they both produced compromises between the technological and the traditional that are at once beautiful and occlusive.

At moments in Le Corbusier, the pressure of such contradictions pushed his "aesthetic of purity" to the point of outright fetishization. Here he is in the same passage from *Decorative Art* quoted above:

> The machine brings before us shining disks, spheres, and cylinders of polished steel, shaped with a theoretical precision and exactitude which can never be seen in nature itself. Our senses are moved, at the same time as our heart recalls from its stock of memories the disks and spheres of the gods of Egypt and the Congo. Geometry and gods sit side by side! Man pauses before the machine, and the beast and the divine in him there eat their fill.

This paean is close to delirious, but then 1925 was the high point of Parisian primitivism *à la* Josephine Baker, and Le Corbusier did eat his fill. Piano is never so extreme, yet sometimes his exquisite designs also disclose a fetishistic side. Consider his Jean-Marie Tjibaou Cultural Center in Nouméa, New Caledonia (1991–98), the distinctive feature of which is a fine series of ten pavilions with curved walls in wood slats that range from nine to twenty-eight meters in height. Disposed as if in a stately village, the pavilions evoke nearby huts, palm trees, and sails all at once, as well as the traditional basketwork and rooftop fetishes of the local culture; at the same time the Center is a state-of-the-art design expressive of the "light modernity that Piano has long favored."[11] For Piano enthusiasts the result is a successful negotiation of the local and the global; for others it might

Jean-Marie Tjibaou Cultural Center, New Caledonia, 1991–98. Photo © Pierre-Alain Pantz.

evoke a contemporary version of primitivist Deco, as though a village were first simulated, then abstracted, and finally sized to the scale of a theme park.[12]

The notion of a "light modernity" is suggestive here. "There is one theme that is very important for me," Piano remarks, "lightness (and obviously not in reference only to the physical mass of objects)."[13] He traces this preoccupation from his early experiments with "weightless structures" to his continued investigations of "immaterial elements" like wind and illumination.[14] Indeed, lightness is the message of his primal scene as a designer, a childhood memory of an awning of sheets billowing in the breeze on a Genoese rooftop, a vision that conjures up the shapely beauty of both classical drapery and contemporary sailboats as architectural ideals. For Piano, lightness is thus a value that bears on the human as well as on the architectural: it concerns graceful comportment in both realms. As a practical

imperative, lightness confirms the drive, already strong in modern architecture, toward the refinement of materials and techniques, but now this refinement seems pledged less to healthy, open spaces and transparent, rational structures, as it was (at least in principle) in modern design, than to decorous touches and atmospheric effects—to an aesthetic value in its own right. A light architecture, then, is a sublimated architecture, one that is particularly fitting (that word again) for art museums and the like. (Often the light effects in such spaces appear so beautifully natural that one might fail to notice that they are produced by costly filtering systems in elaborately louvered ceilings.)

The importance of lightness to recent design was signaled in a 1995 exhibition called "Light Construction" at the Museum of Modern Art, where Piano was represented by his Kansai terminal.[15] The curator of the show, Terence Riley, took his cue from another Italian, Italo Calvino, who in his last book, *Six Memos for the Next Millennium* (1993), proclaimed the special virtues of lightness for the new age: "I look to science," Calvino wrote, "to nourish my visions in which all heaviness disappears."[16] The attraction of this old dream of disembodiment is clear enough, but, viewed suspiciously, it is little more than the technological fantasy of dematerialization retooled for a cyberspatial era, and it has become a familiar ideologeme to us all—though it might seem odd that architecture, long deemed the most material of the arts, would wish to advance it.[17] Viewed even more suspiciously, this lightness is bound up not only with the fantasy of human disembodiment but also with the fact of social derealization. In his 1984 novel about the unreal life of Communist Czechoslovakia—a life saturated with Party ideology that no one believed, a condition that Peter Sloterdijk has taught us to see as "cynical reason"—Milan Kundera coined the phrase "the lightness of being."[18] This kind of lightness is no ideal at all; it is "unbearable," and since the fall of the Berlin Wall the capitalist version of this derealization has become the state of many more of us. Perhaps, in the end, the two notions of lightness—the dream of disembodiment and the nightmare of derealization—must be thought together dialectically (that is, if dialectics has not suffered its own final lightening, as many now think).

For his advocates, the lightness featured in Piano is driven by historical necessity as well as by technological advance. In fact Buchanan offers a fanciful story of a pseudo-Hegelian *Geist* that has passed from the massive forms of ancient Mesopotamia and Egypt (ziggurats and pyramids), through the "colonnaded edifices" of classical "Mediterranean cultures," to the abstract "grids" of modern "Atlantic culture" ("in which nature is enmeshed by the grasp of reason and technology"), and on now to a "Pacific cultural ecology" where, in the hands of designers like Piano, "the lines of the grid will etherealize into intangible conduits of energy and information, or take tactile biomorphic form."[19] For his part, Piano states simply that the Pacific is "a culture of lightness," and that he prefers it to others: "Although I grew up in Europe, I feel much closer to the Pacific, where lightness, or the wind, is much more durable than stone."[20] Yet his version of the Pacific is still European, indeed Mediterranean, only repositioned and updated, which is to say that, as in Hegel, a classical bias underwrites the benign story of historical passage here. This classicism points to another affinity with Corb and Mies (not to mention Adolf Loos and others) whose "aesthetic of purity" also harbored such a bias, and in fact Piano scarcely conceals this fact: his museums in particular are like abstract descendants of classical temples.[21]

Perhaps this beatific notion of a "light modernity" must be viewed dialectically—countered, say, with the less sanguine notions of a "liquid modernity" and a "second modernity" proposed by the sociologists Zygmunt Bauman and Ulrich Beck, respectively. Bauman calls our present stage of modernity liquid because the force of capital that courses through it is so powerful as to uproot any other social formation or economic mode in its way and carry them along in its flow (the fantastic vision of "all that is solid melts into air" in *The Communist Manifesto* becomes more actual all the time).[22] If an architectural image of this condition were needed, one candidate might be the Maison Hermès in Tokyo (1998–2001) that Piano faced in glass blocks which do indeed appear liquid: here the "floating world" of Edo meets the floating world of capital today. For his part, Beck deems modernity to be in a second stage because it has become reflexive, concerned to modernize its own old industrial

infrastructure.[23] This notion is also suggestive vis-à-vis Piano: like other major architects, he is often commissioned to convert old industrial structures (his Paganini auditorium was once a sugar factory), indeed entire industrial sites, in ways that are appropriate for a postindustrial economy of service and sport, culture and entertainment (his Genoa harbor includes an aquarium and a glass sphere

Maison Hermès, Tokyo, 1998–2001. Photo © Michel Denance.

with the largest collection of ferns in the world). In this regard, the most telling example is the Piano makeover of the Fiat Lingotto Factory in Turin (1983–2002). Designed by the engineer Giacomo Mattè Trucco in the late 1910s, this large structure, complete with a test-track for new cars on its roof, is an icon of modern architecture: Le Corbusier concluded *Toward an Architecture* (1923) with images of the track, and Reyner Banham hailed it in *Theory and Design in the First Machine Age* (1960) as "the most nearly Futurist building ever built."[24] Piano has fitted this old factory, which remains the headquarters of Fiat, with a helicopter pad, a glass bubble conference room for company directors, and a private museum for the Agnelli art collection on the roof, while below there is a concert hall, an exhibition space, a cinema, a university branch, and a shopping center.

In our modernity, structures for performance and show are much in demand, as are stadia for sport and entertainment, as well as the usual malls, office towers, banks, and business complexes; and, like his peers Rogers and Foster, Piano is involved in all these categories. In an economy desperate to sustain consumer spending, display

Lingotto Factory conversion, Turin, 1983–2002. Photo © Shunji Ishida.

remains all-important, and here architecture often serves as both stager and staged, both the setting for fine commodities and the fairest commodity of them all. Yet new infrastructure is also imperative, especially for transport, and designers like Piano are at work in this area as well, with innovative airports, train stations, and subway systems. Much of this infrastructure remains regional in scope, but some is global (for example, Kansai Airport is hardly for Osaka alone). If modern architecture was "the international style," then such neo-modern architecture must count as "the global style," and, like the second modernity that it serves, it often exceeds national containers. At the same time, such design still needs a trace of the local in order for its buildings to appear grounded; in fact these traces rise in value, as do any vestiges of the past (as Rem Koolhaas likes to say, there is not enough past to go around, and so its aura continues to skyrocket). Frequently, then, local reference appears in global architecture precisely as a souvenir of the old culture, a token at a remove, a mythical sign: hence the allusion to the floating world in the Hermès store in Tokyo, the village huts in the cultural center in New Caledonia, the spire in the tower planned for London, and so on.

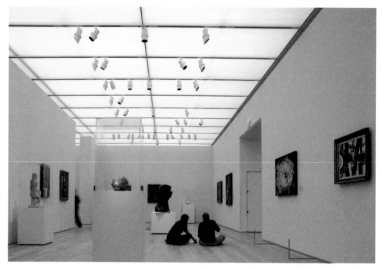

Art Institute of Chicago, 1999–2009. Photo © Nic Lehoux.

Beck calls this phenomenon "banal cosmopolitanism," and, like Rogers and Foster, Piano is adept at its architectural expression. This problematic aspect of global style might prove to be a deadly counter to the "critical regionalism" once posed by Kenneth Frampton in resistance to such "universal civilization."[25] Dedicated to a "poetics of construction," Frampton wants to see a critical moment in the Piano piece, which is said to mediate between the local and the global without capitulation to the conservative tendency of the former or the capitalist rationality of the latter. Yet, as Piano has developed, the piece has become less a resistant element, grounded in material and making, than another affective token or atmospheric effect in a world of banal cosmopolitanism—one that, again, remains classical in essence. In this regard lightness appears able to sublimate not only material nature but historical culture as well, and here fetishization is once more at work. Apparently it, too, can operate at a global scale.

PART II
ARCHITECTURE VIS-À-VIS ART

NEO-AVANT-GARDE GESTURES

In the last decade, Zaha Hadid has advanced from a vanguard figure in architecture schools to a celebrity architect with credibility enough in boardrooms to have several big buildings completed and several other projects launched. This upswing began in 2003 when her Contemporary Arts Center in Cincinnati, her first structure in the United States, opened to wide acclaim, and it was confirmed in 2005 when her BMW plant center in Leipzig, which proved her ability to design for industry, was completed. In 2004 Hadid won the prestigious Pritzker Architecture Prize—the first woman to be so honored—and in 2006 she received a retrospective of thirty years of her work (paintings as well as designs) at the Guggenheim Museum. More recently, her Museum of XXI Arts (MAXXI) in Rome appeared to warm reviews in 2009, and there are other large commissions in the works, including office buildings and cultural complexes in the Middle East, an opera house in Guangzhou, and an aquatic center for the 2012 Olympics in London. Hadid can no longer be dismissed, as her critics were once wont to do, as a woman who stood out in a male profession on account of her brassy personality and exotic background (she was born in Baghdad in 1950). Indeed, for her proponents Hadid has done more than any of her peers to rethink old

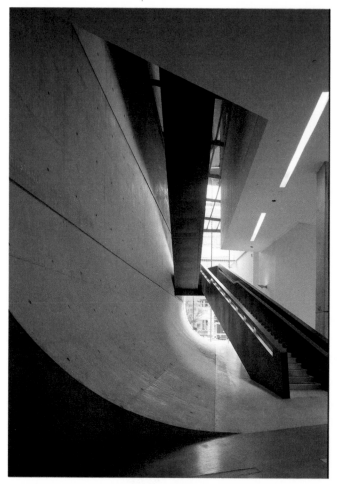

Lois & Richard Rosenthal Center for Contemporary Art, Cincinnati, 1997–2003. Photo © Hélène Binet.

representational modes of architecture and to exploit its new digital technologies. It is this view I consider here, with special attention to her recourse to select moments in modernist art and architecture.

For several years after her 1977 graduation from the Architectural Association (AA) in London, Hadid had little work of her own. In this lull she turned to modernist painting, in particular the Suprematist

abstraction of Kasimir Malevich. Hadid explored this work in paint-ing of her own, which she regarded primarily as a way not only to develop an abstract language for her architectural practice, but also to render the standard conventions of architectural imaging (plan, elevation, perspective, and axonometric projection) more dynamic than they usually appear. Already in her AA thesis, an unlikely

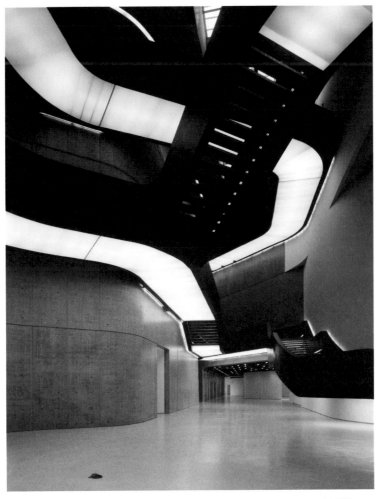

MAXXI (Museum of XXI Century Arts), Rome, 1998–2009. Photo © Hélène Binet.

scheme for a hotel complex on a hypothetical Thames bridge, Hadid adapted the idiom of the Malevich "Arkitektons," plaster models, built up in geometric blocks, that he proposed in the middle 1920s for a monumental architecture in the young Soviet Union. This was only an initial gesture, but it was not an auspicious one, for, however enlivened with Suprematist red and black, the Arkitekton blocks remain static in her adaptation. Nevertheless, her project was shaped: "I felt we must reinvestigate the aborted and untested experiments of modernism," Hadid wrote in retrospect, "not to resurrect them but to unveil new fields of building."[1]

To recover the suspended experiments of the historical avant-garde was a principal strategy of neo-avant-garde art after World War II (think of the multiple remotivations of Dada alone). Of course, modernist art suffered a traumatic suppression under the regimes of Hitler, Stalin, and (to a lesser extent) Mussolini; as a result, such movements as Expressionism, Constructivism, and (again, to a lesser extent) Futurism became somewhat occluded, and a return to them could have the force of rediscovery and revaluation. The case of modern architecture is different: its suppression was not as severe, and, as key figures like Walter Gropius, Le Corbusier, and Mies van der Rohe not only persisted but prospered in the postwar period, there was not distance enough to make them appear strange or new. Thus, for example, when young architects like Peter Eisenman and Richard Meier revisited Le Corbusier in the 1960s, it had little of the repercussive effect of a neo-avant-garde return; it did not reset the terms of discourse radically. Of course, there are partial exceptions to this general rule. As noted in Chapter 1, Reyner Banham had urged designers of his generation to reconsider Futurist and Expressionist architecture, long sidelined by the functionalist and rationalist preoccupations of the International Style, and later in the 1960s another generation of designers began to explore the largely lost precedent of Russian Constructivist architecture.[2] Hadid also probed this precedent at the AA with her teachers Rem Koolhaas and Elia Zenghelis, yet it was unusual for an architect to look to a painter like the Suprematist Malevich—and it was untimely, too, for by the middle 1970s advocates of a return to representation in postmodern architecture had begun to dismiss modernist abstraction

in toto—and what more absolute apostle of modernist abstraction could one evoke than Malevich? At least in this respect, Hadid might be aligned with the different enterprise of postmodernist art, which sought to subject representation to critique rather than to restore it.[3]

"I have ripped through the blue lampshade of the constraints of color," Malevich wrote in 1919. "I have come out into the white. Follow me, comrade aviators. Swim into the abyss."[4] This is a radical claim to non-objectivity, one that aims to negate not only all representation but any worldly association of color, not to mention the earthbound orientation of the traditional picture (with a vertical position that mirrors our own upright posture). Yet not all Suprematist paintings plunge so fully into the abyss: sometimes a residue of a referent remains in Malevich, and often his geometries still read as colored figures against white grounds, even when these grounds might also suggest a space beyond "the blue lampshade" of the sky. In her paintings Hadid exploits some of these ambiguities, such as how Suprematist forms can appear as horizontal or vertical and Suprematist spaces as recessive or shallow. At the same time she complicates these uncertainties, for often in her paintings perspective is not banished so much as multiplied, with the effect that different views exist within single images, and spatial axes are not only rotated but also warped, with the result that her planes run in various directions at once—from us, toward us, and at many angles and curves in between. Suprematist painting was once seen as a radical flattening of the picture plane; Hadid motivates it instead as a dramatic break into an indefinite space-time, in an attempt to "crack open" her objects, to "compress and expand" her spaces, to intensify and liberate her structures, all at once.[5]

An early statement of these goals is her 1983 painting *The World (89 Degrees)*, where, hubristically enough, Hadid transforms a section of the globe into a survey of her own projects to date, with the earth turned on its ear, minus—in a pointed deviation from rectilinear regularity—one degree. "The real world becomes Hadidland," Aaron Betsky enthuses about this manifesto-painting, "where gravity disappears, perspective warps, lines converge, and there is no definition of scale or activity. This is not a specific scene of functions and forms, but a constellation of possible compositions."[6] Here, her longtime collaborator Patrik Schumacher also enthuses, Hadid announced

The World (89 Degrees), 1983.

a "new paradigm" of "complex curve-linearity."[7] However, if this is a new paradigm, it has its problems. To be sure, the turn to abstract painting was a striking move, but it rendered her designs pictorial, even weightless. Hadid points to this tendency in her own account of her early projects, where she writes of "floating pieces" of architecture "suspended like planets."[8] Once released, how are these structures to be regrounded? Malevich forged his abstraction not only by suppressing the referent but also by unmooring the viewer, in part through an extrapolation of aerial views that makes any subject-position difficult

to imagine. This was a radical gesture in painting, but is it a valid one in architecture? Where is the subject, let alone the object, in this floating? At this early stage, however, such concerns did not count for much, and her provocation that representation was as important as construction advanced Hadid in architectural circles.

Hadid did deploy, as a materialist counterweight to the airborne idealism of Malevich, the Constructivism of Vladimir Tatlin. Already in the late 1970s this "opposition between Malevich's *Red Square* and Tatlin's *Corner Relief*" governed her designs for Koolhaas and Zenghelis (in their fledgling Office for Metropolitan Architecture), designs that strive to hybridize the different languages of Suprematism and Constructivism (the former concerned with the transcendental, the latter with the tectonic).[9] Hadid pursued this unlikely synthesis in her own practice after 1979, too, especially in *The Peak* (1982–83), her winning entry in a Hong Kong competition. She describes this unbuilt scheme, in which a resort complex is fractured into a cliff site, as "a Suprematist geology," a paradoxical phrase that points to the tension between the principles represented by Malevich and Tatlin.[10] Yet it was this very tension that positioned Hadid first to be included in the landmark "Deconstructivist Architecture" show curated by Mark Wigley and Philip Johnson at the Museum of Modern Art in 1988, and then to be tapped as the designer of the "Great Utopia" exhibition at the Guggenheim in 1992–93 (where the old rivalry between Malevich and Tatlin was restaged).

For Hadid the next move was to demonstrate that her dynamic representations could be translated into actual buildings, and here again the proposals of Constructivism suggested a way to stitch together her complex geometries. It is also true that, as work began to trickle into her office by the middle 1980s, Hadid simplified her forms. Prow shapes were prominent in the designs of the late 1980s; they govern her first major buildings, a Berlin housing complex (1986–93) and the Vitra Fire Station near Basel (1990–94). In the early 1990s these shapes were joined by wedges and spirals, as in her Spiral House project (1991), and then in the middle 1990s by folds and ramps, as in her Blueprint Pavilion (1995) and her plan for a Prado Museum extension (1996). As with other architects in this new period of computer-aided design, her formal ambitions expanded with

The Peak, 1982–83.

her technical capacities, and this conjunction soon allowed Hadid to imagine walls that emerge "in all directions," as in her Wish Machine pavilion of 1996, and to propose skins that "weave and sometimes merge with each other to form floors, walls, and windows," as in her project for the Victoria and Albert Museum extension in the same year.[11] These devices can be dismissed as extravagant gestures, but they are not entirely arbitrary; in contrast to other architects given to idiosyncratic forms, Hadid worked to make her shapes appear as motivated generators of her structures and spaces.

In the beginning Koolhaas was a guiding star for Hadid: her decision to look back to neglected precedents in modernism was supported by his example, as was her tendency to develop one element in a program or a site as the key to an entire scheme; his attention to the metropolis at large also influenced her. Yet, in the matter of representations elaborated into buildings, Hadid revealed another affiliation, here to Eisenman. In the annals of architecture the elaboration of a representation into an object is hardly a novel operation: the application of single-point perspective was foundational to Renaissance architecture, for example, just as its complication was important to Baroque architecture (think of Brunelleschi and Borromini, respectively). Understood broadly (from El Lissitzky to Theo van Doesburg, say), Constructivism also exploited perspectives and projections as generators of design. Yet Eisenman went further in this direction; sometimes in his early houses his projections seem to determine his buildings. Hadid went further still, as she pushed familiar modes of architectural representation—not only isometric and axonometric projections but also single-point and fish-eye perspectives—into strange explosions of structure and "literal distortions of space."[12] At this time, too, architects like Frank Gehry had developed the form-making of avant-garde design to such a point that it had to confront (once again) its own modernist dilemma: how, given this apparent freedom, to motivate architectural decisions? It was largely an engagement with modes of representation that saved Eisenman and Hadid from the willful shape-changing of Gehry and his followers.

In the midst of her "literal distortions of space," Hadid revealed a drive to challenge the assumed verticality of architecture, to open up

Vitra Fire Station, Weil am Rhein, Germany, 1990–94. Photo © Christian Richters.

building on its horizontal axis (already in 1996 she imagined a bridge for London as "a horizontal skyscraper").[13] In principle this lateral opening can render architecture less monumental and more dynamic; it can also pull the building across its setting in a way that complicates both the relation to its ground and the threshold between its interior and its exterior. It is primarily in this manner that Hadid expanded her practice from discrete structures to "new fields of building," in which her schemes seem to emerge out of tensions immanent in the sites. Sometimes, too, she ran this transposition of axes the other way around: Hadid "flipped up" the ground "to become a vertical plane" as early as a 1990 project for an Abu Dhabi hotel, and she did much the same thing in her 2005 proposal for a Louvre extension for Islamic art.[14] This vertical-horizontal play became central to her architecture, and it made her folds, ramps, and spirals appear as structural elements as well as stylistic flourishes—elements that mediate not only between the levels of a given building but also (again) between interiors and

exteriors and among structure, site, and city. This kind of axial transposition and inside-out connection is still at work, variously, in most of her recent buildings, such as the MAXXI in Rome.[15]

No one would confuse Hadid with a functionalist; often in her practice function follows structure, and structure follows imagination. At the same time, despite her eccentric shapes, she is not quite a formalist either. Rather, a primary motive of her architecture is the release of forces detected in a given project or site, out of which unforeseen structures and spaces might be developed. Yet this site-specific impulse is at odds with the tabula rasa of her Suprematist abstraction, which prompts one to ask to what extent her schemes are indeed derived from her sites. Consider her Car Park and Terminus in Strasbourg (1998–2001), which is sometimes offered as a good example of site-specific architecture. The outline of this complex follows an obtuse angle, which in turn follows the given intersection of road and rail lines, but the design can also be seen as

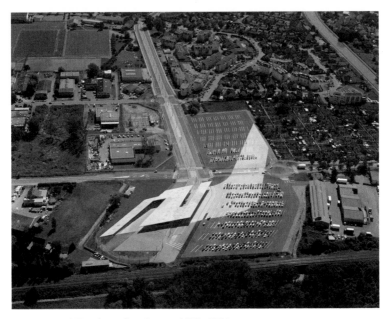

Car Park and Terminus, Strasbourg, 1998–2001.

an architectural abstraction laid over an infrastructural abstraction (Hadid adds a decorative abstraction, too, as she carries the white of the terminus roof over to the car park like a Nike swoosh). In short, the forces here are projected as much as extracted, and one might argue much the same about the braided vectors that make up the MAXXI. Moreover, in architecture no less than in art, the putative extrapolation of a scheme from its site has become a familiar operation; first embraced as a way to avoid the arbitrary, it has become arbitrary in its own way.[16]

Nonetheless, the concern with such forces does point to other historical precedents for Hadid, precedents that her interest in Suprematism and Constructivism has obscured in the reception of her work: Futurist and Expressionist architecture. Sometimes she intimates these affinities in her language. "The whole building is frozen motion," Hadid remarks of her first signature building, the Vitra Fire Station, "ready to explode into action at any moment"; and generally she has called for a "new image of architectural presence" with "dynamic qualities such as speed, intensity, power, and direction."[17] What could be more Futurist in spirit than such statements? "Let's split open our figures," the Futurist sculptor Umberto Boccioni proclaimed in 1912, "and place the environment inside them. We declare that the environment must form part of the plastic whole, a world of its own, with its own laws: so that the pavement can jump up on to your table, or your head can cross a street, while your lamp twines a web of plaster rays from one house to the next."[18] As much as any architect since that time, Hadid has responded to this Futurist call for an opening of structure onto space, an interpenetration of interior and exterior, an intensification of "figure" and "environment" alike. Certainly the planar vectors in her paintings and buildings often seem to fly out of a Futurist box of forms.

Just as the Constructivist dimension in her early work grounds its airborne Suprematist aspect somewhat, so an Expressionist dimension in her later work controls its dynamic Futurist aspect somewhat. Some of the forceful geometries that Hadid has proposed since the Vitra Fire Station are modeled in massive materials such as concrete, and more and more she has tended to an Expressionist sculpting of large volumes. For example, the sleek but sturdy profile of her

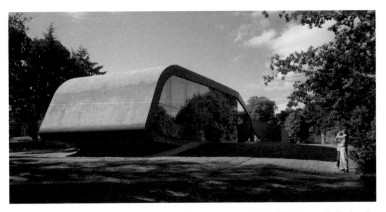

Ordrupgaard Museum extension, near Copenhagen, 2001–05. Photo © Roland Halbe.

Landesgartenschau (1996–99), an exhibition hall and research center in Weil am Rhein, Germany, suggests a synthesis of Futurist speed and Expressionist modeling (it both cuts across its landscape and sits heavily in it), and the same is true of her Ordrupgaard Museum extension (2001–05) near Copenhagen, which also resembles a paradoxically suave bunker, her celebrated BMW plant center (2001–05), and other recent buildings. Current projects include a media complex in Pau, France, a train station in Naples, and the aquatics center for the London Olympics, all of which evoke Futurist concerns with media and/or movement. Yet Hadid has modeled them, too, as so many Expressionist shapes, and when her Expressionist modeling overwhelms her Futurist dynamism, the result is often a static image.[19]

Indeed, her buildings do not convey movement so much as they represent it—they are precisely "frozen motion"—and, more than a multiplicity of mobile views, they set up a sequence of stationary perspectives.[20] Vitra, for example, is effectively a built drawing, a cluster of perspectives made literal, and the interiors of her museums in Cincinnati and Rome also suggest a matrix of designed views, complicated but fixed, and evocative of set design as much as anything else.[21] Minimalism showed us long ago that simple objects prompt us to move about them—in large part to test the ideal forms of our conception against the contingent shapes of our perception.

Rendering of London Aquatics Centre, 2005–11.

Ironically, with her complex geometries Hadid might arrest her viewer-visitors more than activate them.[22] Moreover, despite the lightness of her pictorial and digital means, there is often a heaviness in her materials and masses. This effect counters the vaunted immateriality of her work; it also leads one to question its rethinking of architectural imaging.

"Which features of the graphic manipulation pertain to the mode of representation rather than to the object of representation?" Schumacher asks. It is an excellent question, one that is hardly restricted to contemporary architecture (it might be the primary epistemological puzzle in visual culture today), yet here it seems a red herring, for, despite the formal complication of the two, Hadid tends to collapse her representation into her objects. Indeed, she seems to use digital technology to minimize material constraints and structural concerns as much as possible, and so to jump from drawing to building as directly as she can. This elision marks a key difference from Eisenman, who worked to thicken such translation, not to reduce it, even as he also manipulated axonometric projection in order to generate his early architecture as though automatically, without apparent intervention by any authorial subject (here he was influenced by Sol LeWitt, who wrote famously of his Conceptual art that "the idea becomes a machine that makes the art").[23] For her part, Hadid manipulates perspective even more extremely; yet,

however distorted and multiplied her perspective might be, it still privileges the subject: artist and viewer remain at the center of the representation-become-building. In short, the displacement of the subject proposed by Eisenman is countered more than affirmed by Hadid (and many others in digital design), and, at least in this respect, the deconstructive line of avant-garde architecture is reversed rather than developed.

Finally, what are we to make, in political terms, of the rapport here with Futurism and Expressionism? As for Futurism, its sexist celebration of power and nihilistic attack on culture are not easily forgotten and not always far away. Expressionism also seems weirdly close today: its expressive values are condoned, even encouraged, in a world of neoliberal capitalism. These may not be problems for Hadid (in any event they are hardly hers alone), yet they cannot be dismissed out of hand. And what about the fate of the other modernisms that she explores? Hadid has carried the utopian visions of Suprematism and Constructivism into the promised land of actual building, yet, as she has done so, she has also diverted them—turned Suprematism away from its radical autonomy and Constructivism away from its materialist critique. Here, too, Hadid can hardly be blamed for reversals that occurred long ago; in the final analysis, however, her relation to all these modernisms is less deconstructive than decorative—a styling of Futurist lines, Suprematist forms, Expressionist shapes, and Constructivist assemblages that updates them according to the expectations of a computer age. Too often, then, Hadid suggests not a formalist whose reflexivity is generative, but a stylist whose signature shapes become involuted and stagnant. In this regard she is finally closer to postmodern architecture than to postmodernist art; the difference is that the ingredients of her pastiche are not traditional styles but modernist forms. In the end, then, Hadid might not escape the accusation that the theorist Peter Bürger made long ago against the neo-avant-garde project in his *Theory of the Avant-Garde* (1974): to fail in its critique, as the historical avant-garde did, is one thing, but to repeat such a failure—more, to recoup this critique as style—is to risk farce.[24] It is in this way that the neo-avant-garde becomes a gesture.

This point leads to a final one. When Banham urged a recovery of Futurism and Expressionism to guide the architecture of a Second Machine Age (his own Pop period), he did so in part because he felt that postwar architects must be concerned, as he believed those prewar movements were, with the imaging of new technologies. At least in this respect Hadid might be considered a latter-day Banhamite, a paradigmatic designer of our own Third Machine Age of the computer. And one strain in the Hadid literature does argue that her twists, layerings, and interpenetrations anticipated design parameters that have become viable only with recent digital programs—more, that her visionary demands prodded these technical advances into being (Schumacher writes of a "dialectic amplification" between her architectural schemes and computational tools).[25] Along with Gehry, then, Hadid is presented as a prime architect of the digital period.[26] Yet, ideologically, this position is a fraught one, and it has led her associates to dubious pronouncements about the primary purpose of contemporary architecture ("More than ever," Schumacher asserts, "the task of architectural design will be about the transparent articulation of relations for the sake of orientation and communication").[27] According to some new-media enthusiasts, critical inventions of modernism such as montage are now absorbed by computer programs as so many automatic options, and this kind of argument has also served to position Hadid at the forefront of avant-garde design. "The model for her work," Betsky writes, "is now the screen that collects the flows of data into moments of light and dark."[28] Is this all that it means to further "the incomplete project of modernism"?[29] One hopes that this is not the first and last context for "new fields of building."

POSTMODERNIST MACHINES

From a distance, the Institute of Contemporary Art in Boston (2002–06) looks almost modest. A simple box on the harbor in scale with the other few buildings there, it seems to eschew the sculptural iconicity that many art museums have recently embraced. It is only when we round the austere edge of the building and see how its top floor cantilevers over the Boston Harborwalk that we are struck by its physical presence. From this vantage, too, we can grasp the diagram of the design overall. In effect the architects, Diller Scofidio + Renfro (DS+R), pulled the narrow path of the water walkway into a broad platform of wood planks, which they then stepped up to produce a public grandstand for outdoor performance.[1] This angle measures the height of the first floor, which, faced with glass, contains the admissions, "art lab," store, and café. On the exterior the diagonal continues upward to describe the second and third floors, also faced in glass, where the theater, "digital studio," education center, offices, and theater are located (the last is the indoor continuation of the outdoor grandstand, and it, too, fronts the harbor). Finally, the third floor supports the exhibition galleries of the fourth level, the 17,000 square feet of which are column-free; with twelve-foot squares of polished concrete flooring and sixteen-foot ceilings with

Institute of Contemporary Art, Boston, 2002–06. Photo © Iwan Baan.

skylights and scrims, this neo-Miesian pavilion is a luminous media-tion of city, water, and sky (the glassed corridor that juts out over the boardwalk provides an uninterrupted view of the harbor). Suspended beneath the third floor, like the cockpit of an amphibious spaceship, is a media room—a wedge of broad steps and computer screens that drops down, vertiginously, to a long window that looks onto the water below. Here the loop of the building—the gradual rise out of the harbor, the strict angles that define its volumes, and the abrupt return to the harbor—is complete.[2]

Such devices as ramps, spirals, and loops are pronounced in recent design. Zaha Hadid features ramps in her Cincinnati Contemporary Arts Center, for example, while Rem Koolhaas exploits the spiral in the Seattle Public Library and the loop in the Beijing CCTV. Yet the immediate precedent of the ICA design is a 2002 scheme by DS+R for an Eyebeam Museum of Art and Technology in New York, which also features dramatic cantilevering. Given a program that called for spaces for both exhibition and production, the architects chose to weave the two kinds of spaces together: a two-ply slab of fiberglass

Rendering of Eyebeam Museum of Art and Technology, New York, 2002.

and concrete was to snake up from the street, undulating side to side to shape each level, with floor becoming wall and wall reverting to floor at the turns, thus enfolding the two activities (exhibition and production) in multiple ways. Although the two projects differ in appearance—the Eyebeam would be all curves, the ICA is all angles—they share a logic of flow or circuit. Moreover, each scheme responds to a fundamental paradox, which they attempt to turn to advantage: with the Eyebeam the difficulty was a program that is half museum and half atelier, while with the ICA it was a museum dedicated to attention to art but sited on a harbor front inclined to distraction (not that the two modes are always so opposed). "The museum wanted to turn inward," Ricardo Scofidio remarks; "the site wanted to turn the building outward. The building had to have a double vision."[3] What the architects thus produced, Elizabeth Diller adds, is both "a self-conscious object that . . . wants to be looked at" and "a machine for looking."[4] This last phrase sounds modernist in its pragmatic efficiency—if the house according to Le Corbusier is a "machine for

living in," then a museum might well be a machine for looking—but it also points to a postmodernist turn of mind that imagines architecture as a prosthetic subject, one possessed here of exhibitionistic and voyeuristic proclivities to boot (note again that, for Diller, this "self-conscious" museum "wants" to be looked at and to look).

This conceit of architecture-as-subject has often guided work by DS+R. Whereas designers like Hadid have sometimes carried a mode of representation into the architectural object as such, DS+R have sometimes projected an aspect of vision into the very building. This approach was already programmatic in Slow House (1991), a scheme for a beach home on Long Island, New York, that is structured in its entirety as though it were a view—a vector of sight that bends and expands from a narrow entrance to a large picture-window one hundred feet away (the view was to be redoubled on a monitor that relays a live video feed of the water).[5] Fifteen years later the ICA design complicated this idea of architecture as "eyebeam." On the one hand, the architects wanted not only to disrupt "the touristic gaze" of the site (as the video screen would do at Slow House) but also to "disperse views" within the museum (along the building, across it, up it, and so on); they are "always partial and fleeting," Diller says of these sight-lines; "they follow you and hide from you" (note again the subjectivizing of architecture here).[6] At the same time, Charles Renfro adds, DS+R conceived the museum as an "optical instrument" in its own right; for example, the suspended mediatheque on the harbor front functions as a "viewfinder," as does the large glass-enclosed elevator at the core of the building, and again the vista from the harbor-side corridor is panoramic.[7] Along with the circuit up from the harbor, around and through the museum, and back down, it is this cluster of views that both opens up the ICA and ties it back together.

The notion of architecture as a visual matrix is smart, but it raises two concerns. First, in the trope of a machine for living, the house is still an environment for people; in the metaphor of a machine for looking, the museum becomes a quasi-person in its own right. Prepared by the modernist notion of film as a prosthetic "kino-eye," with the new human defined as "man with a movie-camera," this museum-as-cyborg suggests a postmodernist reversal—as if the architecture could do the looking for us. In the guise of our activation, then, architecture-

Slow House, Long Island, 1991.

as-vision might almost displace us as engaged viewers. Second, a museum that makes such an insistent claim on our visual interest might challenge the art at its own game: though the galleries are given pride of place in the cantilevered pavilion, they might seem secondary

to the other space-events of the building. Perhaps, in this regard, the ICA represents a new moment in the art-architecture complex: if it declines to compete with the art at the level of sculptural iconicity, as at the Guggenheim Bilbao, or, for that matter, at the level of awesome scale, as at the Tate Modern, it vies with the art in the register of the visual—that is, in the otherwise privileged dimension of the visual artist. Of course, with the boardwalk, grandstand, and theater, the ICA also emphasizes the performative. This, too, is a field in which these architects excel, yet, as artists explore the building as stage and/or as site, they might feel somewhat subordinate to it. "We began the project with the assumption that architecture would neither compete with the art nor be a neutral backdrop," Scofidio comments. "It had to be a creative partner."[8] Collaboration here, then, is a given, and this relationship might not always be welcomed by others. Have we reached the point where interdisciplinarity is designed in, as it were, as a value in its own right?[9]

"DS+R is an interdisciplinary studio," we are told, "that fuses architecture with the visual and performing arts," and it has pursued this fusion as actively as any office.[10] The relevant work here divides, roughly, into multi-media pieces (usually in collaboration with theater and dance companies); site-specific installations; images and objects that reflect on desire, gender, and display; and electronic interventions that blend architecture and media. An early instance of theatrical work is *The Rotary Notary and His Hot Plate (Delay in Glass)* (1987), a collaboration with Susan Mosakowski inspired by *The Bride Stripped Bare by Her Bachelors, Even* (a.k.a. "Large Glass," 1915–23) by Marcel Duchamp. Here DS+R suspended a large mirror at a forty-five-degree angle above the stage in order to divide its space vertically into two visual zones, as the Large Glass is divided. The mirror could move up and down, a wall panel could rotate as well, and the result was a "perpetual motion machine" of bodies, prosthetics, and images that, again like the Large Glass, kept the performers in a state of continual (dis)connection.[11] This simple use of the mirror was a pure act of architecture, for it transformed the stage into the basic modalities of architectural representation: the movements seen on stage counted as the plan, and the movements seen in the mirror as the elevation. DS+R have exploited this device

The Rotary Notary and His Hot Plate (Delay in Glass), 1987. Multi-media performance.

to transform the space of dance, too, as in *Moving Target* (1996), which, based on the diaries of Nijinsky, explored various states of emotion deemed "normal" and "pathological."[12] With *Inertia* (1998) DS+R again collaborated on a dance piece, in this case one that investigated different representations of motion in a way that reached back to the photographic studies of time-motion undertaken by Eadweard Muybridge and Étienne-Jules Marey. Broadly, then, a cluster of concerns emerges from such performances: the staging of desire and emotion, the imaging of movement and work. Architecture might seem to be extrinsic to such topics, dear as they are to postmodernist art, but, *pace* the discourse of "fusion," the interdisciplinary thrust of these projects is first to suggest that architecture is always already present somehow—as unseen setting or frame—and then to disrupt this normative use of architecture with a critical intervention.

Some of these interests carry over into DS+R installations, images, and objects, which tend to interrogate "spatial conventions of the everyday."[13] An early instance is *The withDrawing Room* (1987), in which they cut up and repositioned parts of the former home of

the Capp Street Project, an art space in San Francisco. With sections removed from the walls, and table and chairs suspended from the ceiling, the structure of everyday domesticity was disarticulated in a manner at once surgical and dadaistic. *Bad Press* (1993–98) also treated home life, with the focus here on the work done by women (work that was once subject to time-motion studies as well—that is, to the overt disciplining of the laboring body). In this "dissident housework series" (its subtitle), white male dress shirts were ironed into bizarre twists and folds; reminiscent of the "involuntary sculptures" of Brassaï and Dalí, these shapes also recalled the contorted poses of hysterics, as if unpaid women had struck back directly at white-collar men.[14] In a related installation titled *Indigestion* (1995) DS+R allowed visitors to do the rearranging of the social unit, represented here by a dinner table set for two. Through an interactive touch-screen one could mix-and-match various table-partners with different gender and class designations, even as the same recorded conversation droned on. Once again architecture intervened in everyday space, but it was also there all along.

The interrogation of the everyday led DS+R to the production of sleek objects, such as monogrammed towels and highball glasses, with each given a surrealistic twist: some towels express gender conflicts, for example, while some glasses dispense pharmaceuticals. Along with these (dis)agreeable objects of private desire and disgust came ambiguous images of public seduction and aggression, as in *Soft Sell* (1993), a large projected image of a luscious female mouth on the façade of an abandoned porn theater on Forty-Second Street and Seventh Avenue. In the audio the disembodied feminine personage solicited passersby with such questions as "Hey you, wanna buy a ticket to paradise? Hey you, wanna buy a vacant lot in Manhattan?" Finally, DS+R have explored the tokens of tourism and the spaces of travel. *Tourisms* (1991) is an installation of fifty Samsonite suitcases, one per state; suspended from the ceiling in ten rows of five, each is opened to reveal a "suitcase study" of a tourist attraction represented by a vintage postcard (for example, the boyhood home of Ronald Reagan in Illinois). If *Tourisms* brings the sights to us (it is also a play on the traveling exhibition), the multi-media performance *Jet Lag* (1998) brought us to travel. This collaboration explored two stories

of bizarre voyaging: an American grandmother who took her grand-
son across the Atlantic 167 times in order to elude his father, and an
English sailor who disappeared in a solo round-the-world race after
faking his positions to officials.

The "fusion" of architecture with art was the distinctive move made
by DS+R during its first two decades of work. Whereas architects like
Hadid have pursued a neo-avant-garde strategy, whereby design was
to be advanced by a selective return to historical precedents in art
and architecture alike, DS+R have followed a postmodernist strategy,
whereby design was to be complicated by a lateral turn to contempo-
rary practices in art.[15] This interdisciplinary move allowed DS+R to
skirt many of the battles over "history" and "theory" that beset the
architectural discipline in the 1980s and 1990s. Yet often their blur-
ring of genres might be too dependent on postmodernist art, indebted
as their investigation of exhibition and display is to Conceptual prac-
tice, and their concern with desire and spectatorship is to feminist
practice (some of the aforementioned projects echo the work of
Dennis Adams, Laurie Anderson, Jenny Holzer, Mary Kelly, Barbara
Kruger, Louise Lawler, Allan McCollum, Martha Rosler, Krzysztof
Wodiczko . . .). In short, what might be innovative in an architec-
tural context might appear less so in an artistic one. Moreover, this
involvement sometimes implicated DS+R in the ambiguous position
of much postmodernist art—that is to say, in a deconstructive posi-
tion that, as it spoke within the conventions and institutions that it
sought to question, often shaded into complicity with them. Might
it be that interdisciplinarity, once thought to be transgressive, has
become almost routine, not only in art and academic worlds but also
in architectural practice, and even normative in the "new spirit of
capitalism" at large—that is, in an economy in which we are invited
(indeed compelled) to connect, collaborate, network, and so on?[16]

This difficulty is sometimes touched on, gingerly, in the reception
of DS+R. For example, Aaron Betsky describes DS+R as "display
engineers" who participate in the culture of consumption in order
to expose its workings. "These artists display display," yet, in doing
so, Betsky claims, they "frustrate" this culture even as they "surf"
it.[17] For his part, Michael Hays sees DS+R design as "a tool of social
cartography" that "discloses the extrinsic, ideological structures that

contaminate and complicate the intrinsic, supposedly pure forms and techniques of architecture." Yet this "scanning," Hays continues, is but "a placeholder for a critique that has become impossible" because "critical distance and difference have been annulled."[18] However sophistical Betsky is, and however dire Hays, both have their points: often contemporary design does appear to be located between display and engineering—the function that connects image and structure—and often it does seem merely to scan the culture (a euphemism for "to mirror"?). This is a vanguard DS+R should not be so eager to lead.

Less effective when they fuse art and architecture, DS+R are more pointed when they demonstrate its sub rosa disciplinary presence and when they bring their architectural expertise to bear on cultural questions, such as the effects of new media and technologies on space and subjectivity.[19] This constitutes a second topos of their work, and initially it was based on two propositions. The first is that a prime condition of contemporary culture is a convergence of immediate seeing with mediated viewing. DS+R underscored this convergence first at Slow House, with its juxtaposition of picture window and video monitor, and later at the ICA, with its *mise en abyme* of window and screen in the mediatheque (where the harbor view might initially be mistaken for another digital image). The second proposition is that the flow of video has become the telltale form of media visuality and temporality today, perhaps as cinematic montage was in a previous moment of modernity; several projects by DS+R refashion the contemporary façade as imagistic and mobile in this way.[20] Indeed, to put it broadly, if much modern architecture focused on structure and space, and much postmodern design on symbol and surface, then much contemporary practice *à la* DS+R is drawn to a zone somewhere in between—to a mediated blend of screen-space.[21] Of course, one danger here is that to further the confusion between architecture and media is to serve an already pervasive culture of special effects and faux phenomenologies. Ironically, for all their theoretical attention to the body, DS+R do not engage corporeal experience very deeply.

In the exploration of architecture and media, DS+R first addressed the spatial effects of video surveillance. In *Para-site* (1989), an

Para-site, 1989. Multi-media installation.

installation at the Museum of Modern Art in New York, they positioned cameras at three thresholds of the museum (the entrance, the escalators, and the doors to the sculpture garden) and set up monitors in a gallery that was radically rearranged in the manner of *The withDrawing Room* (for example, four chairs were set on the ceiling and the walls); here viewing was aligned with surveillance, and both were disrupted in the process. Later, in *Jump Cuts* (1995) DS+R installed a horizontal bank of twelve screens on the façade

of a cineplex theater in San Jose, California, on which was carried a montage of live footage of patrons in the lobby and scenes from movie trailers; here viewing was juxtaposed with being watched, and movie-going with monitoring. Finally, in *Overexposed* (1994–2003) and *Facsimile* (2003), DS+R also relayed images of the interior of a building to its exterior. In the first work a video panned the former Pepsi-Cola Building on Park Avenue in Manhattan, pausing at intervals so that fictional images from office life might be projected, while in the second piece a video monitor moved along the façade of Moscone Convention Center West in San Francisco, showing a live feed of the lobby mixed up with scripted scenes in the offices.

Such projects led DS+R to consider the uses and abuses of architectural transparency. Historically, glass worked to dematerialize the traditional wall and so to expose the hidden interior of buildings, and many architects have associated this disclosure not only with professional honesty but with democratic openness. DS+R are rightly skeptical of this shaky analogy; the technology of glass has also proved useful for purposes of surveillance by corporations and governments alike, and this use, DS+R assert, "spawned new paranoias."[22] Yet this is only the first transvaluation of transparency; in our exhibitionistic culture, they claim, it is followed by a second, as "the fear of being watched has transformed into the fear that no one is watching."[23] And with this change has come another: "Once considered invasive, electronic surveillance is now the accepted social contract in public space, a welcome assurance of security, and a performance vehicle."[24]

This narrative of the vicissitudes of architectural transparency seems a little neat, and certainly in the wake of illegal wiretaps, "Patriot Acts," and the like, our ease with surveillance is not so obvious. Nonetheless, the postulate of a "post-voyeuristic, post-paranoid vision" is provocative, especially given that our primary accounts of the gaze, whether Sartrean, Lacanian, or feminist, are indeed tinged with a paranoia that positions the subject of the gaze as its object-victim as well.[25] Moreover, DS+R have put this notion to suggestive use not only in media interventions like *Overexposed* and *Facsimile* but in actual designs such as the Brasserie restaurant (2000) in the Seagram Building in Manhattan, where surveillance cameras relay images of arriving patrons to a bank of video monitors above the bar,

even as these same patrons make a grand entrance down a prominent gangplank into the dining area.[26] However, to call this exhibitionistic relation to vision "post-voyeuristic" makes little sense in psychoanalytic terms, for in the Freudian account the exhibitionist is the voyeur in disguise, who acts out precisely for his or her own imagined viewing—and this might well be the case at the Brasserie.

DS+R have worked to alter our relation to the gaze in other ways, too—first with Duchampian gestures at the disturbance of vision (a topos of the work from *The Rotary Notary* to the ICA), and then with the calculated deployment of outright obscurity, as in the Blur Building (2002), a pavilion designed for the Swiss EXPO on Yverdon-les-Bains. This structure jutted out like a jetty onto Lake Neuchâtel, where, through a high-tech system of pumps, nozzles, and computer programs, it produced an immersive cloud into which visitors were invited to wander. On the one hand, its lightweight framework represented an extreme of structural transparency; on the other hand, the Blur Building was "devoted to obscurity" in a way that sought to challenge the usual spectacles of such expositions with literally "nothing to see."[27] And yet the very opacity of a project like Blur, enigmatic as it is, can be converted into a spectacle in its own right.[28]

Blur Building, Yverdon-les-Bains, Switzerland, 2002. Photo © Beat Widmer.

The postmodernist strategy of "blurred genres" assumed that categories like "art," "architecture," and "media" are given as separate; today, however, that separation seems a matter of modernist doctrine more than ontological fact, and, as with the transvaluations of architectural transparency, DS+R have adapted accordingly. In effect, they have moved from a practice of "fusion" to one that understands "blur" to be always already at work in a site—a practice that often elaborates mixed conditions into appropriate structures.[29] This thinking is evident in two recent commissions in New York, the first involving Lincoln Center, the second involving the old elevated railway on the West Side known as the High Line.

Initially hired to refashion the public spaces at Lincoln Center (including the information kiosks), DS+R were soon given an expanded portfolio: an addition within the School of American Ballet, an extension of the Juilliard School, a renovation of Alice Tully Hall, and a new restaurant in front of the Vivian Beaumont Theater on the North Plaza. At the American Ballet they added dance studios in the form of glass boxes suspended within the given space, and at Juilliard they provided new rehearsal and class rooms for jazz, orchestra, and dance, as well as a black box

Alice Tully Hall renovation, New York, 2006–09. Photo © Donna Pallotta.

theater. Alice Tully is transformed in both appearance and acoustics, with its walls now wrapped in a super-fine wood that, with an internal lighting system, also brightens and dims, as if naturally. Moreover, as the horizontal thrust of Juilliard is continued toward Broadway, Alice Tully has a proper front and urbanistic presence for the first time. Here the design draws on the ICA: faced in glass, the hall cantilevers out; it includes a suspended dance studio exposed to the street (reminiscent of the ICA mediatheque); and it leads to a stepped terrace (as with the ICA grandstand) where people can gather and performances occur. In short, DS+R develop their own language here, yet they do so in the service of the program.

Finally, the restaurant (which looks onto the pool in front of Vivian Beaumont) helps to bridge Juilliard and Alice Tully with the other halls of the Center, and its wavy wedge of a roof animates the rectilinear geometries of these adjacent buildings.[30] This slope also provides a field of grass for visitors, like a bit of Central Park transplanted to the Center; clearly, this reconnecting of Lincoln Center to the city is the thrust of the project overall. Built during the 1960s, the Center was conceived as a modern acropolis of high culture; literally elevated on a giant plinth, it appeared to disdain its run-down neighborhood. DS+R wanted to close this distance as much as they could (over the years the area has gentrified in any case): as they sought to "intertwine civic and museum space" at the ICA, so here they wanted to interconnect urban and cultural activity—and in the process to develop a design that was also an alternative to the imagistic architecture of many institutions of late.[31]

If the Lincoln Center brief was to refashion a grand cultural space, the High Line project was to refunction a derelict industrial structure. An elevated freight-train track of steel and concrete built during the Depression, the High Line runs for nearly a mile and a half from Gansevoort Street (where the Whitney Museum plans to build) to the old depot on the West Side at Thirty-Fourth Street. Not used since 1980, it was condemned when Rudolph Giuliani was mayor, but a group called Friends of the High Line formed to save it, and the movement was galvanized after photographs taken by Joel Sternfeld revealed how extraordinary this ruin was—how many little ecosystems

The High Line, New York, 2005–09, in collaboration with James Corner Field Operations. Photo © Iwan Baan.

of urban nature had flourished there, how many views it might open up, how many activities it might entertain. The Bloomberg administration was responsive, and eventually DS+R were commissioned, in collaboration with Field Operations led by James Corner, a landscape design studio, to develop it as a new kind of urban park (the area is just under seven acres overall), with regular points of access to the streets eighteen-to-thirty feet below.

A first principle of the designers was to keep the promenade slow, in counterpoint to the speedy esplanade along the Hudson given over to bikers and skaters. A second principle was to maintain its unruly nature, to protect it from too much design. To this end they conceived the notion of "agritecture," a hybrid of agriculture and architecture, that has helped them to shape the High Line as a walkway that weaves green, planted areas with grey, surfaced areas. Via various paths, with ramps down to "pits" and up to "mounds" and "flyovers," one passes through a range of micro-environments from wetland to mossland to meadows, with abundant sites along the way for sitting, talking, and observing. Such a topological operation is one effective way for designers to avoid the temptation of mere image-making.[32] Like the ICA, then, the High Line is a platform for looking as well as walking; its design thus suggests an intelligence attentive to sight and site alike. It also suggests an intervention in the expanded field of architecture whereby the designers extrapolate from the mixed conditions on the ground (or, in this case, slightly above it). This is in keeping with a strong tendency in recent art toward a model of fieldwork, of projects produced out of site research, and this points in turn to yet another moment in the art-architecture complex, one that is rich with democratic potential.

Today, however, DS+R are at a crossroads, one telling of the times. On the one hand, their blurring of genres, their fusion of architecture, art, and media, is part of a postmodernism that has little purchase left on capitalist modernity—indeed, that might front for that modernity as much as anything else. On the other hand, DS+R have also learned to discover a different kind of mixed condition at work in the sites and the programs given them to develop— a condition of tensions, even of conflicts, that their designs have begun to open up, to mediate in ways that do not simply smoothen.

MINIMALIST MUSEUMS

Before Walter Gropius and Le Corbusier ever crossed the Atlantic, they sought precedents for modern architecture in America, and they found them in the grain elevators and daylight factories that lined the old waterways of industrial cities. For the Europeans, these structures were shaped by functional and/or rational criteria alone, or rather they could be made to appear so for polemical reasons; thus, for example, when Le Corbusier published photographs of such buildings, first in his magazine *L'Esprit nouveau* in 1919 and then in his manifesto *Vers une architecture* in 1923, he removed ornamental details that distracted from this reading, the force of which, finally, was more stylistic than anything else.[1] To look to America for an architectural origin in this way was a kind of primitivism, but it was a kind of futurism, too, for these Europeans also saw the United States as the land of industrial production, which they anticipated as the imminent condition of all modern design. This European America, then, was "a Concrete Atlantis," a semi-mythical place with a paradoxical temporality (the United States was the oldest country, Gertrude Stein once remarked, because it lived in the twentieth century the longest).[2]

Grain silo.

THREE REMINDERS TO ARCHITECTS

I

VOLUME

Page from Le Corbusier, *Vers une architecture* (1923; English translation 1927). © FLC/ARS.

In the industrial examples singled out by Gropius and Corb there was a tension between the volume of the building (as with grain elevators) and the transparency of its structure (as with daylight factories). This structural transparency was complicated by another transparency, for such buildings were first known to these Europeans through photographs, which dematerialized them somewhat.[3] This double tension between materiality and dematerialization runs throughout art and architecture of the twentieth century. Exacerbated by a consumer capitalism that depends on the fungibility of products (often as images), it is pronounced in advanced art since 1960, governed as it is by a dialectic of practices that, on the one hand, articulate bodies and objects in actual spaces and, on the other, play on the effects of media signs—practices that I will simply group under the terms "Minimalist" and "Pop" here. This dialectic remains strong in advanced architecture, too, as practiced by prominent designers informed by this art, such as Rem Koolhaas, Jean Nouvel, Bernard Tschumi, Steven Holl, Richard Gluckman, Yoshio Taniguchi, Tadao Ando, Toyo Ito, Kazuyo Sejima, Peter Zumthor, Jacques Herzog and Pierre de Meuron, and Annette Gigon and Mike Guyer. With new light materials and techniques these architects have transvalued the modernist principle of structural transparency, sometimes to the point of travesty.

Already by the late 1920s, the clear exposition of structure and space was deemed the key criterion of modernist design. For Sigfried Giedion such transparency was predicated on long-established technologies of glass-and-steel and ferro-concrete, yet in order to be valued as such it had to await a twentieth-century shift in "the way of living" or *Lebensform*, as well as a prompt from analogous investigations in other arts (such, for example, was his understanding of the chief motive behind Cubist painting).[4] In the same years László Moholy-Nagy conceived transparency as a transformative operation that cut across all the visual arts. Less concerned with structure and space than with light, Moholy urged architecture in particular to integrate the different transparencies promoted by mediums like photography and film. In fact he saw this integration as necessary to the "new vision" of modernist culture at large.[5]

This technophilic extrapolation of art and architecture did not fare well after the technological catastrophes of World War II, and transparency was no longer an automatic value. In an influential text on the subject written in 1955–56 but not published until 1963, Colin Rowe and Robert Slutzky devalued "literal" transparency, in which structure and space are revealed by means of clear glass and actual openings, in favor of "phenomenal" transparency, in which structure and space are rendered indeterminate by means of "Cubist" surfaces and skins that "interpenetrate without an optical destruction of each other."[6] (Note how, even as they also draw on the prestige of Cubist painting, they motivate it in a way different from Giedion, for whom its "simultaneity" of views was key.) To favor phenomenal over literal transparency seems a minor transvaluation, but it marked the moment when, once again in architectural discourse, attention to surface began to be as important as articulation of space, and a reading of skin as important as an understanding of structure. That is, it marked the moment when, at least discursively, postmodern architecture was prepared in its principal version as a scenographic surface of symbols, as practiced by Robert Venturi and Denise Scott Brown among many others.

Again, Rowe and Slutzky published on transparency in 1963, which was also the moment of the full emergence of Minimalism and Pop. The tension between literal structure and phenomenal effect is central to these practices, too, and it is especially active in the ambiguous afterlife of Minimalism in recent architecture.[7] Distinctions are important here. By "Minimalism" I do not mean simple reduction to basic geometries, whether this is brutal or clean in its material expression (examples of both can be found in Ando and Zumtor, for instance) or, indeed, fetishistically elegant (as it is in John Pawson and many others). In my understanding of Minimalism, this initial reduction is performed only in order to prepare a sustained complexity, in which any ideality of form (which is thought to be instantaneous, even transcendental, in conception) is challenged by the contingency of perception (which occurs in particular bodies in specific spaces for various durations). Another formulation of this Minimalist tension is that between the literal structure of a geometric form, say, the recognition of which is on the side of conception, and the phenomenal effect of its multiple shapes from different perspectives, the experience of which is on the side of

perception.[8] Without this tension Minimalism becomes banal, aesthetically and philosophically—so much "good design" or tasteful décor, which is what "Minimalism" has come to signify for many people.[9]

For artists like Carl Andre and Richard Serra literal transparency is a matter of production as well as structure; we recapitulate the making of the sculpture as we view the abutted brick units of the former, say, and the propped lead sheets of the latter. This commitment is a modernist one, reinforced by the neo-avant-garde recovery, in the early 1960s, of the materialist principles of Russian Constructivists such as Vladimir Tatlin and Aleksandr Rodchenko.[10] In both iterations, Constructivist and Minimalist, this imperative to reveal the process was an imperative to defetishize the work of art, to open it up to public understanding (it is this program, which is at once aesthetic, ethical, and political, that is often reversed in fetishistic versions of Minimalist design). At the same time the Minimalist line of practice committed to literal structure is not immune from the Pop line concerned with phenomenal effect: again, the two are bound up with one another dialectically, and each carries the other within it.[11] As we will see in Chapter 10, some bona fide Minimalists like Donald Judd and Dan Flavin are as involved in the phenomenal as they are in the literal, and thus do not fit neatly into either category. The same is true of such architects as Koolhaas, Herzog and de Meuron, Sejima, and Gluckman: in some projects they retain the literal even as they elaborate the phenomenal (often with projective skins and luminous scrims), while in other projects they heighten both elements to the point where they are transformed, confused, or otherwise undone.

In what follows I highlight the vicissitudes of both these dialectics in recent architecture—Minimalist and Pop and literal and phenomenal—largely through a focus on a single institution of contemporary art, the Dia Art Foundation. Other instances might also serve (and I will refer to some in passing), but Dia is the most telling of this aspect of the art-architecture complex. Dia is suggestive, too, regarding greater shifts in this complex, shifts that define its present configuration involving not only an unexpected conversion of functions—of old industrial structures refashioned as new art spaces—but, more importantly, a thorough commingling of once semi-distinct spheres—of the cultural and the economic.

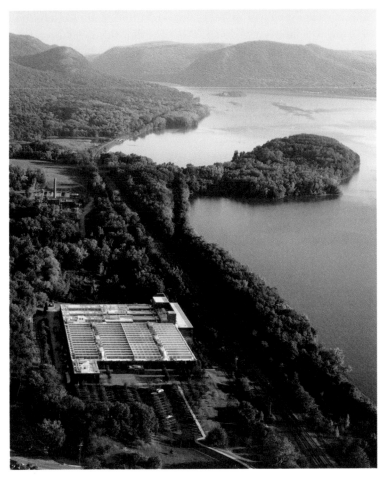

Aerial view of Dia:Beacon, 2002. Photo Michael Govan © Dia Art Foundation.

Upon its founding in 1974, Dia supported a select group of innovative artists like Judd, Flavin, and Walter de Maria, most of whom emerged in the Minimalist break with the traditional parameters of painting and sculpture in the early 1960s. Initially directed by Heiner Friedrich, a German dealer who had exhibited such artists in his galleries in Cologne and New York, Dia was funded by his wife Philippa de Menil, a daughter of Dominique de Menil, the heir to the

Schlumberger fortune (made from drill bits for oil testing and digging) and a distinguished patron in her own right (the Menil Collection in Houston was largely her doing). Along with a third collaborator, a young art historian named Helen Winkler, Friedrich and de Menil saw that Minimalist work had opened a structural gap in art institutions: neither private nor public in address, it was beyond the financial means of most collectors as well as the physical limits of most museums, and Dia was one attempt to bridge this divide. Certainly the early projects underwritten by Dia, such as *The Lightning Field*, a vast grid of 400 stainless-steel poles staked out by de Maria on a New Mexico plain in 1977, were often grand. Even more ambitious was the famous Marfa complex of art that Judd developed, with Dia support, on an old army base in west Texas from 1979 to 1986.

During this time, however, Dia met with economic problems: as the oil crisis deepened in the late 1970s, Schlumberger shares fell, and de Menil struggled to keep Dia afloat financially. Eventually her family intervened, Friedrich resigned in 1985, and Charles Wright, an initiate in contemporary art who was also trained in the law, became the director. Even as he settled with disgruntled artists upset about necessary cutbacks, Wright continued the signature focus on single-artist installations and long-term exhibitions. At the same time he opened Dia to new projects by younger artists (such as Jenny Holzer and Robert Gober) and curators (first Gary Garrels and then Lynne Cooke).[12] To this end Wright developed the Dia building on West Twenty-Second Street as an exhibition space, which marked the birth of Chelsea as an art neighborhood; in addition, with the Andy Warhol Foundation, he initiated the Warhol Museum in Pittsburgh. Both were industrial buildings renovated by Richard Gluckman, who is the architect of the "Dia aesthetic"—which combines a modernist transparency of structure with a Minimalist sensitivity to light and space—as much as any Dia administrator or artist.

Often involved with industrial materials and techniques, Minimalist art was often scaled to industrial space, too. Usually made in old lofts converted into inexpensive studios, it seemed fitting to exhibit this art in these settings as well—that is, in old factories and warehouses transformed into large galleries. In this way, along with changes in zoning laws, the emergence of Minimalism abetted the partial

Former Dia Center for the Arts, 548 West 22nd Street, New York. Photo Florian Holzherr.

transformation of SoHo from a light-industrial neighborhood into an art-gallery district, and similar areas in some cities also modernized in this manner. In this way, too, the emergence of Minimalism prompted the partial expansion of exhibition formats beyond the given models of the traditional salon and the modernist white cube.

Here an early contribution from Dia was its 1978 conversion of a SoHo loft building (c. 1890) at 393 West Broadway, originally a mixed-use structure of retail below and manufacturing and storage above. Gluckman transformed it into an open expanse, punctuated only by its original columns, and to this day it serves as an effective foil for *The Broken Kilometer* (1979) by de Maria, a floor piece of 500 polished bronze rods two meters in length arrayed in five rows of 100 rods each—that is, in a way that all but measures the space. This reciprocity, whereby the art articulates the architecture even as it is framed by it, soon became characteristic of the Dia aesthetic. Focused on Flavin, the next Dia projects included the conversion of a firehouse in Bridgehampton, Long Island, into an installation space, which Gluckman again rendered as simply as possible. Once more the work punctuates the architecture, yet the fluorescent lights long used by Flavin also produce a colored brilliance that renders the space somewhat indeterminate. As we will see in Chapter 10, Flavin developed literal and phenomenal transparency in tandem, and his example encouraged Gluckman to work toward a similar reconciliation

Walter De Maria, *The Broken Kilometer*, 1979. Photo Jon Abbott © Dia Art Foundation.

in his own practice. His Minimalist initiation also helped him to resist the blandishments of postmodernism, which were strong in the mid-1980s—and not appropriate to the Dia aesthetic in any case.[13]

It was at this time that Gluckman converted the Chelsea loft building (c. 1909), also originally of mixed use, into the principal spaces for Dia exhibitions.[14] Although built only two decades after the SoHo warehouse, this five-floor structure is more advanced in its engineering, and its reinforced concrete can support a greater span than the wood joists of the SoHo type. This expanse was well suited to installations by artists invited to work there, most of whom were legatees of Minimalism in one way or another. Once more Gluckman opened up the space in such a way as to clarify its structure, and this structure in turn helped to clarify the art; this rapport between art and architecture could be material, formal, tectonic, scalar, or all of the above. By this point such give-and-take had come to define the Dia aesthetic.

In 1989 Gluckman began to design the Warhol Museum in Pittsburgh, the hometown of the artist. Completed in 1994, this was another conversion of an industrial building (c. 1911), originally occupied by the Frick and Lindsay Company, which supplied machine tools to the steel industry. However, with an auditorium, movie theater, offices, study center, store, and café, the Warhol Museum differed programmatically from the Kunsthalle format of the Dia Center. Of course, Warholian Pop also differs from the Minimalist fare most often associated with Dia; indeed, Warhol represents the other side of the aforementioned dialectic of postwar art, for if most Minimalists play on the repetitive objects of industrial production, Warhol plays on the serial images of mass consumption. Yet, rather than mimic this mediated imagery in postmodern fashion, Gluckman again stressed the structural clarity of the industrial building in a way that set the Warhol representations into relief. Exposing the beams of the ceilings and chamfering the columns of the spaces turned both elements into quasi-Minimalist units that frame such famous sequences as the Elvises (1962–63), the Maos (1972), the Skulls (1976), and the Shadows (1978). To register the uncanny dematerialization at work in the Shadows, say, or to feel the deathly disembodiment in the Skulls, requires the foil of such an embodied

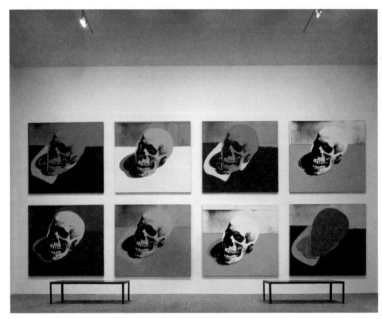

Installation of Andy Warhol's *Skull* paintings at the Andy Warhol Museum, 1994.
Courtesy of the Andy Warhol Museum, Pittsburgh. © 2010 The Andy Warhol
Foundation for the Visual Arts, Inc. / Artists Rights Society (ARS), New York.

space, which is delivered here through both the materiality of beams
and columns and the luminosity of scrims and skylights.

In 1994 the directorship of Dia passed to Michael Govan, a protégée
of Thomas Krens, who was then head of the Guggenheim Museum. By
this time Dia had acquired nearly 700 works, including many by artists
beyond the Minimalist core such as Joseph Beuys, John Chamberlain,
Robert Smithson, Richard Serra, Michael Heizer, Fred Sandback,
Robert Ryman, Agnes Martin, Gerhard Richter, Blinky Palermo,
Hanne Darboven, and On Kawara. Dia required more space to show
this extensive collection—more than a resurgent real-estate market in
Manhattan seemed to allow. Govan had worked on Mass MoCA, a
project developed by Krens to transform a disused factory complex
in northwestern Massachusetts into a contemporary Kunsthalle (it
opened in 1999), and with this concept in mind he searched for a simi-
lar building within an hour north of New York City. It was found in

an old box-printing factory owned by Nabisco (the National Biscuit Company) in a town on the Hudson River called Beacon. Built in 1929 out of reinforced concrete, the structure is a classic factory shed, with many rows of skylights, vast stretches of maple floors, and broad spans between columns—again, the expanse thought necessary to the new scale of art broached by Minimalism—and at 240,000 square feet the exhibition space is enormous. Govan and Cooke renovated the complex with the artist Robert Irwin and the architectural firm Open Office, and the result is the apogee of the Dia aesthetic.

Despite the relative diversity of the art on view (which extends to Fluxus, Conceptual, and site-specific work), certain paradigms basic to Minimalism and Pop dominate. One is the grid, which structures the luminous monochromes by Agnes Martin and the paintings of color bands by Blinky Palermo, as well as the typological photographs of outmoded industrial structures by Hilla and Bernd Becher and the tabulated images of German cultural history (1880–1983)

Gerhard Richter, *Six Gray Mirrors (No. 884/1–6)*, 2003. Dia:Beacon. Photo Richard Barnes.

by Hanne Darboven. A related paradigm is the modular unit. As one would expect, this order of "one thing after the other" (as Judd once described it) governs the Minimalist works on view—plywood boxes by Judd, fluorescent lights by Flavin, and open circles and squares cut in immaculate stainless steel by de Maria—but it also informs other pieces such as an impressive sequence of Warhol Shadows, a long row of On Kawara date paintings, and six large panels of dark gray glass by Richter. Of course, the grid and the module pre-exist Minimalism, but Minimalism turned them into a basic syntax for postwar art, and when the art at Dia:Beacon does not conform to these paradigms, it is still informed by them (for example, the enormous geometric cavities by Heizer, the delicate string installations by Sandback, and the torqued steel pieces by Serra).

In principle grids and modules can go on indefinitely, and this serial extension is another factor in the scalar expansion of contemporary art museums. Yet such expansion was compelled by address as well as by seriality and scale: as art after Minimalism pushed further into the space of the museum, in order both to engage the viewer and to articulate the architecture, this space became as important as any wall for painting or any platform for sculpture, and many practitioners became installation artists almost by default. Installation modes still prevail in art today, which is another reason so many large museums have come to exist in the form either of refashioned factories, as at Dia:Beacon, or power stations, as at Tate Modern (or extravagant originals, as at the Guggenheim in Bilbao or the MAXXI in Rome). Yet a circularity has also emerged here, for where artists once turned to industrial spaces in order to exceed the old studio, salon, and white-cube models of artistic production and exhibition, they are now returned neatly to industrial spaces refurbished as Kunsthalles and museums (or, again, to new hangars designed for this purpose). In sum, what was once a tense reciprocity of art and architecture, as in the original Dia aesthetic, has become an elegant tautology, as now at Dia:Beacon, and if this is not quite a reversal, it is at least a containment.

Of course, one can view this arrangement as perfectly fitting: what could be more appropriate, after paintings of modern life in national museums and abstract works in white cubes, than Minimalist

Michael Heizer, *North, East, South, West*, 1967/2002. Dia:Beacon. Photo Tom Vinetz.

installations in industrial sheds? Yet this very decorum is the problem, for it reduces the pressure that the art exerts on the architecture, and one might still hope that institutions would foreground such contradictions rather than design them away. An additional twist appears here, too. With its industrial turn, Minimalism moved beyond the artisanal modes of art still dominant in modernist painting and sculpture, but it also lagged behind the postindustrial trajectory of society at large. The grain elevators that appeared exotic to Gropius and Le Corbusier were familiar to Andre, Serra, and others who grew up in industrial cities in decline. From this perspective industrial production was already touched with the allure of the outmoded (or even the aura of the extinct, which is how industrial structures sometimes appear in the Becher photographs). In short, industrial production was ripe for aestheticization, and at Dia:Beacon this aestheticization is complete (to close the circle, the old Nabisco box factory would only require an installation of Warhol Brillo boxes). Moreover, with the original Dia industrial wealth was converted into cultural capital through artistic patronage (both Friedrich and de Menil were children of machinery magnates); this process is updated at Dia:Beacon, for its primary benefactor was Leonard Riggio, CEO of Barnes & Noble, the book chain that exemplifies the postindustrial mode of extensive marketing, massive warehousing, online ordering, and super-fast

delivery. Of course, this condition exceeds any one individual; indeed, it is indicative of greater shifts in the art-architecture complex—here of a depressed working-class area refitted as an art-tourist destination or, again, of old industry recouped as new culture.[15]

Such contexts damp down the critical charge of the art, again especially in its relation to the architecture, even though this work often remains intense in these settings. Yet this intensity is telling in its own way. Long ago Michael Fried, the great foe of Minimalism, condemned such art as "theatrical," by which he meant that its move into actual space was also an opening to mundane time (for time is required to experience space in this way), and thus that it violated the distinctive character of visual art not only as strictly visual in nature, but also as nearly instantaneous in reception ("theatrical" implied, too, that Minimalism pandered to its audience with seductive effects).[16] However, many installations at Dia:Beacon appear less theatrical than sublime. As in the old Kantian conception, this sublime remains a double movement: the viewer is overwhelmed by immense works in vast spaces, but then recoups this awe intellectually, and so feels empowered by this force in the end.[17] One hundred and fifty years ago the Hudson River School of landscape painters like Frederick Church (whose home "Olanna" is not far from Beacon) also produced a pictorial version of this American sublime. Might Dia:Beacon constitute a Hudson River School II, with aesthetic experience reworked as perceptual intensity at an industrial scale?[18] This is to suggest, finally, that this art appears oddly pictorial in such settings. Obviously at Dia:Beacon one does not behold a picture of the sublime à la Church, but one does seem to stand within a sublime tableau—several in fact. The pictorialism-writ-large of such installations qualifies the old charge of their theatricality, but, more importantly, it reverses the Dia aesthetic of a tense reciprocity of art and architecture—an aesthetic in which the viewer becomes sensitive not only to the character of each discipline but also to the rapport between the two, and in the process reflexive about his or her own perceptual and cognitive experience.

"Art has no history," Heiner Friedrich reasserted when Dia:Beacon opened, "there is only a continuous present"; and the art at Dia:Beacon does seem to exist in a perpetual moment of heightened experience,

without the pressure of prior art, historical context, or social framing brought to bear on it.[19] In general the Minimalist line of art tends to such an aesthetic of presence, which invites modes of exhibition that are also presentist in character. Of course, other factors have contributed to this norm in contemporary display, such as the rise of single-artist installations (in which Dia has played a central role), of private-collection museums, and of pilgrimages to both kinds of sites (Marfa is only the best-known example); all privilege an encounter with a removed aesthetic space over one with a shared historical time. Discussed as a shift from a museum of "interpretation" to one of "experience," or simply as "the cultural logic of the late capitalist museum," this phenomenon is familiar by now.[20] What goes unremarked is how it has worked its way into modern museums as well, including the flagship of the genre, the Museum of Modern Art in New York.

Here I review only a few aspects, pertinent to our discussion, of the latest version of MoMA, which, redesigned by Yoshio Taniguchi, reopened in late 2004 not long after Dia:Beacon. The first point has to do with how the two major architectural divisions in the building inscribe the two major art-historical divisions in the presentation. The core of the museum remains its historical collection of painting and sculpture, presented chronologically on the fifth and fourth floors. These floors divide circa 1940, as do most courses and textbooks on twentieth-century art—a conventional break that accepts the artistic hiatus produced by totalitarianism, World War II, and the Holocaust. Yet these events—political repression, extreme dislocation, and mass death—are not acknowledged as such at MoMA; indeed, its story of twentieth-century art remains so affirmative that this old diplomatic silence, long deemed necessary to postwar reconstruction, is maintained to this day.[21]

This is the first break remarked by the building; the second is the more salient one here. If the hiatus between prewar and postwar art is bridged too smoothly from the fifth floor to the fourth, the gap between modernist and contemporary art is not bridged at all from the fourth floor to the second: circa 1970 one drops to the cavernous Contemporary Galleries.[22] Like other modern museums that seek to comprehend the contemporary, MoMA confronted the predicament of the expanded scale of art after Minimalism, and its response was

also to go big—big as in 15,000 square feet with walls twenty-one feet high—even though big does not necessarily mean capacious (in fact big can be inflexible, as the New Museum in New York attests). However one dates the break between modernist and contemporary art, it now seems that such a break has occurred; hence this architectural divide would not be an issue if MoMA did not insist on historical continuity instead.[23] For reasons that are both cultural and financial, the museum has opted to stay in the hunt of contemporary art (perhaps it feared it might become a period piece if it did not), so its leaders have reasserted a connection between the modernist and the contemporary, even as its architecture underscores a break—not only in the great gap between the floors but in the different character of the spaces (for example, chronological galleries versus presentist expanse, with a new-media black box on the side). One might go further. In some respects the contemporary has become primary: its galleries are the first we encounter and the largest overall, and the architectural drama of the redesign—the five-story glass curtain wall at the first landing and the vast 110-foot atrium on the second floor—is focused there, too. At least to this degree, the contemporary tail wags the modernist dog.

View of "Contemporary: Inaugural Installation," the Museum of Modern Art, NY, 2004. Digital image © The Museum of Modern Art/Licensed by SCALA / Art Resource, NY.

The second aspect of the new building to underscore concerns its lightness, to which the glass curtain and the grand atrium contribute significantly. The glass shimmers in sunlight, and the atrium prompts one to look up, through the vertical cuts in the white walls, to the floors above; the first effect tends toward dematerialization, the second toward levitation. Brilliantly engineered, the atrium is

Yoshio Taniguchi, the Donald B. and Catherine C. Marron Atrium in the David and Peggy Rockefeller Building, the Museum of Modern Art, NY, 1997–2004. Photo © The Museum of Modern Art/Licensed by SCALA / Art Resource, NY.

supported structurally from above; it is thus free of heavy columns, which adds to the quality of lightness. Indeed, with a separation of an inch or two from the floor, the galleries seem to float a little, as this reveal turns the walls into planes that do not appear quite grounded.[24] Taniguchi is a master of such light construction, and, as noted in Chapter 4, Terence Riley, then curator of architecture at MoMA, is a champion of this style: he feels such transparency to be both true to the precepts of modernist design and appropriate to the virtuality of our digital world.[25] Yet here again a contradiction arises, for, as we have seen, the literal transparency of modern architecture was pledged to structural clarity more than to phenomenal effects. Thus, even though the new MoMA is presented as faithful to the modernist tradition, in important respects it is not; or, rather, if it is loyal, what counts as modernist has changed, and indeed "modernist" here has come to mean "Minimalist," and both to imply lightness: a sublimation of material and technique, not an exposure; a fetishization of substance and structure, not a defetishization—in short, the near-opposite of what "modernist" and "Minimalist" once meant. In this way, too, the modernist and the contemporary have parted company, despite the stylistic environment of elegant austerity that they now share at MoMA.

In a sense abstraction still rules at MoMA, but it is not the pictorial-spiritual variety, the white-on-white of Malevich or the primary colors of Mondrian; it is architectural-financial. "Raise a lot of money for me, I'll give you good architecture," Taniguchi is said to have remarked to the trustees. "Raise even more money, I'll make the architecture disappear."[26] To make $425 million vanish is an excellent trick. Yet the money does not disappear; one feels its refinement everywhere, and its rarefaction permeates everything. The *New York Times* celebrated the new MoMA as "a transcendent aesthetic experience"; apparently, in its privileged form of spatial effect, such experience costs a lot. As Koolhaas has remarked, "Minimum is the ultimate ornament, a self-righteous crime, the contemporary baroque. Minimum is the maximum in drag. It does not signify beauty but guilt."[27] In fact, at MoMA as at Dia:Beacon, one senses more pride than guilt, but it is true that their aesthetics of minimum is maximal, the most sublimated of sublimes. Of course,

MoMA and Dia:Beacon display far more differences than similarities. In my account alone historical narrative is played down at Dia, and its old reciprocity between art and architecture has become a near tautology; at MoMA, by contrast, historical narrative is foregrounded, and the architecture seems to withdraw behind the art, as if, per modernist belief, it truly were autonomous. Yet the two presentations can also be seen as two parts of the same operation, that of sublimation—one that is at once aesthetic, architectural, and financial.[28]

Let me draw out a few implications of our discussion thus far. Regarding the Minimalist-Pop dialectic between contrary impulses to materialize and to dematerialize both object and subject, the Pop term has become dominant, as might be expected in a society given over to technologies of image and information. So, too, in the literal-phenomenal dialectic between contrary impulses to reveal and to veil both structure and space, the phenomenal term has become privileged, with the literal sometimes transformed into the phenomenal, which is also often heightened or otherwise intensified. In Chapter 10 I take up some consequences of these developments for recent art; here I want to do the same for recent architecture.

 As for the dominance of the Pop term, consider the relevant designs of Herzog and de Meuron, whose interest in both Minimalism and Pop is well known. They apply its idioms cannily: often they use serial units in such a way that material and image are all but conflated, sometimes with materials deployed as images and sometimes the reverse. For example, on the façade of the Ricola Production and Storage Building (1992–93) in Mulhouse-Brunstatt, France, a photograph of a leaf by Karl Blossfeldt (from his 1928 *Urformen der Kunst,* which sought to disclose the "architecture" of nature) is silk-screened inside plastic panels; and on the exterior of the Technical School Library (1994–97) in Eberswalde, Germany, various motifs based on press photos selected by the artist Thomas Ruff are printed on concrete panels. In such cases, however, the Minimalist-Pop dialectic is not elaborated so much as collapsed—in favor of the Pop term. "The rectangular body of the building is really covered up, almost

Herzog and de Meuron, Eberswalde Technical School Library, Eberswalde, 1994–97. Courtesy of Herzog and de Meuron. Photo © Margherita Spiluttini.

dissolved," Herzog and de Meuron comment; "in our work pictures have always been the most important vehicles."[29] At the same time they insist that "architecture is perception," and, like many architects informed by Minimalism, they speak of their structures in phenomenological terms.[30] They thereby suggest that the pictorial and the experiential can no longer be separated and, more, that they embrace this condition. In the world of these architects, then, perception is reduced to the visual, and phenomenology is shot through with pictures.

As for the dominance of the phenomenal, it often seems to subsume the literal. For instance, the layered glass palisade designed by Nouvel for the Cartier Foundation for Contemporary Art (1991–94) in Paris is celebrated not for its quality of transparency but for its effects of "haze and evanescence," while the double glass façade designed by Herzog and de Meuron for the Goetz Collection (1992) in Munich is said to perform "a complete reversal of the

structural clarity of the so-called Miesian glass box."[31] What is literal transparency or structural clarity, these designers ask, when, with synthetic substances and advanced techniques, "the traditional character" of "conventional materials . . . disappears"?[32] If the Cartier and Goetz buildings attest to a reversal of the literal into the phenomenal, other projects effect a blurring of the two, which is often produced through such devices as skins or scrims (or even, as in the Blur Building [2002] of Diller Scofidio + Renfro mentioned in Chapter 6, manufactured clouds). The result here is that surface tends to overwhelm structure (this is also true, for example, in much "blob" architecture and other buildings that privilege the envelope above all else), or, rather, the two combine in the production of atmosphere and affect.[33]

Sometimes, too, each term in the literal-phenomenal dialectic appears qualitatively transformed, whereby the literal is rarefied as the light (as now at MoMA) and the phenomenal is intensified as the brilliant (as at Cartier) or, conversely, as the obscure (as with the Blur Building). Sometimes the effect here is to dazzle or to confuse, as if the paragon of architecture might be an illuminated jewel or a mysterious ambiance. Certainly such work can be beautiful (this is its great appeal), but it can also be spectacular in the classic sense of Guy Debord: an enigmatic object the production of which is mystified, a commodity-fetish at a grand scale. Here light is transvalued once again: if modernists celebrated it as a medium of utopian spirituality (as in the Glass Chain circle of Bruno Taut) or as a figure of technological progress (as with Moholy), light is now largely put in the service of enigmatic and/or special effects.[34] Implicit in this architecture of lightness is that transparency, whether desired or not, is impossible in a world given over to the commodity-form—that is, where the workings of most things are so many black boxes. "I could not understand objects I used daily: the TV, the refrigerator, the personal computer," Herzog commented as early as 1988. "All these objects seem to me to be a kind of synthetic conglomeration . . . They are in a way so mixed with other materials that decomposition back into the original form is no longer possible."[35] If this is true of a refrigerator, how much more so of a contemporary building? Rather than resist this condition, this line of thought seems to run, why not make

Jean Nouvel, Cartier Foundation for Contemporary Art, Paris, 1991–94.
Photo © Ateliers Jean Nouvel.

a virtue of it somehow? The argument leads one, as it has led Herzog
and de Meuron, to advocate an architecture not merely of surface
over space but of the two conflated as "surfaces for projection."[36]

In 1963 Rowe and Slutzky wrote of the "equivocal emotions"
that a play between literal and phenomenal transparency might
provoke, an equivocation that can be reflexive, even critical,
in effect. However, what the triumph of the phenomenal often
produces is less equivocation than suspension—of a subject
"suspended in a difficult moment between knowledge and block-
age."[37] This outcome sounds harmless enough, yet what is this

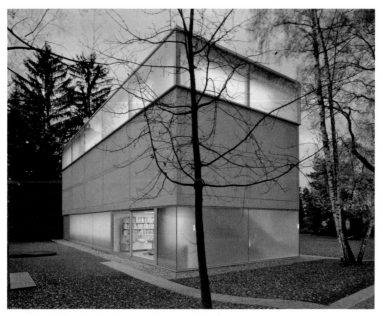

Herzog and de Meuron, Goetz Collection, 1989–92. Munich. Courtesy of Herzog and de Meuron. Photo © Margherita Spiluttini.

"difficult moment," structurally, if not one of fetishization, which holds the subject between a recognition of the real and a refusal of it, precisely between knowledge and blockage? As with the commodity fetish, such designs as the Tate Modern Project proposed by Herzog and de Meuron might mystify us with "surfaces for projection"; and as with the sexual fetish, they might offer an intensity of affect but at the possible cost of psychic and/or social arrest. Of course, one could argue, it is exactly architecture like this that is most appropriate to contemporary subjectivity and society. Not only does architecture as projection suit a subject given over to the visual and the psychological, a subject defined in terms not of the complexities of the phenomenological but of the vicissitudes of the imaginary.[38] But an architecture of "equivocal emotions" also suits a society pervaded by "cynical reason"—that is, by a self-protective ambivalence that is not "false consciousness" so much as it is sophistical indifference ("I know the rich have interests opposite to my own, but nevertheless I

will identify with them").[39] Here again, however, it is this very decorum that is the problem—and why, in any case, would one advocate an architecture that further privatizes the subject and occludes the social?

At stake here are not mere preferences in design but important implications for subjectivity and society alike. Perhaps the rationalist subjectivity assumed by literal transparency—a subject invited to understand space, to critique architecture, to defetishize art and culture—is a fantasy of its own, another myth of Enlightenment in need of demystification. Yet what are the alternatives advanced in recent architecture? Pastiche postmodernism *à la* Venturi positioned the subject as the master of architectural history, able to cite its styles

Herzog and de Meuron, The Tate Modern Project, London, 2005–. Image © Hayes Davidson and Herzog and de Meuron.

at will, even as it also presented this subject with amnesiac simulacra. Conversely, deconstructivist postmodernism *à la* Eisenman positioned the subject as the object of architectural language, even as it also allowed this subject a delusory degree of agency in its manipulations. The subject interpellated by the architects under discussion here is different again—once more, a subject suspended in a difficult moment between knowledge and blockage. Again, it might be that modernist transparency mystifies more than it demystifies, that it cannot reveal the technological basis of a contemporary building (or anything else) in contemporary society. But is this pretext enough to produce an architecture of obfuscation, one that tends to reinforce a subjectivity and society given over to a fetishism of image and information? In our present of ever-greater financial, corporate, and governmental black boxes, transparency might be a value to recover.

PART III

MEDIUMS AFTER MINIMALISM

SCULPTURE REMADE

"What does making sculpture mean to you right now?", Richard Serra was asked in 1976. With only a decade of mature work behind him, he replied: "It means a life-time involvement, that's what it means. It means to follow the direction of the work I opened up early on for myself and try to make the most abstract moves within that. To work out of my own work, and to build whatever's necessary so that the work remains open and vital . . ."[1] Much in this statement holds true many years later. "Opened up" suggests that his work develops from salient predecessors—not only such sculptors and painters as Constantin Brancusi and Jackson Pollock, but, as we will see, particular architects and engineers as well—predecessors whom Serra strives both to displace, in order to make a space of his own, and to carry forward. "[T]he most abstract moves" underscores that this carrying forward brooks no return to figurative traditions, pictorial conventions of figure-and-ground or even Gestalt readings of images. "[T]o work out of my own work" indicates that his art, once opened up, is driven by its own language more than by any precedents. Yet, lest this language become involuted, the work must also remain "open and vital" through building—through the exigencies of actual materials, projects, and sites. The statement thus points

to three dynamics that have governed his art since its opening up, three forces of which it is the fulcrum: engagement with particular precedents; elaboration, through pertinent materials, of an intrinsic language; and encounter with specific sites.

In 1986, ten years after this statement, the Museum of Modern Art mounted an exhibition titled "Richard Serra: Sculpture." What is the relation posed by the colon? In a title like "Piet Mondrian: Painting," it reads almost as an equation, a reflexive relation of immanent analysis, with painting refined by Mondrian to its essential lines and primary colors. This relation was supported by a medium-specific paradigm of modernist art that does not hold for the generation of Serra. He might still ask the ur-modernist question "What is the medium?" but his response does not aim for an ontology of sculpture in modernist fashion. Serra does not evade the medium; on the contrary, he is singularly committed to its concept (unlike his peers in Minimalism, Fluxus, Arte Povera . . .). Yet this category has changed, in part through the force of his example, and today sculpture is not given beforehand but must be proposed, tested, reworked, and proposed again.[2] This is the modus operandi of his work.

In 1965 Donald Judd could state flatly that "the specific objects" of Minimalism were "neither painting nor sculpture."[3] On the one hand, sculpture had contracted to the space between an object and a monument, the restrictive coordinates given by Tony Smith for his six-foot steel cube *Die* (1962).[4] On the other hand, it had stretched to the point where great expanses could be contemplated as sculpture, or at least as its site; the notorious example, again offered by Smith, was the unfinished New Jersey Turnpike.[5] Not a few artists became lost in the arbitrary realm of this expanded field. However, for the more astute the ramifications of Minimalism were more precise: a partial shift in focus from object to subject, or from ontological questions about the nature of the medium to phenomenological conditions of particular bodies in particular spaces—which effectively became the new ground of sculptural art. This shift was fundamental for Serra, and he has developed its logic further than anyone else—that is, within the category of sculpture. At the same time Serra was critical of Minimalism, skeptical about the non-transparency of its construction as well as its

preoccupation with painting. Although the Minimalist object is often called sculpture, it developed primarily from Color-Field painting *à la* Barnett Newman, as evidenced by the early work of Judd alone. For Serra, even though the unitary forms and serial orderings of Minimalist objects were pledged against the relational composition of painting, they remained bound up with its pictorial conventions. Like his peers, he wanted to get beyond this pictorialism, especially as it underwrote Gestalt readings of art, which he saw as idealist totalizations that serve both to conceal the construction of the work and to suppress the body of the viewer.[6] Yet Serra wanted to defeat this pictorialism completely, and in sculptural terms. What might this mean?

In 1966, when Serra first opened up his work, it meant that the Minimalists had obviated sculpture more than exceeded it. (This was hardly their doing alone: many Conceptual, performance, mixed-media, and installation artists would do the same thing.) So

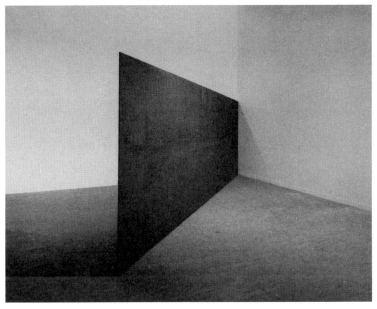

Strike: To Robert and Rudy, 1969–71. Hot-rolled steel. 8 x 24 feet x 1 ½ inches. Photo Peter Moore.

the question became: How might one proceed differently, sculpturally, to develop the category deconstructively rather than to declare it void triumphally? In response Serra stressed, beyond the point of Minimalism, the very terms that were suppressed in both dominant models of modernism and Gestalt readings of art, terms like materiality, corporeality, and temporality. First, in lieu of a logic of medium-specificity, he substituted a logic of materials, of specific materials submitted to specific procedures. Hence his well-known "Verb List" (1967–68)—"to roll, to crease, to fold . . ."—which issued in several kinds of work: sheets of lead rolled, torn, or otherwise manipulated; molten lead splashed along the base of a wall and peeled back in rows; slabs of concrete stacked or sheets of lead propped; and so on.[7] These processes transformed the traditional object of sculpture, and they led Serra to particular works that opened up distinctive lines of investigation. After the art historian George Kubler, he calls them "prime objects" inasmuch as "they present each problem in its greatest simplicity."[8] Thus *To Lift* (1967), a signal piece in process art in

To Lift, 1967. Vulcanized rubber. 36 x 80 x 60 inches. Photo Peter Moore.

which the action of the title is performed on a thick sheet of rubber, first raised the question of surface typology for Serra. *House of Cards* (1969), made up of four four-foot squares of lead that support one another, set up all the prop pieces that rise from the floor. *Strike* (1969–71), a single plate of steel, eight feet high, that juts out twenty-four feet from its bisected corner, prepared all the wedges and arcs that cut into space. *To Encircle Base Plate Hexagram, Right Angles Inverted* (1970), a steel circle, twenty-six feet in diameter, embedded in a street in the Bronx, first established physical site as fundamental to his practice. And so on.[9]

Yet not all results avoided pictorial associations, as Serra acknowledged in a self-critique of 1970: "A recent problem with the lateral spread of materials, elements on the floor in the visual field, is the inability of this landscape mode to avoid the arrangement qua figure ground: the pictorial convention."[10] Characteristically, rather than pull back, he pushed forward, and highlighted the very term, ground, that seemed most problematic. For Serra this emphasis on place was signaled by Carl Andre in the middle 1960s with his arrangements of bricks and plates, and then confirmed in 1970

One Ton Prop (House of Cards), 1969. Lead. Four plates, each 48 x 48 x 1 inches. Photo Peter Moore.

Rock garden in Myoshin-ji temple complex, Kyoto.

through his encounters with *Spiral Jetty* (1970) by Robert Smithson in Utah, *Double Negative* (1969–70) by Michael Heizer in Nevada, and, above all, Zen gardens and temple complexes in Japan (especially Myoshin-ji in Kyoto). All three instances pointed to a condition of "the discrete object dissolved into the sculptural field."[11]

With this opening to field, two terms emerged with renewed force for Serra: the body of the viewer and the time of bodily movement.[12] After such sited works as *Shift* (1970–72) and *Spin Out: For Bob Smithson* (1972–73), Serra was prepared, in 1973, to describe "the

Shift, 1970–72. Concrete. Six sections. King City, Ontario.

sculptural experience" in terms of a "topology of [a] place" demarcated "through locomotion," a "dialectic of walking and looking into the landscape."[13] In this way sculpture became a parallactic operation, in which the work frames and reframes the subject and the site in tandem, and it guided Serra after his breakthrough in 1970, not only in pieces placed in a landscape so as to reveal its topology (from *Shift*, say, to *Sea Level* [1988–96]), but also in works positioned in an urban context so as to reframe its structures (from *Sight Point* [1972–75] to *Exchange* [1996]), as well as in pieces set in an art space so as to refocus its parameters (from *Strike* [1969–71], say, to *Chamber* [1988]). Of course, place is fundamental to all this work, yet, as Rosalind Krauss has argued, site-specificity is not its end so much as its medium; or, more precisely, its medium is "the body-in-destination" in a particular site, and in this respect the body remains as primary as place.[14] Thus emerged a revised formulation of sculpture as a relay—a relay between site and subject that (re)defines the topology of a specific place through the motivation of a specific viewer.

So by 1976, when the question "What does making sculpture mean to you right now?" was asked, certain emphases were already clear. First, the stress on making—on the verb or sculptural process, rather than the noun or categorical medium—was correct. This making led Serra to foreground materials such as lead and steel, which were inflected by pertinent procedures into motivated structures. This became the first principle of sculpture for Serra, and it might be called "Constructivist," for it concentrates, as Russian Constructivists like Vladimir Tatlin did, on the expressive development of structures out of the appropriate treatment of materials (which the Constructivists called *construction* and *faktura* respectively).[15] The second principle, which might be called "phenomenological," was that sculpture exists in primary relation to the body, not as its representation but as its activation—its activation in all its senses, all its apperceptions of weight and measure, size and scale. The third principle, which might be called "situational," was that sculpture engages the particularity of place, not the abstraction of space, which it redefines immanently rather than represents transcendentally. Together these principles have guided Serra ever since in his understanding of sculpture as a

Sight Point (for Leo Castelli), 1972–75. Weatherproof steel. Three plates, each 40 x 10 feet x 2 ½ inches. Stedelijk Museum, Amsterdam.

structuring of materials in order to motivate a body and to demarcate a place.

This provisional definition of sculpture also suggests a partial typology of work since the 1970s, which includes landscape markings, urban framings, and gallery interventions. Examples of each category include, respectively, *Afangar* (1990) positioned on an Iceland island, *Torque* (1992) placed at a German university, and *Sub-tend 60 Degree* (1988) set in a Dutch museum. Serra expanded this typology in subsequent decades. On the one hand, he returned to

The Hedgehog and the Fox, 1998. Weatherproof steel. Three plates, each made up of two identical conical/elliptical sections inverted relative to each other, 15 ½ x 91 ½ x 24 ½ feet x 2 inches. Princeton University, New Jersey.

early modes, such as his props, to reconnect with his basic syntax of "pointload, balance, counter-balance and leverage."[16] On the other hand, he elaborated subsequent modes, such as his arcs, in new ways. Serra first tilted the arcs, then doubled and trebled them, then waved them so as to form a new type, the serpentine ribbons. These ribbons bow in and out in such a way as to suggest corridors and enclosures; the torqued ellipses and spirals also produce passages and surrounds at the same time. So, too, as if to counterpoint these complex manipulations, Serra elaborated other types like the rounds and blocks which, rather than frame space, concentrate it through sheer mass.[17] This is what it is to develop a sculptural language.

Yet a paradox remained: Serra insisted that his work was strictly sculptural, while his best critics regarded it as a deconstruction of sculpture.[18] The paradox was only apparent, however, for with Serra sculpture effectively becomes its deconstruction, its making becomes its unmaking. For sculpture to harden into a category is for sculpture to become monumental again—for its structure to be fetishized, its

viewer arrested, its site forgotten, again. In this light, to deconstruct sculpture is to serve its "internal necessity" (to evoke an ur-modernist formulation), and to extend sculpture (in relation to process, body, and place) is to remain within it. This is to say, finally, that Serra turned a paradox into a dialectic, one focused first on the question of site.

"The biggest break in the history of sculpture in the twentieth century," Serra has remarked, "occurred when the pedestal was removed"—an event that he understands as a shift from the memorial space of the monument to the "behavioral space of the viewer."[19] This shift was a dialectical one, which opened up another trajectory, too, for with its pedestal removed, sculpture was free not only to descend into the materialist world of "behavioral space" but also to ascend into an idealist world beyond any specific site. Consider how Brancusi, the most significant prewar sculptor for Serra and his peers, developed this dialectic. With his ambition to convey near-Platonic ideas—the idea of flight, say, in the ascendant arc of *Bird in Space* (1923)—his work is an epitome of idealist sculpture. At the same time it celebrates sheer material, and his bronzes are often polished to the point where they reflect their environment. Brancusi also articulated this dialectic in the particular terms of the pedestal: some of his pieces absorb the base of the sculpture into its body, as it were, with the effect that sculpture becomes siteless, as in *Bird in Space*, while others appear to be nothing but base, nothing but support, as in *Caryatid* (1914).[20] In this way Brancusi was as committed to the idealist realm of the studio (he bequeathed his own space to France as his ultimate work of art) as he was to the specific siting of abstract sculpture (as in his complex of pieces in Targu Jiu, Romania). Once-dominant accounts of modernism privileged the idealist side of this dialectic, the hypostasis of sculpture as pure form. As a critical counter to this position, Serra and his peers developed its materialist side—of sculpture plunged into its support and re-grounded in its site—which is one reason why this collective work stands as a crux between modernist and postmodernist art.[21]

Of course, the antinomy between idealist and materialist impulses is also active in modern philosophy and, indeed, in modern society at large. More salient here is the contradiction between the artisanal, individualistic basis of traditional sculpture and the technological, collective basis of industrial production. In industrial society

old paradigms of sculpture—of plaster, marble, bronze or wood, modeled, carved, cast or cut—were destined to become archaic; indeed, for Benjamin Buchloh these models were "definitely abolished by 1913" with the advent of the first readymade by Duchamp and the first construction by Tatlin.[22] Such materialist paradigms

Constantin Brancusi, *Bird in Space*, 1923/1941. Polished bronze. 56 ¾ x 6 ½ inches. © CNAC/MNAM/Dist. Réunion des Musées Nationaux / Art Resource, NY.

repositioned sculpture subversively in terms of epistemological inquiry (the readymade) and architectural intervention (the construction), with the consequence, according to Buchloh, that sculpture faced "the eventual dissolution of its own discourse as *sculpture*."[23] Predicated as they were on the old idealist models, most Western institutions (museum and academy alike) overlooked these materialist paradigms. Nonetheless, the contradiction between artisanal sculpture and industrial society hardly disappeared; it persisted, even in the very practices that sought to resolve it—that is, to reconcile individual craft and collective industry through various versions of welded sculpture, found objects, and assemblage, all of which mix signifiers of craft and industry alike. (Buchloh cites Julio Gonzalez, David Smith, John Chamberlain, and Anthony Caro in particular, figures whom Serra has questioned to different degrees as well.)[24]

In the 1960s, however, artists such as Judd, Flavin, Andre, Robert Morris, and Serra both recovered and related the models of the readymade and the construction. They did so in ways that served not only to deconstruct the idealist presuppositions of most autonomous sculpture, but also to demystify the quasi-materialist compromises of most welded sculpture, found objects, and assemblage—"literally to 'decompose'" these mythical models through the direct exposition of industrial materials, processes, and sites.[25] Again, Serra and his peers also pushed the situational aspect of sculpture, after its break with the pedestal, to the point where this break, which was only announced in 1913 with the readymade and the construction, became actual by 1970, with new site-specific practices.[26] Yet in what sense, then, did these practices remain "sculpture"—a term some of these artists abjured or at least avoided?

For Serra, too, the initial project was to demystify modernist models, to defetishize them along Constructivist lines. "In all my work," he wrote in an important text of 1985, "the construction process is revealed. Material, formal, contextual decisions are self-evident. The fact that the technological process is revealed depersonalizes and demythologizes the idealization of the sculptor's craft."[27] Note the last phrase in this statement. For some critics this categorical insistence on sculpture appeared to mythify the Constructivist demystification of the medium, in effect to turn

this critique back into sculpture.[28] For Serra, however, the insistence was necessary inasmuch as sculpture lacked a secure basis, a strong language, of its own, and it became his project to develop one.

"The origin of sculpture is lost in the mists of time," Baudelaire wrote in one expression of this lack; "thus it is a Carib art."[29] Here, in a short section of his *Salon of 1846* titled "Why Sculpture is Tiresome," the great poet-critic repeats some tiresome complaints about sculpture: that it is too material, "much closer to nature" than painting, and too ambiguous, more unstable than painting because, as an object in the round, "it exhibits too many surfaces at once."[30] These criticisms adhere to the idealism not only of Hegel, whose hierarchy of the arts positioned sculpture below painting on account of its relative materiality, but also of Diderot, whose celebration of the *tableau* privileged the putative instantaneity of our experience of the singular surface of painting over the implicit duration of our experience of the "many surfaces" of sculpture. As we have seen, Serra and his peers challenged these persistent idealisms.[31] But what about the provocative remarks about "lost origin" and "Carib art"? By "Carib" Baudelaire implies that sculpture is primitive, even fetishistic (he discusses fetishes in this same section of the *Salon*). In his time the fetish was understood as an impure thing, a hybrid object not worthy of the cult worship devoted to it, and in this regard it served as a discursive token of the lowest registers of world art and religion alike (as it does in Hegel, among others). Hence the "lost origin" of sculpture: Baudelaire suggests that its cultic beginnings as a fetish do not provide sculpture with an adequate basis to develop into a proper art.[32] Obviously, Serra does not agree with Baudelaire; yet he, too, believes that sculpture does not possess a secure foundation, and so seeks a principle (or set of principles) that might stand in lieu of its "lost origin." What is more, he uses its "Carib" status as material, impure, and hybrid to critical advantage in doing so.

Again, Serra presents a distinctive definition of sculpture: that it motivate a body and frame a place in a parallactic relay between the two. But he also positions sculpture between two other terms: opposed to painting on the one side, and critical of architecture on the other. In his *Salon of 1846*, Baudelaire calls sculpture a "complementary

art," "a humble associate of painting and architecture."[33] This is in keeping with the Hegelian hierarchy of the arts that ascends from architecture through sculpture to painting (and on to music, poetry, and finally philosophy).[34] In effect Serra uses the middle term of this old hierarchy to pressure the adjacent terms. More precisely, he employs the relative materiality of sculpture, its ability to activate body and site, in order to critique painting (which does not perform this activation), and the relative autonomy of sculpture, its ability to demonstrate structure, in order to critique architecture (to the extent that it obscures its own tectonics). In the process Serra presents a further principle of sculpture, one that is not medium-specific but medium-differential, and that turns its "Carib" vice (again as impure and hybrid) into a critical virtue.[35]

Serra approaches this differential understanding of sculpture through a philosophical point of procedure drawn from Bertrand Russell. "Every language has a structure about which nothing critical in that language can be said," Serra remarks; only a second language with a different structure can perform this analysis.[36] He first adapted this principle in order to think through the relation of his drawings and films to his sculpture, but it also speaks to the relation of his sculpture to painting and architecture. On the one hand, Serra insists on the absolute status of sculpture as a language of its own; on the other hand, he manipulates this language to partake of aspects of painting and architecture, but only in order to articulate its differences from them. Thus, for example, even as his sculpture opposes painting to the degree that it resists figure-ground conventions, it also partakes of the pictorial in the sense of its framing of a site.[37] And even as his sculpture critiques architecture to the degree that it refuses the scenographic, it also partakes of the architectural in the sense that it also privileges the structural.

Above I touched on the differences from painting, so here I will focus on the differences from architecture. Whatever its own restrictions, sculpture is less bound up with capitalist rationalization and bureaucratic regulation, and thus more free to intervene critically in other areas, not least in matters of architecture. Yet Serra suggests more: that sculpture can recover a neglected principle in architecture, in its tectonic basis, and recover it as a "lost origin" *for sculpture.*

Often his sculpture "works in contradiction" to the architecture of its sites.[38] This relation can be aggressive (it does not aid the destroyers of *Tilted Arc* [1981–89] to note that it questioned the banal architecture of the Federal Plaza in New York), but it can also be subtle, complementary, even reciprocal, whereby sculpture and architecture serve as foils for each other. Thus there are pieces (often arcs) that primarily frame architecture, such as *Trunk* (1987), first installed in a Baroque courtyard in Munster, Germany, and there are pieces (often blocks) that are primarily framed by architecture, such as *Weight and Measure* (1992), first installed in the neoclassical hall of the Tate Gallery in London; and there are pieces that do both, such as *Octagon for Saint Eloi* (1991), which stands in sympathetic rapport with the Romanesque church behind it. Sometimes in such historical settings a reversal of roles occurs, too: the sculpture seems to foreground the architecture, as with the two austere blocks of *Philibert et Marguerite* (1985) that throw into relief the ribbed vaulting of the sixteenth-century cloisters in which they are set.

Often, however, Serra relates to architecture in order to critique it, and this critique is of two kinds at least. The first is procedural, to do with basic modes of architectural representation: elevation and plan (that is, the structure of a building seen *en face* and its array of spaces seen from above). In his work, as Yve-Alain Bois has remarked, Serra often destroys, "in the very elevation, the identity of the plan," and vice versa, with the result that neither presentation (in front or from above), neither view (from outside or inside), delivers the other, let alone the sculpture as a whole.[39] Serra intends this impediment as a way not only to resist the becoming-image of the work but also, in so doing, to reassert the rights of the body against the abstract objectivity (even the panoptical mastery) of architectural representation. The second critique is polemical, to do with the superficiality of postmodern architecture. There are two primary targets here: its privileging of scenography over structure ("most architects," Serra remarked in 1983, in the postmodern heyday, "are not concerned with space, but rather with the skin, the surface") and its masking of consumerism as historicism ("symbolical values have become synonymous with advertisements," he commented in 1984).[40] Thus his stress on the tectonic has a double edge: it addresses

Octagon for Saint Eloi, 1991. Weatherproof steel. 6 ½ x 8 x 8 feet. Eglise Saint Martin, Chagny, Saône-et-Loire, France.

the historical absence of the tectonic in sculpture—which, again, it proposes as a "lost origin"—and it questions the recent atrophy of the tectonic in architecture.

Another key term in the lexicon of Constructivist art, the tectonic is also advanced in architectural discourse, especially by Kenneth Frampton. His argument is polemical, too: like Serra, Frampton assails the scenographic kitsch of much postmodern architecture, and he insists on the bodily and the tectonic in protest against the capitalist technologies of the simulacral and the virtual that much architecture has lately embraced.[41] Yet his argument is also ontological in a way that differs from Serra: "the structural unit," Frampton states, is "the irreducible essence of architectural form."[42] In fact Frampton projects an origin myth of architecture (along the lines of "the primitive hut" advanced by Abbé Laugier in the service of neoclassical architecture): after Gottfried Semper, Frampton believes that architecture is founded in the apposition of a compressive mass (as exemplified in brick construction) and a tectonic frame (as exemplified in wood construction). Thus, for Frampton, "the very essence of architecture" is located in "the generic joint," and this "fundamental syntactical transition from the stereotomic base to the tectonic frame" becomes "a point of ontological condensation."[43] According to Frampton, this apposition of mass and frame is not only material (brick versus wood) and "gravitational" (heavy versus light) but also "cosmological" (earth versus sky), with "ontological consequences" that are transcultural and transhistorical in value.[44]

Much here is resonant for a reading of Serra, though, again, he stops well short of the metaphysics entertained by Frampton. The joint is crucial in his work, too; left bare, not welded, the intersection of his steel plates is where structure reveals production most clearly, and demystifies old modes of sculpture in doing so. Louis Kahn liked to say that ornament is the adoration of the joint; for Serra, "any kind of joint—as necessary as it might be for functional reasons—is always a kind of ornament," and he respects it precisely through his exposure of it, his refusal to "ornament" it at all.[45] So, too, the coordination of mass and frame in Frampton, which occurs paradigmatically at the joint, may correspond to the coordination of "weight and measure" in Serra. Certainly the relation of load and support is fundamental to his

work, and his lead and steel props in particular subsume the tectonics of wood and the stereotomics of brick (Serra calls the prop "the most basic of engineering principles"). Above all Serra joins Frampton in his insistence on the tectonic. This, too, is most apparent in the props (to which he returned in the late 1980s as if to offer a counterexample to the flimsiness of postmodern architecture), for, again, the props demonstrate his "building principles" of "pointload, balance, counter-balance, and leverage" most directly. Other works, especially of the late 1980s, declare these principles as well: works such as *Gate* (1987), which consists of two Ts of steel bars on either side of a gallery beam (they appear almost to support the ceiling); *Timber* (1988), a T of steel plates also set under a gallery ceiling; *T-Junction* (1988), another T of steel bars, set short of the gallery ceiling, in which the horizontal element is extended; and finally *Maillart* (1988), in which this horizontal element is extended even further, supported by two bars, in a structure that suggests a bridge (as does the titular reference to the great Swiss engineer Robert Maillart [1872–1940]).

However, there remains this obvious difference: Frampton claims the tectonic for architecture, Serra for sculpture. How to decide between the two? Perhaps there is no need to do so; perhaps architecture and sculpture have a common ground in the tectonic; perhaps in an industrial age they might even share an originary principle in engineered construction.[46] Serra is forthright about his commitment to engineering, as in his statement from 1985:

The history of welded steel sculpture in this century—Gonzalez, Picasso, David Smith—has had little or no influence on my work. Most traditional sculpture until the mid-century was part-relation-to-whole. That is, the steel was collaged pictorially and compositionally together. Most of the welding was a way of gluing and adjusting parts which through their internal structure were not self-supporting. An even more archaic practice was continued: that of forming through carving and casting, of rendering hollow bronze figures. To deal with steel as a building material in terms of mass, weight, counterbalance, load-bearing capacity, point load has been totally divorced from the history of sculpture, whereas it determines the history of technology and industrial building.

It allowed for the biggest progress in the construction of towers, bridges, tunnels, etc. The models I have looked to have been those who explored the potential of steel as a building material: Eiffel, Roebling, Maillart, Mies van der Rohe. Since I chose to build in steel it was a necessity to know who had dealt with the material in the most significant, the most inventive, the most economic way.[47]

Despite the predominance of European figures in his tectonic pantheon, an American mythos is at work here: long before Duchamp, in defense of his urinal, nominated plumbing and bridges as the great American contributions to civilization, Walt Whitman had sung the praises of the Brooklyn Bridge (as would Hart Crane and Joseph Stella later), and Serra participates in this ethos of building as an analogue of self-building.[48] Also germane here are certain aspects of his personal formation, which include memories of his father as a pipe-fitter in a San Francisco shipyard and experiences as a young laborer in steel mills in the Bay Area.

The very insistence on the tectonic, in Serra as in Frampton, speaks to its atrophy in recent practice. In this respect another story might be in play here—that of a "dissociation of sensibility" between architecture and engineering on the one hand, and between sculpture and engineering on the other.[49] The first dissociation is sometimes dated, emblematically at least, to the foundation of the École Polytechnique in France in 1795, when training in these fields was divided. The second dissociation never occurred because sculpture and engineering were never united in the first place: again, "steel as a building material . . . has been totally divorced from the history of sculpture." So, unlike Frampton, who sometimes dreams of a rapprochement between architecture and engineering, Serra has no fall to redeem, only an opportunity to exploit, as the separation of sculpture from engineering was a historical given. Thus he was free to rework sculpture vis-à-vis engineering so as to render it pertinent to an industrial age. This reorientation, which is essential to his originality, runs throughout his work, but it is programmatic in a piece like *Maillart Extended* (1988), a post and lintel of steel bars that extends the pedestrian walkway across the Grandfey Viaduct (1925), designed by Maillart in Switzerland, in a sculptural way that reveals its structural logic.[50]

Drawing for *Maillart Extended*, 1988. Grandfey Viaduct, Switzerland,

There is a risk here, however: again, Serra might demystify sculpture as artisanal craft, only to mythify it as industrial structure. In effect this is to turn on Serra his own critique of welded sculpture—that it is a compromise-formation between art and industry—and to suggest that his productivist aesthetic, now outmoded, conceals more than it reveals the contemporary relation between art practice and productive mode in society at large. Yet this productivist aesthetic was not outmoded when Serra emerged in the middle 1960s (again, Russian Constructivism was only recovered from relative oblivion by his generation of artists and historians). "We came from a postwar, postdepression background," Serra once remarked of a group including Andre and Morris, "where kids grew up and worked in the industrial centers of the country."[51] As noted in Chapter 7, they brought this frame of reference into artistic practice in ways that transformed the parameters not only of its materials and processes but also of its siting and viewing—the expanded scale of the work in loft studios, its opening to distant landscapes, its encounter with urban architecture, and so on.

Obviously much has changed over the last fifty years. Our economy has shifted to a largely postindustrial order of consumption, information, and service, which alters the relative position occupied by Serra and his peers.[52] However, in this context his commitment to industrial structure might be seen as resistant not only to the pervasive decay of the tectonic in architecture, but also to its putative outmoding

The Drowned and the Saved, 1992. Weatherproof steel. Two right-angle bars, each 56 x 61 x 13 ¾ inches. Kirche St Kolumba, Erzbischöfliches, Diözesanmuseum, Cologne.

in a postindustrial order of digital design.[53] In other words, if the industrial model of the tectonic is now outmoded in part, it might be strategic to reassert its claims; it might even be endowed with a new critical force.[54] Certainly Serra can be taken to rebuff not only the scenography of most postmodern architecture but also the "novel tectonics" of much contemporary design, with its fascination with extreme engineering (Rem Koolhaas in his CCTV in Beijing) and/or digital image-making (Zaha Hadid in nearly all her work).[55]

In the 1990s Serra pushed the tectonic element of his sculpture to other ends, two of which could not be expected, for each appeared as a dialectical transformation of prior concerns. First, there were works, such as *The Drowned and the Saved* (1992) and *Gravity* (1993), the first positioned temporarily in the Stommeln Synagogue in Germany, the second permanently in the Holocaust Memorial Museum in Washington, DC, that develop the symbolic associations of the tectonic in ways that point to spiritual meanings—not in opposition to secular conditions of sculpture, body, and site, but by means of them. In such pieces the spiritual is not imaged (this taboo remains in force), but it is evoked, and, though this evocation is not monumental (this restriction is also secure), it is commemorative. This is a commemoration expressed in "weight and measure" alone; rather than refer to an event elsewhere, the memorial is immanent to the structure.[56] Second, there were works, such as the torqued ellipses, in which structure, in pace with engineering, is complicated to the point of a new order of effect: these pieces are so physically intense that they become psychologically intense, too. Like the commemorative turn, this psychological development was a surprise, given the avoidance of private spaces of meaning in much Minimalist and Postminimalist art, yet this psychological dimension is not necessarily a private one.[57]

In the Western tradition, Rosalind Krauss has argued, a monumental logic governed official sculpture, at least in the paradigmatic form of the statue, which "sits in a particular place and speaks in a symbolical tongue about the meaning or use of that place."[58] Modernist sculpture broke with this logic not only in its abstract forms and found materials but also in its break with the pedestal,

Gravity, 1993. Weatherproof steel. 12 x 12 feet x 10 inches. U.S. Holocaust Museum, Washington, D.C.

which, again, was a dialectical event that opened sculpture to the possibilities of both modernist sitelessness and postmodernist site-specificity. In certain works of the 1990s, Serra posed a further transformation of these terms: a sculptural paradigm that is neither siteless nor site-specific, but both autonomous and grounded in other ways.

This direction became apparent in the early 1990s with works placed before a French church (*Octagon for Saint Eloi*), within a German synagogue (*The Drowned and the Saved*), and at the Holocaust museum in Washington (*Gravity*). Such sites are not strictly private or public, but potentially intimate and communal nonetheless. *The Drowned and the Saved* suggests a commemoration of the Holocaust by place as well as by title (which alludes to the great memoir of the Shoah by Primo Levi). Again, this subject is not imaged but evoked through structure alone, in which two L-beams (the horizontal longer than the vertical) support one another through abutment. Serra once termed this bridge form a "psychological icon"; it is emblematic of spanning and passing, and both kinds of movement are intimated here.[59] There are those who cross the bridge, who pass over the abyss—the saved—and those who are not allowed to cross, who are dragged under—the drowned. These two passages, these two fates, are opposed, but they come together, as the two beams come together, in mutual support. In this way the tectonic principle first articulated for the props in 1970—"as forces tend toward equilibrium the weight in part is negated"—takes on a spiritual significance, for in this support there is a reciprocity that intimates a reconciliation of the drowned and the saved.[60] This is a reconciliation, not a redemption: again, the grace is immanent, not transcendental; it depends on the gravity of the structure, to which it is equal and opposite. Like the Holocaust, both exist in our space-time—in history, not beyond it.

If *The Drowned and the Saved* foregrounds measure, *Gravity* foregrounds weight, which also takes on a spiritual significance.[61] *Gravity* is a massive plane that steps down from the Hall of Witnesses in the Holocaust museum to the floor below; the psychological icon here is not a bridge but a stairway, which has symbolic associations of

its own. Does this stepped plane intimate descent or ascent? Does it express gravity or grace? Although movement is implied by the steps, it is also stilled by the plane, and in such a way that oppositions of descent and ascent, of gravity and grace seem suspended (another symbolic form is in play here, too: the memorial wall). Pieces like *Gravity* and *The Drowned and the Saved* indicate a partial shift from a parallax of subject and site to an arresting of the viewer before the work. This arresting can be felt negatively, with *Gravity* seen as a wall and *The Drowned and the Saved* as a bar—that is, as so many blockages evocative of a traumatic reality that cannot be assimilated. Or this arresting can be felt positively, as a symbolic constellation of the sacred and the secular.[62] Like the arresting of the viewer, the abstraction of the work, which here seems to follow spiritual as well as aesthetic principles, is also effective in its ambiguity.[63] Is this refusal of representation vis-à-vis the Holocaust a sign of impossibility, of melancholic fixation on a traumatic past, or is it a sign of possibility, of a mournful working-through of this past that is also a holding-open to a different future? In either case the Shoah is commemorated, but not raised to the oppressive status of a religion of its own.[64]

Weight and equilibrium, gravity and grace, have effects that are psychological as well as bodily and spiritual. In 1988 Serra recalled a childhood memory of a ship launching at the yard where his father worked:

> It was a moment of tremendous anxiety as the oiler en route rattled, swayed, tipped, and bounced into the sea, half submerged, to then raise and lift itself and find its balance . . . The ship went through a transformation from an enormous obdurate weight to a buoyant structure, free, afloat, and adrift. My awe and wonder at that moment remained. All the raw material that I needed is contained in the reserve of this memory which has become a recurring dream.[65]

One need not turn to a psychoanalysis of screen memories and primal fantasies to register the psychological impact of this event, and, though this dimension surfaced strongly in the late 1980s, it was latent in previous work.[66] Indeed, from the beginning Serra and

such peers as Robert Smithson, Bruce Nauman, and Eva Hesse were
ambivalent about the apparent rationalism of Minimalism. On the
one hand, their project was also rational: to foreground process in
order to demystify the viewer about the making of sculpture. On the
other hand, this making indicated a bodily engagement that often
implicated the erotic and the psychological (this is most evident in
Hesse, but it is present in the others, too).[67] In the work begun with
the torqued ellipses, Serra folds the rational and the irrational into
one another. The rational aspect—to manifest production and struc-
ture—remains; but the irrational aspect—to disorient the viewer
with the insides turned out and the outsides in—is pushed to the
point where one seems to experience different sculptures at almost
every step. That is to say, as Serra increases complexity, he does not
forfeit legibility; he tests the viewer more rigorously than heretofore
(he calls this "thinking on your feet"), but he also allows the viewer
more choice, even more agency, as he or she looks, moves, feels, and
reflects.

"The generation of the 1960s made an art of the human subject
turned inside out," Krauss has argued, "a function of space-at-large."[68]
This remains the case with Serra, but the opposite has become true
as well: with the torqued pieces the viewer appears to be inside and
outside the sculpture at once, so that the subject-turned-inside-out is
also a space-turned-outside-in, as if it, too, were made a function of
the subject. In this way, Serra has opened up a psychological spati-
ality in his work, one of evocative interiors often associated with
Surrealism; this was not to be predicted, for, as we have seen, Serra
long plied the Constructivist line of modernism, which is contrary to
the Surrealist trajectory. Yet, as he has developed this Constructivist
line, he has also transformed it to the point where it is no longer
strictly opposed to its old other.

This convergence of contrary trajectories attests to the semi-
autonomy of artistic development won by Serra. Again, this practice
deconstructs sculpture vis-à-vis its site, but in a way in which unmak-
ing is not opposed to making any more than a commitment to
site-specificity is opposed to the category of sculpture.[69] Indeed, this
semi-autonomy of the work is crucial to its site-specificity, as it must
be if site-specificity is to be site-critical as well. This point—that semi-

CATIA printout of *Double Torqued Ellipse*, 1998. Outer ellipse 14 x 37 ½ x 40 feet; inner ellipse 14 x 20⅓ x 32 feet.

autonomy can be the guarantee of criticality, not its undoing—is often lost in recent developments in site-oriented and project-based work, which sometimes threatens to dissolve artistic practice into sociological or anthropological fieldwork. Serra has always stressed the internal necessity of sculpture, always insisted on the useless-ness of art in general. Here this necessity, that uselessness, does not void the criticality of art; Serra shows that it can also underwrite it. Periodically, this is an important lesson to relearn.

To understand how a sculpture is constructed is not necessarily to know how it is configured, and just as Serra exploited the tension between conception and perception in his early work, so he has exacerbated the tension between structure and configuration in his later work. His multiple ribbons and torqued pieces are the results of this complication. In some ways these works suggest a Baroque counterpart to classical Minimalism: as in classical architecture, the Minimalist object engages the subject but remains external to him or her, while, as in Baroque architecture, the ribbons and the torques envelop the subject, and the effect is often an extraordinary chiasmus: a spatial overwhelming of the subject and a subjective deforming of space. In some ways it seems that the space is a projection of the body, a projection that one then experiences as if from the inside.

Etymologically, Baroque means "misshapen pearl." However, Gilles Deleuze proposed "the fold" as a more apt term for its signal creations, whether these are taken to be the painting of Tintoretto, the architecture of Borromini, or the philosophy of Leibniz. For Deleuze a prime effect of the Baroque fold is to detach the interior from the exterior, "but in such conditions that each of the two terms thrusts the other forward."[70] Deleuze relates this effect to the art-historical schema of Heinrich Wölfflin (who established the classical/Baroque differential as a fundament of art history) as well as to the metaphysical reflections of Leibniz:

> As Wolfflin has shown, the Baroque world is organized along two vectors, a deepening toward the bottom, and a thrust toward the upper regions. Leibniz [also] makes coexist, first, the tendency of a system to find its lowest possible equilibrium where the sum of masses can descend no further and, second, the tendency to elevate, the highest aspiration of a system in weightlessness, where souls are destined to become reasonable.[71]

Such a system of counterposed vectors and of mass that coexists with weightlessness returns with the torqued sculptures of Serra.

Serra has made this connection to the Baroque, too. For example, he tells us that the torqued ellipses were inspired in part by a momentary misrecognition inside the San Carlo alle Quattro Fontane (1665–76), the Borromini church in Rome that is a masterpiece of Baroque architecture. One day in 1991 Serra entered the nave from the side, and mistook the ellipses of the dome and the floor to be offset in relation to one another:

> The space rises straight up and doesn't change in its regular oval form from top to bottom. It is kind of an "oval cylinder." For me walking in from the side aisle was more interesting than standing in the central space. Then it occurred to me that I could possibly take what I perceived from the side aisle, and torque the space.[72]

In other words, Serra saw that he might twist in elevation such volumes as oval cylinders, ellipses, and spirals. First he tested this intuition with a model made up of two wood ellipses held parallel

Double Torqued Ellipse II, 1998. Weatherproof steel. Outer ellipse 11 ¾ x 27 ½ x 36 feet; inner ellipse 11 ¾ x 28 ½ x 19 ½ feet.

but askew to one another by a dowel. He made a template from this model, and a lead sheet was cut and rolled from it. His studio then applied a computer program to calculate the necessary bending of the projected ellipses at full scale, a bending that only a few steel mills in the world could then execute. This is how the torqued ellipses (first singles, then doubles) were generated, and the torqued spirals followed. In each instance there is a Baroque disconnection not only of elevation and plan but also of inside and outside.[73]

This double disconnection already occurred in the multiple arcs, but they still carve out a principal trajectory that we can anticipate. This is not true of the torqued pieces; one cannot foresee or recall much about them (memory is tested here, too). The walls tilt in and out, left and right, sometimes together, often not; as a result they pinch, then release, and then pinch and release again, in ways that cannot be calculated precisely because they are torqued—that is, because the radii of the curves do not hold steady. There is no way to gauge the structure or the space ahead, and the same goes for the skin of the sculpture: "Because

Torqued Spiral (Right Left), 2003–04 (in foreground). Weatherproof steel. 14 x 46 ¼ x 43 feet x 2 inches. Guggenheim Bilbao.

the surface is continuously inclined, you don't sense the distance to any single part of the surface," Serra comments. "It's very difficult to know exactly what is going on with the movement of the surface."[74] One feels continuously dislocated, and even more so with the spirals, which, unlike the ellipses, do not have a common center and are not sensed as two discrete forms: thus it can seem that each new step produces not only a new space and a new sculpture, but even a new body. Sometimes, as the walls pinch, one feels the weight of the piece press down; but then, as the walls open up again, this weight is eased—it appears to be funneled up and away. Suddenly both body and structure feel almost weightless, and again even more so with the spirals, as they seem to spin more smoothly, more rapidly, as one walks through them.

Here Serra echoes archaic structures such as the labyrinth and the omphalos, structures that fascinated the Surrealists, too. But the torqued pieces are not mazes—one knows one is headed either toward or away from the openings—and the centers are without the oracular aura of the omphalos. Again, this quasi-Surrealist spatiality complicates his old commitment to Constructivist tectonics, yet a new language of building is forged in the process, one that undoes such old oppositions as rational and irrational, and mechanistic and biomorphic.[75] At the same time the torqued pieces suggest futuristic structures as well, such as the "warped spaces" that permeate both computer graphics and contemporary architecture. Often in such design the subject is not situated, at least not in the manner of representational modes like perspective or of other mediums like painting or film; indeed, the apparent auto-generation of forms is almost oblivious to the subject, with the result that the subject can appear unfixed, almost elided.[76] Serra evokes these effects in his torqued pieces, but only in order to check them in the interest of embodiment, placement, and context. As a result he stays clear of two pitfalls of neo-Baroque architecture today—its tendency to indulge in arbitrary forms and its tendency to efface the subject—even as he matches its provocative proposals about surface and speed.

Implicit here, then, is a further critique of recent architecture. With computer-assisted design and manufacture, it sometimes seems that any form can be conjured and built, and Serra points, by counter-example, to the waning of formal motivation and tectonic rationale

that often results. This critique applies to recent art, too—especially practices involving projected images that are also inclined to an asubjective virtuality. With Serra, on the contrary, there is a layering, not a collapsing, of different spatialities and subjectivities, in a way that allows the complexity of experience to be sensuously retained, not futuristically flattened.

NINE

FILM STRIPPED BARE

We enter a dark space to the whirr of a sixteen-millimeter film projector, and a pencil of white light cuts across the empty room to a distant wall. It registers as a dot, yet slowly the dot becomes an arc, and a small section of a cone is carved out of the space. As the thirty minutes of the film elapse, the arc grows into a circle, and a full cone of light is described in the room; then the process begins again. During the time of this describing we cannot help but touch the light as though it were a solid and investigate the cone as if it were a sculpture—cannot help but move in, through, and around the projection as though we were its partner, even its subject. Such is the experience of *Line Describing a Cone* (1973) by Anthony McCall, a classic of "structural film."[1]

Fast-forward thirty-three years. Again we enter a dark space, but there is no sound, as the projector, now digital, is silent. There are two such machines, located above us, with the projected figure, also double, on the floor at our feet. This figure is far more complex than a line describing a cone: it has no obvious beginning or end, and its development cannot be readily anticipated; in fact it can scarcely be understood. As a result, over the sixteen minutes of this projection, we tend to observe the tracing on the floor more assiduously than we

Line Describing a Cone, 1973. 16 mm black-and-white film projection (30 minutes; here seen in the 24th minute). Photo Hank Graber.

do with a horizontal piece like *Line Describing a Cone*, in order to tease out the logic of its configuration in time, a logic that also defines the moving veils of light that fall from above—though we know this correlation more than perceive it. Gradually (it requires more than one iteration), we see that one of the two figures is an ellipse that contracts and expands while the other figure, a wave, travels toward it; there is also a line that rotates through the wave, complicating both forms. At the same time a very slow filmic wipe connects the two figures such that the one is always eclipsing the other, making breaks, which produce apertures in the veils of light, and forging connections, which produce closures, in the process. Gradually, too, we see that, in the course of a cycle, one figure turns into the other: ellipse becomes wave and vice versa. This is the experience of *Between You and I* (2006), one of several vertical projections McCall has made since 2004.

Between the first series of films represented by *Line* and the second represented by *Between*, there was a long hiatus in this work (largely due to the falling away of support for structural film in the art world

Sequential frames of *Between You and I*, 2006.

of the 1980s and 1990s); nonetheless, McCall calls them all "solid-light films."[2] Solid light is a beautiful paradox, one that conjures up the old debate about its nature (i.e. is light a particle or a wave?), and McCall invites us to play with the paradox—to touch the projections as if they were material even as our hands pass through them with ease, to see the volumes as solids even though they are nothing but light. The play is sensuous, to be sure, but it is also cognitive, for we are prompted to ask (as McCall does, rhetorically, here), "Where is the work? Is the work on the wall [or the floor]? Is the work in space? Am I the work?"[3]

In effect this is also to ponder, "What is the medium?" It is film, evidently enough, but film denatured, stripped bare, reduced to projected light in darkened space. At the same time film is expanded here, in the sense that it is made both to draw lines and to sculpt volumes. In the process it is also questioned, particularly in the recent projections, which are digital and so, technically speaking, not filmic at all (they have none of the slight flicker of the early pieces, for example); the vertical pieces disrupt the horizontal orientation of cinema as well.[4] "I was certainly always searching for the ultimate film, one that would be nothing but itself," McCall has recalled, and this ambition is in keeping with the modernist project of artistic reflexivity and autonomy.[5] Finally, however, what is disclosed here is less any essence of film than the recognition that mediums do not operate in this way—that they are not so many nuts to crack, with a meat to eat and a shell to discard, but a matrix of technical conditions and social conventions

Between You and I, 2006. Digital projection. Peer/The Round Chapel, London. Photo Hugo Glendinning.

in a differential relation to the other arts. Thus this search for the "ultimate film" implicates other mediums, too, which, like Richard Serra and others before him, McCall shows to be arrayed in an aesthetic field, one that significant practice always works to reconfigure and to renew.

Of course, the first art implicated here is cinema, even though McCall pares away most of the attributes associated with it, not only illusionistic space and fictional narrative but also the spectatorial precondition of this imaginary "elsewhere" (as he calls it)—that is, the viewer fixed in place (seated in fact), with eyes locked on the screen, and mostly oblivious to apparatus, ambience, and audience alike (the cone of projected light in particular).[6] It is "the first film to exist in real, three-dimensional space," McCall has asserted of *Line*, and it "exists only in the present."[7] This here-and-now-ness holds for his other films as well, and yet, as suggested, the effect is not to deliver film into a stable state of autonomous purity but to place it in correspondence with various arts—cinema first (especially in the horizontal projections), then sculpture (especially in the vertical projections), but other mediums and disciplines, too.[8]

"The body is the important measure," McCall says of the dimensions of his projections. Not only do they assume its scale, but they also incite us to move with the light—to play and/or to experiment with it—as it moves in turn; again, we interact with a McCall film as though we were somehow its subject.[9] This bodily reference is one key connection with sculpture; another is that the films also carve volumes out of space. Non-traditional genres are elicited as well; for example, when the projectors engage the floor, the films implicate installation, too.[10] On this score, beyond sculpture and installation, the solid-light films invite us to think about the architectural parameters of the given venue, which they both obscure and illuminate in ways that make us sense the space haptically as well as optically—that is, to feel our way around it with our hands out and our eyes wide open. One could say more about the rapport of the projections with other disciplines. Again, just as the films sculpt space, they also trace lines, and so implicate drawing as well.[11] In fact they are drawings in light, literal *photo-graphs* in motion (which is, after all, what film is), and so photography is also engaged. In many ways

the great pleasure afforded by the work comes as we move from an experiencing of the different phenomenologies of these media to a puzzling over their provisional ontologies and back again. Sensuous and cognitive, the space of the solid-light films is thus philosophical, too.

This play with the aesthetic field began for McCall in the early 1970s, in close relation to the reflexive project of structural film (in which he participated in London and New York) as well as the expanded field'of sculpture after Minimalism (which he experienced primarily in New York, where he has lived since 1973).[12] McCall evidences his commitment to both practices in his belief that viewers of the early films tend to turn away from the projection and toward the projector in order to reflect on the reality of the apparatus rather than on the appearance of the image, like so many Platonic subjects no longer captivated by the imagistic illusion on the cave wall. This is not always the case, however: viewers also attend closely to the tracing, and, given the increased complexity of the vertical films, they do so even more so with these. That is, they play not only with the paradox of solid light but also with the tension between the film-as-drawing ("Is the work on the wall or the floor?") and the film-as-sculpture ("Is the work in the space?"). This tension develops the one produced by many Minimalist objects—the tension between the known form and the perceived shape, between the given Gestalt and its multiple manifestations from various perspectives. As we saw in Chapter 8, this discrepancy is activated by the viewer set in motion by the object in space; with the solid-light films it is also produced by the movement of the projected figures. Indeed, as the figures become more intricate, the tension between the known and the perceived becomes more intense, but never to the point where the viewer feels overwhelmed by complexity or stunned by speed. This is so in part because McCall hews to the principle that the viewer should be "the fastest thing in the room," lest one be arrested before the mobile figure and become a passive observer.[13]

The viewer, then, is not stopped by the films; again, one moves in and out of the projections, through and around them, in order to experience the manifold of time and space that they produce. This

is also the case with later sculptures by Serra, whose torquing of ellipses and other shapes is clearly relevant to the recent films. Of course, light is permeable and mobile where steel is neither; nevertheless, some of the questions raised by the two artists are similar. For instance, with Serra one works to correlate the experience of his curved spaces, interior and exterior, with the image of the sculpture as a whole, or, in architectural terms, to correlate the elevation of the structure with its plan. With McCall, too, one strives to hold together the shapes of the light veils that fall from above with the patterns of the projected lines that are traced below; and, like Serra, McCall complicates this correlation as his work advances, as if to lead us, as students of his language, through a progression of encounters or examinations. In both cases the viewer is entrusted to learn each new piece, in effect to accompany the artist in the development of his compositions, and in this way a dialogical relation is set up with the oeuvre as a whole.[14]

This is also to say that the work tests the mettle of our visual skills. Just prior to *Line Describing a Cone*, Michael Baxandall published an influential study of Renaissance art, *Painting and Experience in Fifteenth-Century Italy* (1972), which argues that early Renaissance masters both assumed and advanced the quotidian talents of their viewers. The ability to gauge different sizes, as practiced at the marketplace, might also be summoned in the contemplation of spatial perspective, as before a painting by Piero della Francesca, say, or the ability to dance in complicated ensembles might also be tapped in the appreciation of figural groupings, as before a composition by Pisanello, say. "Much of what we call 'taste' lies in this," Baxandall writes, "the conformity between discriminations demanded by a painting and skills of discrimination possessed by the beholder. We enjoy our own exercise of skill, and we particularly enjoy the playful exercise of skills which we use in normal life very earnestly."[15] The playful exercise of visual expertise is entertained by McCall, too, whose work offers a pleasurable pedagogy in properties of line, volume, space, and movement.[16] Skills that range from basic Euclidean geometry to advanced mathematical equations are entertained here, and there is delight in this informal learning. The experience is also a sociable one: one can witness complete

strangers debate the intricacies of the forms, and schoolchildren invent impromptu games in the volumes.

This intimate interaction, which is both private and public, is central to the experience of the solid-light films. They do invite us to ask, "Am I the work?", but the question is not a solipsistic one; and, though we are placed within immersive environments, there is no oceanic feeling or sublime effect manufactured for us.[17] At the same time the semi-paranoia of modern accounts of vision and visuality does not pertain either. Think of Heidegger on "the world picture"— his argument that perspective underwrote the modern view of the world as a technological "standing reserve" and of the individual as its instrumental master; or Sartre and Lacan on "the gaze"—their arguments that, even as we might assume this mastery over "the world picture," we are also subject to it—subject to the gaze *of* the other (as in other people) as well as to the gaze *as* other (as in our inhuman surround that seems to observe us). "I am in the picture," Lacan writes ominously, "I am *photo-graphed*" by the light of the world, queried in my lack by its gaze.[18] This fearful inflection is also present in Foucault with his notion of an institutional gaze that disciplines us, and in feminist film theory with its demonstration that classic cinema positions us prejudicially as spectators according to gender.

McCall demurs from the anxious assumptions about the visual that underlie these arguments. First, the sense that we are "in the picture, photographed by its light" is here met with interest, not dread. Then, too, even as his projections are scaled to the body, they hardly discipline it: on the contrary, they invite its participation. Finally, even as the films play with our discrepancies as figures, they do not fix on our differences: again, on the contrary, viewers become partners not only to each piece but to one another. In some ways McCall returns us to the benevolent phenomenology of Merleau-Ponty, for whom we are positioned, first and foremost, as bodies among fellow bodies in "the flesh of the world," not as images to be screened for the volatile (dis)identification of others. The films thus suggest an aesthetic of "symmetries and repetitions and doublings" based on common properties of our shared corporeality, which in turn suggests an ethics of intimacy and reciprocity rather than one of alienation and aggression.[19]

Breath, 2004. Digital projection. Hangar Bicocca, Milan, 2009. Photo © Giulio Buono.

If the horizontal pieces redouble the usual orientation of both seeing and cinema, the reference to vision and film is less insistent in vertical pieces such as *Breath I–III*, *Meeting You Halfway*, and *Coupling* (all of which deploy one projector), yet the engagement of the body might be more profound as a result. Indeed, the three *Breath* pieces evoke a lung inhaling and exhaling, an evocation of the body less as an image than as an organism. McCall points to corporeal associations in his terminology for the vertical pieces, too—not only "footprint" for the patterns traced on the floor, but also "membrane" for the surfaces of light and "standing figure" for the volumes that they describe.[20] At the same time they produce strong architectural resonances as well: McCall sometimes refers to the vertical shapes as "chambers," and even as they open and close before us, we tend to stand distinctly inside or outside them at any given point in time.[21] This architectural connection is deepened by the large spaces necessary to stage the films, the vertical ones in particular (which are sometimes shown in industrial structures converted into galleries).

Breath III, 2005. Digital projection. Hangar Bicocca, Milan, 2009. Photo ©
Giulio Buono.

The cycle of the vertical projections varies between fifteen and
thirty-two minutes. *Breath* (2004) consists of an ellipse that expands
and contracts as a wave travels through it, producing openings and
closings in the figure as it does so. *Breath II* (2004) puts two traveling

0 min. 3 min. 6 min.

9 min. 12 min. 15 min.

Sequential frames of *Breath III*, 2005.

waves into action, at different speeds, as the ellipse around them expands and contracts, and this interaction produces even more apertures and closures (some of which appear, if one is inside the figure, as sudden dead-ends). In *Breath III* (2005) the breathing ellipse is inside the traveling wave, and their mobile configuration is more open as a result. As the title suggests, *Meeting You Halfway* (2009), which consists of partial ellipses that face each other, performs an encounter between two figures. In the first half of the cycle both contract slowly and then expand rapidly (though they do so at different speeds), whereas in the second half one ellipse follows this pattern while the other does the reverse. The movement is mostly vertical; the slight horizontal motion comes from a floating wipe that moves back and forth across the two forms, revealing more of the one while covering more of the other.[22] As usual with McCall, this scheme sounds logical as far as figure and rhythm go; it is the protean volumes that draw our attention. Finally, *Coupling* (2009) explores a new form, which the artist calls a "circle wave." When a violin string is bowed or plucked, a wave moves with different amplitudes between the fret and the bridge, producing the sounds we hear; if we imagine this line, complete with undulations, as a circle, then we have a circle

Meeting You Halfway, 2009. Digital projection. Hangar Bicocca, Milan, 2009. Photo © Giulio Buono.

wave. In *Coupling* two circle waves appear, one inside the other. The undulations not only distort both circles but also, at different times in the cycle, break the circles at opposite points, thus creating two openings, one to the exterior of the projection, the other in its interior.

This account only begins to describe the footprints of these pieces. As for the volumes, they have to be experienced in situ; as with recent shapes devised by Serra, they cannot be anticipated or recalled with much accuracy. The projections thus slow and thicken space in ways that make the ambiance more substantial and the viewer more responsive than usual; at the same time the complexity of the figures poses a challenge to perception and cognition alike. Again as with recent pieces by Serra, they are hard to learn, perhaps impossible to know, and this might prompt two different thoughts: on the one hand, we might reflect on the difficulty of our everyday negotiations of space, actual and virtual; on the other, we might trust all the more in our experience and intuition in this navigation, whereby these mapping skills are affirmed.[23] Yet not all is benign here: there remains the dark, which is the medium of the projections as much as the light is. It supports the films, but it also surrounds us, and it has primordial associations that cannot be bracketed entirely.[24]

At the same time, inside the vertical projections in particular, one is bathed in a pale, silvery light. This experience might evoke legendary encounters with celestial luminosity, some pagan, some Christian. On the pagan side, there is the mortal Danae impregnated by Zeus with golden rain, as pictured by Titian, say, or the mortal Endymion bathed in the light of his lover Selene, the moon, as pictured by Girodet. On the Christian side, there is the Annunciation of the Virgin, or the ecstatic communion of Saint Teresa with God, both of which are usually figured as rays of heavenly light bestowed on mortals below. This spiritual dimension is difficult for a materialist like McCall to discuss—"bodies and interactions and exchange are not divine ideas," he has stated simply—but he does not deny that it exists.[25] Yet secular associations are salient here, too, such as the tendency of life forms to bend toward the light of the sky. An even more worldly connection is to the light of stage spots, which underscores once more how the projections are also performances in which we figure.

Although the solid-light films emerged in the double context of structural film and site-specific installation of the early 1970s, they also look to a key moment in the historical avant-garde moment, the

Coupling, 2009 (in foreground). Digital projection. Hangar Bicocca, Milan, 2009. Photo © Giulio Buono.

light experiments of László Moholy-Nagy in the 1920s and 1930s. Moholy based his mature practice on this fundamental question: Can mediums associated with indirect reproduction—that is, of a musical performance in a recording, or of worldly appearance in a photograph, or of a dramatic story in a film—be opened to direct

production—that is, to the active making of sound, light, or motion? In this modernist quest Moholy took, as his privileged mediums, the photograph and the film, which he understood almost etymologically as a matter of light written on a support. According to Moholy, this new technology of filmic transparency was certain to transform other mediums, and already in *Painting, Photography, Film* (1925) he proposed a re-mapping of the visual arts into an "entire field of optical expression."[26] It is this famous thesis of a "new vision" that Moholy elaborated in *From Material to Architecture* (1929; published in English in 1932 as *The New Vision*), which redefined painting as "material," sculpture as "volume," and architecture as "space," and posited a necessary passage from the first condition to the last—"from material to space." In short, transposed from photography and film, transparency was to become a "new medium of spatial relationship" in general.[27] Moholy went on to explore this radical dematerialization, especially in his *Light Prop for an Electric Stage* (1930) and other "light-plays," but his work was cut short by wartime exile and premature death.

In his neo-avant-garde moment of the early 1970s, McCall effectively recovered this truncated avant-garde project: his films also pass through the screen of reproduction to the reality of production, and they also move "from material to space" via "light-plays." Yet in doing so McCall reversed the Hegelian emphasis in Moholy on the progressive sublimation of the arts, and regrounded his exploration of vision and space in the given materiality of our bodies and our architectures.[28] Whereas dematerialization was a dream for modernists like Moholy, it has became a default for many artists lately: in much installation involving film and video projection, a virtualizing of bodies and architectures seems all but automatic.[29] Here again McCall makes an important intervention with his insistence on embodiment and emplacement: the experience of his solid-light films, early and recent, is one that, though immersive and intense, is not sublime or schizoid; it is also one that, though private and contemplative, is social and interactive.[30] To play with light effects is often to abandon (or at least to occlude) space in favor of image or illusion. This is not the case with McCall: as with Serra, a mobile viewer, who is also perceptually and cognitively alert, stands in counterpoint to

László Moholy-Nagy, *Light-play: Black/White/Gray*, 1930. Frames from 16 mm black and white film (5 ½ minutes). Courtesy of Hattula Moholy-Nagy.

the stunned or arrested subject of spectacle, which is also private or at least nonsocial in a way that the solid-light films are not. At least for the duration of his films McCall diverts these aspects of spectacle to other ends, and these qualities give his work a renewed relevance and a redoubled criticality.

TEN

PAINTING UNBOUND

For years I took Donald Judd at his word: that Minimalist objects are opposed to any pictorial illusionism or virtual space whatsoever. But is this account true to his art, let alone that of his close colleague Dan Flavin, early or late? Moreover, what is the fate of the opposition between "specific objects" and illusionist space in the aftermath of Minimalism, and the role of artists like Judd and Flavin in that story?[1] In the past I have argued that Minimalism is a crux between late-modernist painting (from Barnett Newman to Frank Stella, say), which was a primary point of reference for Judd, Flavin, and peers, and postmodernist art, which sought to move beyond the traditional mediums with different materials, processes, and sites; and that central to this break was the initial posing of the specific object of Minimalism against the residual illusionism of late-modernist painting.[2] Yet, however opposed to such illusionism discursively, might Minimalism also be propped up by it, bound up with it, even invested in it?

In my literalism, which was deepened by the literalism of Postminimalist practices such as process, body, and site-specific art, I did not attend to how illusionism might be preserved in Minimalism, even expanded by it (think of the reflective surfaces and refractive depths in some Judd boxes, or the brilliant color and immersive light

in all Flavin lights); or, further, how illusionism might be released in the optical effects of the "light and space" art that developed with Minimalism and after (think of the reflective glass cubes of Larry Bell, the haloed light disks of Robert Irwin, the colored light ambiances of James Turrell, and so on).[3] In short, if Minimalism contested the illusionistic remainder in late-modernist painting, how thoroughly did it do so, and for how long? Was its break with pictorial virtuality only partial and temporary, a historical ruse on the way to the recent

Robert Irwin, Untitled, 1967. Painted metal and metal cylinder mount. 24 ½ x 54 inches. Photo © 2010 Robert Irwin / Artists Rights Society (ARS), New York.

triumph of the virtual (in the digital pictorialism of recent photography, say, or the projected images of recent video installations)—a triumph that is hardly restricted to art (as we have seen, it is pervasive in architecture, too)? This possibility leads me to ask whether, even as Minimalism remains a crux in twentieth-century practice, its aftermath might not also be, at least in part, a *catastrophe*.

In an early response to Judd, Rosalind Krauss questioned the terms of his literalist program. Although Judd might stipulate that a positivistic "list of physical properties" is the proper approach to his art, Krauss wrote in 1966, his individual pieces "both insist upon and deny the adequacy of such a definition"; more importantly, even as "object-art would seem to proscribe both allusion and illusion," its appearance often involves both.[4] As a case in point Krauss offered a 1965 piece by Judd, one long aluminum bar set on the horizontal and broken up at progressive intervals by short aluminum pieces painted purple (there are variants). In the first instance, as one walks along

Donald Judd, Untitled, 1969. Stainless steel and Plexiglas. 33 x 68 x 48 inches.
Pinakothek der Moderne, Bayerische Staatsgemaeldesammlungen, Munich.
Image: Bildarchiv Preussischer Kulturbesitz / Art Resource, NY.

Donald Judd, Untitled, 1979. Clear anodized aluminum and blue anodized aluminum. 12 x 200 x 12 inches.

this work, it evokes both foreshortening and perspective; then, too, even as the colored bars appear to be the luminous figure against the solid ground of the aluminum bar, one sees, at either end of the piece, that the long bar is both hollow and supported by the short bars. Here as elsewhere, then, allusion and illusion are conjured by Judd, if also checked.

According to Krauss, Judd developed this ambiguity from the late *Cubi* sculptures of David Smith that play with the structure of the pictorial frame: "The[se] works wed a purely optical sensation of openness (the view through the frame) that is the presumed subject of the work, with an increased sense of the palpability and substance of the frame. Smith in this way embraced the modality of illusionism within pictorial space from painting, and used this to powerful sculptural advantage."[5] Here the virtual is seen to serve as a foil for the specific, the illusionistic for the actual, and there is a related foiling in Judd, too. Yet the salient point here is the simple one that the illusionistic thereby persists in his work, and additionally so in the translucent colors of some of his Plexiglas pieces, the reflective opticality of some of his metal surfaces, and the shadowy depths of

David Smith, *Cubi XXVII*, 1965. Stainless steel. 111⅜ x 87¾ x 34 inches. Art
© Estate of David Smith/Licensed by VAGA, New York. Photo © David Heald.

Donald Judd, Untitled, 1969. Galvanized iron and Plexiglas.
120 x 27⅛ x 24 inches overall. Image: Albright-Knox Art Gallery / Art
Resource, NY.

some of his stacked units.[6] However, though the illusionistic is thus present in his art, it is lost in most discourse about it, his own above all. "Three dimensions are real space," Judd states baldy in "Specific Objects." "This gets rid of the problem of illusionism . . ."[7]

Judd was averse to illusionism because it exemplified the exhausted conventions of traditional painting for him.[8] In fact he was so averse to illusionism that he projected it away from his art and, to a lesser extent, that of Flavin, too, and so occluded its continued presence there. "They don't involve illusionistic space," Judd declared in 1964 of the Flavin "icons," geometric constructions of solid colors on Masonite with electric and/or fluorescent lights attached to the surfaces or the edges, which Judd described as "blunt" (high praise for him). However, he qualified his assessment somewhat with the Flavin fluorescents that followed: "I want a particular, definite *object*," Judd wrote in 1969. "I think Flavin wants . . . a particular *phenomenon*."[9] Flavin never signed on to the program of "specific objects" (for example, he rarely placed his lights flat on the floor, which his early works do not touch at all), and he was always suspicious of the term "Minimalism." Yet both artists entertained a play between "object" and "phenomenon," material support and illusionistic effect: in his appraisal Judd turned an oscillation *within* each practice into an opposition *between* the two.[10] That said, the oscillation is more intense in Flavin, for essential to our experience of his fluorescent pieces is the rapid relay of our attention among the metal fixture, the transparent glass, the luminous gas, the extended glow of color, and the spatial diffusion of light, and he knew as much: "the composite term 'image-object' best describes my use of the medium" (91).[11]

Flavin once described this oscillation in terms of "irony": "The radiant tube and the shadow cast by its supporting pan seemed ironic enough to hold alone" (87).[12] I understand him to mean two things here: not only that the pan and its shadow might "hold" the radiance of the tube—that is, ground it physically (a grounding that contrasts with installations by Irwin and Turrell where the cause of the support is often obscured by the effect of the light), but also that his viewers might be "held" by the tension between material object and immaterial light—that is, captivated by it. Object and

Dan Flavin, *icon V (Coran's Broadway Flesh)*, 1962. Oil on gesso on
Masonite, porcelain receptacles, pull chains and incandescent bulbs. 41⅝ x 41⅝
inches. Photo © 2010 Stephen Flavin/Artists Rights Society (ARS), New York;
courtesy of David Zwirner, New York.

light thus "ironize" each other in the sense that we cannot decide
for either one as primary. In this respect Flavin is more ironist than
literalist, or, rather, he finds an ambiguity in literalism that "holds"

Dan Flavin, *the diagonal of may 25, 1963 (to Constantin Brancusi)*, 1963.
8-foot yellow fluorescent light. Photo Billy Jim © 2010 Stephen Flavin/Artists
Rights Society (ARS), New York; courtesy of David Zwirner, New York.

Dan Flavin, *untitled (to the "innovator" of Wheeling Peachblow)*, 1966–68. 8-foot daylight, yellow and pink fluorescent lights. Photo Billy Jim © 2010 Stephen Flavin/Artists Rights Society (ARS), New York; courtesy of David Zwirner, New York.

both work and viewer in tension. In contradistinction to the famous maxim of Stella, what you see is not quite what you see with Flavin: our perception of his pieces changes with our position; often we see complementary colors that are not actual at all; and we cannot locate the light with much precision (Flavin once described it as "over, under, against" all at once [88]). This undecidable aspect of his work is one reason why its tension between illusionism and anti-illusionism is not a "dialectic"—a term that suggests a developmental logic foreign to Flavin as well as a possible resolution that his irony works to undercut.[13]

For Flavin the struggle with illusionism was chiefly a struggle to hold "the lamp as image back in balance with [the lamp] as object" (87). A version of this tension preceded his fluorescent works; in fact it was in play ever since he moved, in the late 1950s, from his fussy watercolors and drawings to his smashed tins and tools on brushy Masonite grounds, which Flavin called, in a typical riff of Joycean assonance, "plain physical factual painting of firm plasticity" (86). The mix of abstract painting and found object in these early works also attests to two forces active in advanced art of the time: like others in his milieu, Flavin was much impressed by Newman, who later befriended him (it was also the Minimalists who first acclaimed Newman as a master), and Flavin could not avoid the impact of Robert Rauschenberg and Jasper Johns, whose lineage was traced by the 1961 exhibition, "The Art of Assemblage," held at the Museum of Modern Art while Flavin worked there as a guard. Curated by William Seitz, this show included a great variety of things—Cubist and Futurist collages, Dadaist objects, late-Surrealist and Art-Brutish works—most of which were seen through the contemporaneous practice of Neo-Dada and Nouveau Réaliste assemblages. Either Newman or Johns (whom Flavin preferred to Rauschenberg) might have led him to extrude pictorial space into actual space, but altogether this "crush of avant-gardism" made the move irresistible to him (192).

However, a chief motive of this move was not represented in the Seitz show or elsewhere in New York in 1961: the Constructivism of Vladimir Tatlin and Aleksandr Rodchenko. This precedent first came to Flavin by way of a book published in 1962, *The Great Experiment: Russian Art 1863–1922* by the English art historian Camilla Gray (it was also important to Carl Andre and Sol LeWitt, who alerted Flavin

to its publication). Among other images of the Russian avant-garde, Gray illustrates the passage in Tatlin from his semi-Cubist paintings, via the constructions of Picasso, to his early reliefs like *Bottle* (1913), and then on to his abstract corner and counter reliefs as well as his celebrated model for the *Monument to the Third International* (1919-20). Three years later, in 1965, Flavin looked back on this Constructivist project as the newfound basis of his own "proposal":

This dramatic decoration has been founded in the young tradition of a plastic revolution which gripped Russian art only forty years ago. My joy is to try to build from that "incomplete" experience as I see fit. *Monument 7* in cool white fluorescent light memorializes Vladimir Tatlin, the great revolutionary, who dreamed of art as science. It stands, a vibrantly aspiring order, in lieu of his last glider, which never left the ground (84).

The statement is suggestive in several ways. Nearly in neo-avant-garde terms (though this concept was not yet available as such), Flavin sees his proposal as a postwar recovery of an "incomplete" project of a prewar avant-garde; by the same token he does not deny the drastic differences in historical conditions.[14] The Tatlin project was part of a revolutionary transformation in art and society alike, and it commemorated a new political order; the Flavin proposal is for a "dramatic decoration," a far more modest ambition, and it pays homage not to an entire society in the making, but to a failed artist who had withdrawn into the romantic vision of his late man-propelled glider, *Letatlin* (1929–31). This recovery, then, connects to a retreat in the Constructivist program, and, like the glider, the fluorescent pieces do remain at the threshold between the aesthetic and the utilitarian, the virtual and the real.

This tension between the illusionistic and the actual runs deep in modernist art, where it might attest to the old antinomy between idealism and materialism in modern culture at large.[15] The tension is in play, for example, in Constantin Brancusi, who, along with the Russians, was a signal precedent for the Minimalists (Flavin dedicated his breakthrough piece, *the diagonal of may 25, 1963*, to

Vladimir Tatlin, model of the *Monument to the Third International*, 1919–20. Wood. Photo © The Museum of Modern Art/Licensed by SCALA / Art Resource, NY.

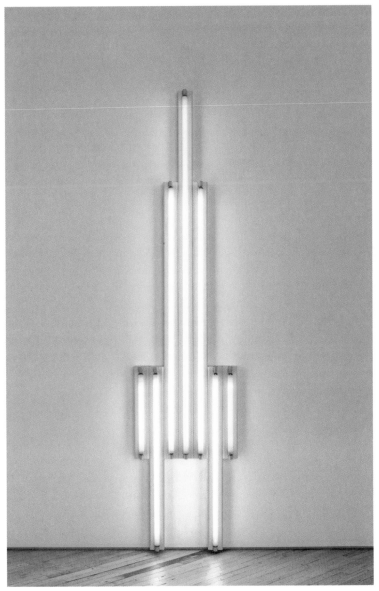

Dan Flavin, *"monument"* 7 *for V. Tatlin*, 1964. White flourescent lights. 10
feet high. Photo Billy Jim © 2010 Stephen Flavin/Artists Rights Society (ARS),
New York; courtesy of David Zwirner, New York.

the Romanian artist); it is also in play in another key predecessor, Jackson Pollock, especially in the drip paintings that starkly juxtapose the opticality of line and color with the materiality of paint and canvas. Of course, some artists, such as Morris Louis, elaborated the optical term in Pollock, while others, such as Allan Kaprow, developed the material term, while still others, such as Flavin, attempted to do both at once.[16] The tension between the illusionistic and the actual is also immanent in the two models of the object with which Flavin associated his art: "the icon" and "the fetish." Of course, his interest in these categories was hardly novel—among others, Tatlin and Malevich were drawn to Russian icons, and Picasso and Matisse to African fetishes—but Flavin inflects them in distinctive ways. He used the first term as the rubric for his early paintings with attached lights: "I had to start from that blank, almost featureless, square-fronted construction with obvious electric light which could become my standard yet variable emblem—the 'icon'" (87). Less often he applied the second term to his fluorescent lights, which he called, in an apparent oxymoron, "modern technological fetishes" (87).

In her book on the Russian avant-garde, Gray illustrates, near the Tatlin reliefs, a late-fifteenth-century icon, a *Descent from the Cross*, which she attributes to the "Northern School of Russia." Flavin bought this book on August 21, 1962 (the purchase is recorded in his notebooks), but he might have looked through it previously, for two or three weeks earlier he had made a trip to the Metropolitan Museum where (as reported in a note of August 9) he experienced an epiphanic encounter with a Russian icon:

> Last week, in the Metropolitan, I saw a large icon from the school of Novgorod. I smiled when I recognized it. It had more than its painting. There was a physical feeling in the panel. Its recurving warp bore a history. This icon had that magical presiding presence which I have tried to realize in my own icons. But my icons differ from a Byzantine Christ held in majesty; they are dumb—anonymous and inglorious. They are as mute and indistinguished as the run of our architecture. My icons do not raise up the blessed saviour in elaborate cathedrals. They are constructed concentrations celebrating barren rooms. They bring a limited light (83).[17]

Russian (Novgorod?) painter, *Christ in Glory*, late fifteenth century. Tempera on wood. 42⅛ x 30⅞ inches. Photo © The Metropolitan Museum of Art / Art Resource, NY.

This rich statement suggests what Flavin needed to "recognize" at this juncture. The icon impresses him with its "physical feeling" and its "magical presence" alike, both of which its very age seems to bear into the present through a "recurving warp." This last phrase points to an experience of historicity that is nonetheless overcome, of an artifact whose distance is declared and surmounted at the same time, precisely because Flavin feels such an affinity with it. Clearly he is taken by the ritualistic power of the Russian icon, as was Malevich before him, or (for that matter) as was Picasso with the African fetish.[18] Flavin wants to recover some of this magic for his art, though he is well aware of the different conditions under which he works: despite his Catholic upbringing (Flavin was once expected to become a priest), there is no "blessed saviour" for him, only "barren rooms." Yet, in a further twist, it is this very duality of the "magical" and the "physical" in the icon that is important to him. For example, of *icon V (Coran's Broadway Flesh)* (1962), Flavin remarked in 1963, "I have tried to infect my icon with a blank magic that is my art" (83).

Perhaps a reading of Tatlin in his own moment will clarify this modernist connection with the icon. "Let us remember icons," the Latvian artist and critic Vladimir Markov wrote in 1914, with early Tatlin constructions such as *Selection of Materials* (1914) in mind. "They are embellished with metal halos, metal casings on the shoulders, fringes and incrustations; the painting itself is decorated with precious stones and metals, etc. All of this destroys our contemporary conception of painting."[19] In this modernist account of the icon, its "physical feeling" (as Flavin puts it) breaks with any illusion of the real world in order to conduct "the people to beauty, to religion, to God" (as Markov puts it).[20] The Tatlin constructions, Markov suggests, retain this anti-illusionism but reverse its thrust in such a way that the viewer is directed not toward a transcendental realm of God but toward an immanent "culture of materials" (as Tatlin calls his Constructivism). Flavin works to hold on to both vectors, the transcendental and the immanent; equally affected by the Novgorod icon and the Tatlin constructions, he positions his work in the space between them, in the intermediate world of "blank magic" that they define.

Vladimir Tatlin, *Selection of Materials*, 1914 (no longer extant). Iron, glass, stucco, asphalt.

A year earlier, in 1913, Markov had also written about African sculptures or "Negro fetishes" (as such sculptures were often called then) as another implicit model, via Picasso, for the new Russian art, and he noted that these very material objects (he describes them as "architectural constructions with only a mechanical linkage") nevertheless carry a profound "spiritual conviction."[21] Here Markov intuits a duality of the physical and the metaphysical that was long a staple of discourse on the fetish, a term used by early modern European traders (first Portugese, then Dutch) for West African objects of worship: for its celebrants (the Europeans believed) the fetish *is* a god, not a representation of one—the divinity resides *in* the thing.[22] When Flavin alludes to his fluorescent pieces as "fetishes," it is this duality of "the physical" and "the magical" that is highlighted.

Again, Flavin holds other dualities in tension, too, such as the utilitarian and the aesthetic: "I can abuse lighting in a sufficiently useful way and still accomplish what I regard as art," he once commented.[23] Supplied by "any hardware store" (91), fluorescent lights were placed in the early 1960s, as they are still today, in workaday spaces: factories, offices, lunchrooms, subways, train stations. (In 1976–77 Flavin installed a row of lights on three platforms at Grand Central Station, where they remained for a decade, unseen as art by most passersby.) Of course, they are also used commercially, in which case the unnatural colors often appear gaudy; in fact, beyond workaday, the lights can be tacky, and Flavin did not shy away from this association either: he once remarked that the fluorescents might evoke "a Brooklyn Chinese restaurant."[24] Sometimes his incandescent icons even suggest a campy side (with its fleshy tint and flashy lights, *Coran's Broadway Flesh* was titled in homage to "a young English homosexual who loved New York City" [83]).

On the one hand, then, Flavin held that "there is no room for mysticism in the Pepsi denigration" (another of his pungent phrases); "my fluorescent tubes never 'burn out' desiring a god" (94). Mel Bochner agreed with this assessment: "Any attempt to posit the objects with a transcendent nature is disarmed by the immediacy of their presence," he wrote in fall 1966.[25] On the other hand, the lights can also be glorious, and the effects ecstatic; Flavin used the latter term in its literal sense of quasi-religious transport (*ex-stasis,* taken out of self,

Dan Flavin, Untitled, 1976–77. White flourescent lights on Tracks 18–19, 39–40 and 41–42, Grand Central Terminal, New York. Photo © 2010 Stephen Flavin/Artists Rights Society (ARS), New York; courtesy of David Zwirner, New York.

out of world). Here, then, is another irony of different associations held together in tension to "disarm" the viewer: evocations of train stations on the one hand and of transcendental spaces on the other (Flavin designed lights for a church in Milan, finally realized in 1997, a year after his death).[26]

Flavin also engages other oppositions, such as materiality and immateriality and immediacy and mediation, oppositions that were in play everywhere in advanced art of the 1960s, and often enough he seemed to speak for both sides. On the one hand, Flavin claimed, "the physical fluorescent light tube has never dissolved or disappeared by entering the physical field of its own light" (91); on the other hand, he admitted, the "brilliance" of the light can "somewhat betray its physical presence into approximate invisibility" (91). Once more Flavin wants to hold the different effects in tension: "Regard the light and you are fascinated—practically inhibited from grasping its limits at each end. While the tube itself has an actual length of 244 cm [eight feet], its shadow, cast from the supporting pan, has but illusively dissolving ends. This waning cannot really be measured

without resisting consummate visual effects" (87). Yet this tension is difficult to maintain, and frequently his works appear less site-specific than site-erosive, with the light so bright as to dematerialize both support and space, to render them "approximately invisible." An "8-foot fluorescent light pressed into a vertical corner," Flavin acknowledged about pieces like *pink out of a corner (to Jasper Johns)* (1963), "can entirely eliminate the definite structure" (87).

This effect leads me to my primary claim: already with Flavin the apparent anti-illusionism of Minimalism begins to be trumped, transformed into an expanded field of illusionism, or, more precisely, with Flavin this trumping becomes available and, for some artists, desirable.[27] This line out of Minimalism, then, moves beyond the frame of painting and off the pedestal of sculpture into a realm less of specific objects than of a pictorial space writ large, bound only by the architectural limits of gallery or museum. From this perspective Flavin does not negate illusionism so much as he extrudes it into space; it is a "reversed illusionism" (as Dan Graham once called it).[28] Such installations of colored light, Krauss wrote as early as 1969, have "the simultaneous depth and physical inaccessibility of illusionistic space" and thus "bear on the conventions of painting."[29] And, indeed, more intensely than any painter, Flavin mixes color in our eyes, and, more boldly than any practitioner of collage or assemblage, he treats actual space as an element in a three-dimensional composition. At such moments in his work the literal does not counter the illusionistic so much as it is subsumed by it, and Flavin can be taken to prompt not only an utter abstraction of the pictorial (this was largely achieved by Pollock and others) but its outright atomization.[30] If Minimalism is "neither painting nor sculpture" for Judd, it begins to be both-and with Flavin, with each category transformed in the process—painting pushed to the optical, and sculpture to the spatial.[31] This revises the common understanding of Minimalism fundamentally, for, if seen thus, it inaugurates not only a move from illusion *into* space but also a refashioning of space *as* illusion. And yet, though Flavin points the way here, he does not follow it, at least not fully.[32]

"As I have said for several years," Flavin wrote in 1966, "I believe that art is shedding its vaunted mystery for a common sense of keenly realized decoration. Symbolizing is dwindling—becoming

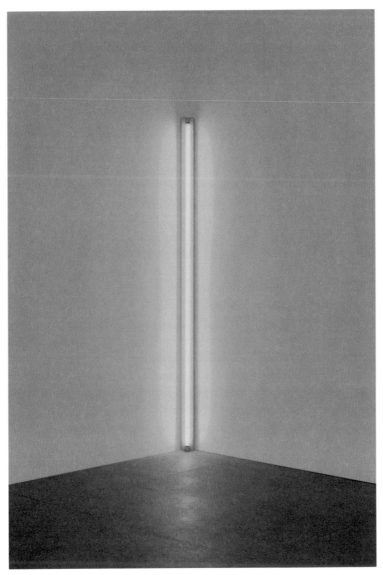

Dan Flavin, *pink out of a corner (to Jasper Johns)*, 1963. 8-foot pink fluo-
rescent light. Photo Billy Jim © 2010 Stephen Flavin/Artists Rights Society
(ARS), New York; courtesy of David Zwirner, New York.

slight. We are pressing downward toward no art—a mutual sense of psychologically indifferent decoration—a neutral pleasure of seeing known to everyone" (89). Eccentric though Flavin could be, here he conforms to central tendencies in neo-avant-garde practice: toward the anti-auratic and the anti-symbolic, the indifferent and the neutral—in short, toward a zero degree of art. However, as we have seen, he did not want to shed "vaunted mystery" altogether; nor was "decoration" a slight to him, as it was to most abstract artists from Kandinsky, Mondrian, and others in the 1910s and 1920s to Greenbergian painters like Morris Louis and Kenneth Noland in the 1950s and 1960s. For decoration is valued negatively only if abstraction is pledged absolutely to medium-specificity and/or aesthetic autonomy, and for Flavin it was not. "At times," he said of his icons, "they may be lamp blocks losing their identity to a greater ensemble"; and of his fluorescents he commented, "the lights are integrated with the spaces around them" (82, 89). For Flavin, art as decoration hovered not only between use and non-use but also between discrete work and architectural ensemble.

This is one reason that Flavin refused any connection with "the term 'environment'": "It seems to me to imply living conditions and perhaps an invitation to comfortable residence. Such usage would deny a sense of direct and difficult visual artifice" (95). Despite his move into actual space, then, he wanted to retain the punctual intensity, the emphatic presentness, of late-modernist painting: "I intend rapid comprehensions—get in and get out situations. I think that one has explicit moments with such particular light-space" (95). And, for good and for bad, his conception of art as decoration does offer the optical effects of a late-modernist painting by Jules Olitski, say, or Larry Poons in the spatial medium of colored light, along the lines that Irwin, Turrell, and others would also pursue: "Regard the light, and you are fascinated."[33]

Flavin achieves this presentness through the brilliance of his lights, to be sure, but also through the structure of his arrangements. In the style of the period he associated his "system" of regular units with language, and in contradistinction to much Minimalist art he insisted that it was not durational in effect: "it is as though my system synonymizes its past, present and future states" (90). This is a strong

claim, but it is mostly borne out: even though our perception of a Flavin fluorescent changes in time (as we walk about it, as its colors irradiate one another, and so on), it appears to be present all at once, and, as an arrangement of units, each work can be understood as implicit in all the others, too. Two of his terms for this mode of appearance are "declaration" and "divulgation"; the latter is another term that evokes a semi-religious "revelation" (importantly, to the *vulgus* or common people). In some ways, then, the intensity of this presentness is at odds with the ironies of his art noted above: whereas intensity "fascinates," irony keeps us on edge, even off balance, looking, thinking, moving.

Suspicious of "environmental" art, Flavin was contemptuous of "technological" art, which, in 1967 (in the heyday of enterprises like "Experiments in Art and Technology"), he dismissed as so many "concoctions of theatrical ritual, of easy, mindless, indiscriminate sensorial abuse" (93). In particular he decried "a quasi-fetishistic reverence for technological emanations [presented] as art itself" (93).[34] Yet clearly there is a technological dimension in his work, too, which, again, Flavin also aligned with the fetish: "A common lamp becomes a common industrial fetish," he wrote in 1964, "as utterly reproducible as ever but somehow strikingly unfamiliar now" (83).

Less religious than commercial, the fetish evoked here is the commodity fetish, which, in the Marxist account, we endow with a power that it does not possess because, separated as we are from its production, we do not understand its workings. The difference between his two inflections above is that the fluorescent lights are "industrial fetishes" that, though "unfamiliar" as art, are familiar as objects, while the "emanations" of technological art, because they are obscure in manufacture, effect a "quasi-fetishistic reverence" (Marx wrote of the commodity in similar terms in *Capital*). In a sense the difference is between "blank magic" and black magic, and once more Flavin seems to want it both ways: a defetishized object that is transparent in production (another Constructivist desideratum, as we saw with Richard Serra) and a fetishistic object that is magical in effect. Perhaps Flavin sensed a common ground with viewers on both counts, with his fluorescent pieces at once readable as "common lamps" (as with the self-evident

materials in Tatlin, say) and consumable as "reproducible fetishes" (as with the mass-produced images in Warhol, say).

What does all this have to do with the catastrophe of Minimalism mentioned at the outset? I mean the term in its etymological sense, as a down-turning (*kata-strophe*), which is to say, less as an outright disaster than as a problematic redirection. In my view such a catastrophe of Minimalism follows on Flavin with Irwin, Turrell, and others. This is not to deny the powerful effects of these artists, only to suggest that they elaborated Minimalism in ambiguous ways, especially in the categories of "environmental" and "technological" art that disturbed Flavin.[35]

Robert Irwin, Untitled, 1962–63. Oil on canvas. 83 x 84 inches. Photo © Albright-Knox Art Gallery / Art Resource, NY © 2010 Robert Irwin / Artists Rights Society (ARS), New York.

Even as the Minimalist work might open on to ambient space, its material definition is clear enough. Not so with Irwin: even his initial paintings in this optical mode—such as his near squares of monochromes divided by thin horizontals (1962–64) and made up of small dots (1964–66)—tend to dissolve the physicality of both surface and support. To recall the distinction posed by Judd, Irwin is interested in the phenomenon more than the object, and the two soon fall out of tension in his work. Indeed, like Turrell, Irwin pursues the phenomenon to the other side of painting and object alike, where both are diffused into light and space.[36]

Trained as a painter, Irwin pursued the modernist critique of the pictorial logic of figure and ground—in his own words, of the "abstract hierarchy of mark, frame, and meaning"—to the point of a break with painting as such.[37] This trajectory can be traced in the passage from his early line and dot paintings, through his haloed disks in painted aluminum or plastic (1965–69) and his prismatic columns in cast acrylic (1969–70), to his many installations, both interior and exterior, over the last four decades. For Irwin this move was driven by the philosophical imperative not to "mix up the *objects* of art with the *subject*—'art.' "[38] Further, he understood this subject of art not in epistemological terms (as some Conceptualists did) but in phenomenological terms (as most Minimalists did). "The nexus of modern thought," Irwin states, is "being phenomenally in the world as an active participant," such that "the *one pure subject of art*" is "the nature and infinite potential of human beings to see and to aesthetically order the world."[39] This became his own goal: "I was after a first order of presence," Irwin once commented, and in his view his select predecessors— "Husserl's phenomenological ground, Malevich's pure desert, and Reinhardt's art-as-art"—were so directed as well.[40] Here, in effect, Irwin rewrites modernist abstraction as phenomenology *tout court*, and this rewriting throws the import of the art event utterly on to the viewer, who is "actively charged with completing the *full intent* of the work of art—*experientially*."[41]

Already in 1966 Phil Leider saw the risks of this project (even as he also supported it): the object of art might disappear in the pursuit of its "pure subject," and the critique of the pictorial might lead,

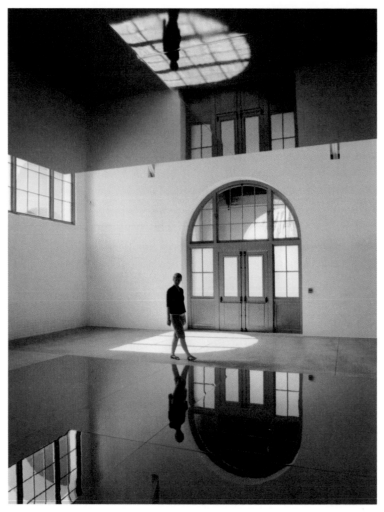

Robert Irwin, *Who's Afraid of Red, Yellow & Blue*, 2006–07. Urethane paint over lacquer on aircraft honeycomb aluminum. Six panels, each ca. 16 x 22 feet. Photo © 2010 Robert Irwin / Artists Rights Society (ARS), New York.

paradoxically, to "the reintroduction of an ambiguous, atmospheric space."[42] Advanced by Irwin, these two possibilities came to pass with Turrell. "This is not Minimalism and it is not Conceptual work," he once commented of his art; "it is perceptual work." And further: "There is no 'object' because perception itself is the object."[43] A student of psychology long interested in Gestalt theory (especially its technique of *Ganzfeld* or "entire field" perception), Turrell began with "projection pieces" (1966–69) that cast light across a corner of a gallery in such a way that a cube seems to hover there. He then followed with "shallow space constructions" that produce screens of colored light through slight openings in gallery walls backed by oblique planes that are brilliantly illuminated—and almost impossible to locate as a result. These installations, which soon became immersive, appear to exist less as fixed entities than as spatial phantoms projected by our retinal apparatus and nervous system. In this way Turrell tends to reverse the Minimalist move to produce delineated spaces and reflexive viewers; rather, his environments often disorient us, even overwhelm us, with the very apparitions we seem to call into being. This diffuse aestheticism has great appeal, but it can also be seen as a sublimated abstraction of luminous forms of mediated spectacle on offer elsewhere in contemporary culture, and the appreciative response of most viewers is not too distant from the "quasi-fetishistic reverence for technological emanations" that Flavin questioned.

Like Irwin, Turrell understands the aesthetic in the original sense of its Enlightenment definition—that is, as a "science of sensitive knowing" vis-à-vis the natural world at large.[44] Phenomenology is also concerned with our perception of this world, and the pursuit of the aesthetic beyond the given mediums of art renewed interest in this philosophy. In phenomenology the world is bracketed in such a way that what is primary in our experience comes to the fore. Yet the spaces engineered by Irwin and Turrell for such perception are entirely artificial, and "sensitive knowing" in this context is utterly mediated. The danger here is not only to dehistoricize the aesthetic (this might be intrinsic to the category) but also to render the phenomenological faux—indeed to replace both the aesthetic and the phenomenological with ersatz versions in which perception is, as it were, done for us.[45] This is to suggest, again, that a reversal

occurs here. In principle these installations are pledged to our experience: "An experience is not framed so much as a situation is made in which experience can be created," Turrell insists; and he conceives this experience in expressly phenomenological terms: "As you plumb a space with vision, it is possible to 'see yourself see.' This seeing, this plumbing, imbues space with consciousness."[46] Yet, as it does so, Turrell also claims, the space becomes "like an eye": "Space has a way of looking. It seems like it has a presence of vision. When you come into it, it is there, it's been waiting for you." The "situation" thus switches from the reflexivity of "seeing yourself see" to the alienation of "space is somehow seeing."[47]

Historically, interest in phenomenology intensifies when perception is pressured by developments in technology and media. "He manages above all to stay clear of that experience from which his own philosophy evolved or, rather, in reaction to which it arose," Walter Benjamin remarked of Henri Bergson, the philosopher of *élan vital* much acclaimed in the early 1900s (and again today). "It was the alienating, blinding experience of the age of large-scale industrialism. In shutting out this experience, the eye perceives a complementary experience—in the form of its spontaneous afterimage, as it were."[48] A similar argument also holds for Edmund Husserl, whose famous *epoche* or "phenomenological reduction" seems all but designed to bracket such conditions as "large-scale industrialism," or, indeed, for Heidegger, who insisted on a primordial order of being against the "world picture" that modernity had put in its place (at least he was explicit about his reaction). Finally, Merleau-Ponty, the greatest phenomenologist after Husserl, can be seen to respond, also in a complementary, even compensatory manner, to the imminent rise of consumer society and media culture. Explored by Pop art, this world is suspended in his phenomenological approach, which was key to some Minimalists (who read his *Phenomenology of Perception* upon its translation into English in 1962). Also influenced by Husserl and Merleau-Ponty, Irwin and Turrell bracket this mediated world, too, but to the extent that they do so their art might also be its "spontaneous afterimage"—an emanation of the very technology that they both exploit and efface.[49]

We might grasp what is at stake here, aesthetically and politically, by recourse to a famous anecdote told by Tony Smith in 1966; a

primal scene in discourse about Minimalism and its aftermath, it concerns a nighttime ride on the unfinished New Jersey Turnpike in the early 1950s. Smith recounts his strange exhilaration in this dark landscape, which he deemed artificial but not-quite-artistic, "mapped out but not socially recognized."[50] His was an aesthetic feeling, he is confident, but one beyond any feeling produced by a painting or a sculpture: "There is no way you can frame it," Smith remarked, "you just have to experience it."[51] Anticipated by the vast freeway in New Jersey, this expanded field of art is accomplished with such massive projects as the Roden Crater in Arizona fashioned by Turrell. Certainly this field seems to be well beyond the pictorial and the sculptural—but might these categories only be extended here in an apparently frameless *beyond*, an immense space of rarefied pictoriality that is technologically manufactured in order to appear perceptually pure? Such spaces do not exceed the conventional frames of art so much as they stretch these frames beyond our capacity to locate them, with the effect that we stand *within* a pictorial-sculptural field write large, positioned there as both subject and object, framer and framed in one.[52]

Intentionally or not, the Smith anecdote rehearses the two-step operation of the sublime as formulated by Kant in *The Critique of Judgment* (1790): a first moment in which the subject is overwhelmed, emotionally, by the sheer scale of the scene or force of the event, followed by a second moment in which the subject recoups, intellectually, such feelings of awe and dread and, in this recouping, enjoys a great rush of personal power.[53] Yet, in the art under discussion, this sublime is highly constructed, often supported by intensive interventions of capital, technology, and labor that serve to aestheticize the natural and to naturalize the aesthetic. However, for the most part, these interventions are played down, or even made to disappear, with the result that the prepared scene appears immaculate to us and we immediate to it.[54] In this regard the second moment of this aesthetic techno-sublime recalls "the oceanic feeling" once described by Freud as a "limitless narcissism in the guise of a loss of ego," wherein the ego communes with its own exhilaration, which it mistakes for the grandeur of the art.[55]

In search of correlatives of his experience on the turnpike, Smith mentions "abandoned airstrips in Europe" and then, without a

hitch in his discourse, a "drill ground in Nuremberg large enough to accommodate two million men."[56] I mention this allusion not to contaminate the expanded field of art after Minimalism with the stagings of Nazi spectacle, but to point to the political manipulations of the sublime in twentieth-century history at large. Intimated here is that the expanded field of aesthetic experience cannot be removed from such spectacles as Fascist rallies, which Benjamin already described in terms of "the artistic gratification of a sense perception altered by technology."[57] In short, Smith allows us to glimpse that the crux of Minimalism prepared not only a progressive desublimation of painting and sculpture into practices that open on to actual space and everyday life, but also a problematic resublimation of the pictorial and the sculptural—a resublimation in which conventional frames of art might be transgressed in a first moment, only to be replaced by mediated formats that appear transparent in a second moment. Again, what is thereby delivered are sensations of intensity that, though once novel in the realm of art, have become almost normative in spectacle culture at large, to which such art, whatever its intentions, serves as an alibi or ally.[58]

Benjamin already noted the effect of immediacy-through-mediation in the cinema of the 1930s: "The equipment-free aspect of reality here has become the height of artifice."[59] With many advances in image-technologies, this effect has become all the more complete since his time. To its credit, some of the art in question here works to engage this cultural given rather than to evade it, but, again, its immersive installations, in which body, image, and space often seem to exist in one continuum, tend to purify the artifice rather than to redirect it. Implicit in Flavin, this effect is furthered by Turrell and others who offer an experience of great immediacy achieved through a process of intensive mediation. Benjamin termed this artifice-reality the "blue flower in the land of technology"; he also called it "dream kitsch."[60] If Turrell is one master of this mode, another is Bill Viola, whose image installations work to convert video into a medium of spiritual transformation. Viola might expose his technological set-ups, but he does so in the service of his blue-flower effect, not in opposition to it. Another master of this mode is Olafur Eliasson, whose immersive environments aim to render natural and technological worlds all but

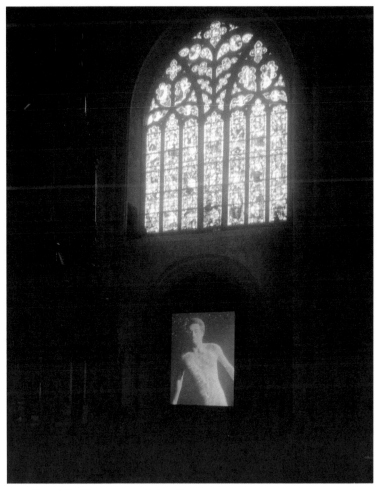

Bill Viola, *The Messenger*, 1996. Color video projection with amplified stereo sound. 25 x 30 x 32 feet. Durham Cathedral. Photo Kira Perov.

synthetic—or rather, to demonstrate that this condition is already the case, that nature is but a "weather project," and that phenomenological experience is now given as mediated.[6] Eliasson also reveals the construction of his environments, but this "alienation-effect" or "laying-bare of the device" now contributes to the artifice, just as our participation now contributes to the spectacle, rather than the

Olafur Eliasson, *The Weather Project*, 2003–04. Multi-media installation.
Tate Modern, London. Photo © Tate, London / Art Resource, NY.

opposite. In such work binaries that have structured our discourse
on art since Minimalism—of the illusionistic and the literal in Judd,
or the absorptive and the theatrical in Michael Fried, or even the
participatory and the spectacular in subsequent criticism—appear to
collapse or to be otherwise undone.[62]

BUILDING *CONTRA* IMAGE

Hal Foster: *Almost from the beginning you have oriented your various interests in relation to "sculpture." Why?*[1]

Richard Serra: I think I can tell you. I started making my props. How do you hold something up against the wall? How do you use something on the wall to hold up something coming off the floor? How do you lean a couple of things together to make them free-stand? There weren't any precedents for the props; they didn't come out of "the specific object." I had done rolls of lead on the floor; I understood I could take material, roll it up, and it'd still be an object even though it was primarily about its own making. Minimalism was completely divorced from process, whereas I was interested in manifestations of making, looking, and walking.

In a sense all the early props have a relation to the body in terms of balance and counterbalance; they're an abstract reference to the body. Then I got to making *House of Cards*: even though it seemed it might collapse, it was in fact freestanding. You could see through it, look into it, walk around it, and I thought, "There's no getting around it, this is sculpture." I understood what my responsibilities were. If you say you're an "artist" you can do lots of things; you

don't have to pin yourself to any one tradition. I know that's a very conventional thing to do: to say "I'm a painter" or "I'm a sculptor." But, as a young visitor in Paris, I didn't sit in front of Giacometti every night at La Coupole, or go to Brancusi's studio every day, for nothing. I was empowered by them. And so after making the *House of Cards*, I knew it was a sculpture—I couldn't play around anymore. It wasn't a question of neither/nor.

Did you feel that the weight of tradition in sculpture was not as heavy as in painting—that it might give you more room to move?

Yes, I thought it was wide open. I didn't want to make sculpture as it was before, but having developed an understanding of tectonics, I thought I could make *my* sculpture.

Apart from points of reference in Giacometti and Brancusi, were there resources for you, say, in David Smith or Mark di Suvero?

No. Andre was important for me, mostly because he didn't join his modules; they were just butted up. One day I said to Carl, "Why don't you get those things up off the ground?" and he said, "Don't worry, Richard, somebody will." And I thought, "OK, I will." That's how it happened.

At that point you were already interested in sculpture as an analogue to the body in terms of balance, counterbalance, compression, friction ... What happened when you put the plate in the corner in Strike?

Strike came after *House of Cards*; it was my break into space. I realized if I wedged a plate into the corner, it would be free-standing. So I got a plate eight by twenty-four feet, and that was *Strike*. It declared the whole space in dividing it, and I realized I could hold the room the way Flavin did, only do it with my own material. But it took me a couple of years to catch up to that implication.

When you began to do the props, you were attending dance perform-
ances at Judson Church. Did it help you to understand the dynamic
play of forces in your own work?

Yes. In that dance one figure would fall and another would catch
and hold him or her. I saw things—in terms of movement and equi-
librium, stasis and balance—I could use in my sculpture. And I was
faithful; I watched it all.

What is extraordinary is that your claiming of sculpture—your
move of picking up the Andre, as you say, and activating the ambi-
ent space—was also potentially a dissolving of sculpture into that
space, into a field of process, movement, time. It is as if the recov-
ery of the sculptural activates the field and this in turn scatters the
sculptural, at least as understood in the traditional sense of the
object alone.

What happens is once you get the sculpture off the ground and free-
standing you want to open up the field. And that took me a couple
of more years.

Once you pulled sculpture up in the props, why pull it apart as well?

When I first lifted plates off the ground, I realized that was also a
limitation, and there was a need to pull them apart, but I didn't know
how. It didn't happen until *Strike*; *Strike* showed me how to cut into
space.

Is that where your trip to Japan in 1970 and your encounter with
Zen gardens comes into play?

Yes, that was enormously important. The gardens open up a percep-
tual field; they made me rethink the undifferentiated field of Pollock
and Anton Ehrenzweig. Most important is the time of the field and
your movement through it: it's a physical time. It's compressed or
protracted, but always articulated; sometimes it narrows to details,
but you are always returned to the field in its entirety.

Can you describe how you processed that experience in Japan? Clearly your work was headed in that direction, but you looked at other artists, too—at Robert Smithson and Michael Heizer. How did those factors come together?

When Smithson and Heizer began doing earthworks, they asked me to join them; I was interested in their work, but it wasn't for me. I saw Heizer as extending Judd's volume into the landscape, and I saw Smithson as dealing with his peculiar iconography of geology, crystallography, and all the rest. I helped him lay out *Spiral Jetty*, and after he died I helped to finish *Amarillo Ramp*. But for the most part earthworks are about a graphic idea of landscape, and I was more interested in a penetration into the land that would open the field and bring you into it bodily, and not just draw you into it visually. What interests me most about landscape is elevation—what happens to your body when the elevation is shifting and there's no horizon to orient you, no flat plane. How do you cut into it, gather the land in a volume, and hold that volume? How do you make walking and looking the content?

That interest has persisted, and you've developed a language of forms to articulate those volumes in different ways in different sites. Did your films clarify this sculptural language for you?

I never understood the idea of "sculptural film." I saw my films as separate investigations, and to say "sculptural film" is like saying "sculptural architecture"—it just doesn't ring true to me.

But surely "sculptural architecture" exists; you mean it's not true to either sculpture or architecture?

Right. In film you have the materiality of the light, the celluloid, the projector, and the frame. Those are the productive limitations of the medium. You might be able to find metaphorical analogues for them in sculpture, but that's all.

Could it be that these different mediums are specific but that they also help to define one another, and that you can learn things about

Hand Catching Lead, 1968. 16 mm black and white film (30 ½ minutes).

sculpture as you make film, and vice versa—or do you see them as entirely separate?

I think everything feeds into everything else, but I don't think one investigates film to make sculpture or the reverse. Although that doesn't mean the investigations are entirely separate, I've never thought they had that much to do with each other. On the other hand, I made *Hand Catching Lead* because someone said they wanted to do a film about the installation of *House of Cards*, and I thought *Hand Catching Lead* would be a better way of giving people an idea of propping a piece together: you either catch it or you don't, you either get the equilibrium right or you don't. But I didn't think of the film as sculpture, nor did I think anyone would see the film in any relation to *House of Cards*. If everything that's not painting or photography has now come to fall under the rubric "sculpture," well, that's a different problem. In sculpture you can't get away from certain things: material, mass, weight, gravity, balance, place, light, time, movement. They're givens, and how you deal with them defines what you make.

Right, but some of those qualities are shared by other mediums and practices.

Maybe light, maybe time, but very few.

Yes, few are shared with film, but more are shared with architecture.

Sure, there are more comparables there.

At least since the Renaissance sculpture has been subordinate to painting in theories of art; it was throughout modernism, too: the dominant models of art are articulated in relation to painting, even when it seems to be antagonistic, as in Minimalism.

It's still seen as secondary. I might just be the odd figure who has produced a large body of work. It might empower some other sculptors, but you don't know whether it'll lead to any resurgence of sculpture per se.

Here's the paradox for me. You've made sculpture more specific, more powerful, in part through a differential engagement with other practices: your work opposes painting in the sense of the pictorial, you say it's quite different from film, it draws on some aspects of architecture and contests others . . .

That's about keeping your mind nimble. Getting caught in your own dictates and polemics doesn't allow you to make new moves. Interest in other fields keeps you flexible. Smithson was a genius at bringing different investigations into his art. You have to keep abreast of a lot of things; you have to be inquisitive.

At the same time you're precise about other practices. For example, your work is not about mixing sculpture and architecture; it's about understanding what structural principles they might share, and developing them in sculptural terms.

Tectonics is implied in the form-making principle of sculpture, first in terms of the base, or, if you don't use a base, in terms of how to get a given material off the ground. Then the question is how do weight, mass, and friction work. I have an advantage because I caught rivets and put up trusses as a kid working in steel mills. I knew enough about the industrial procedure, and I knew I could bring it into making art. Importing new models into a conservative practice always gives you an advantage. Warhol did it; so did Barbara Kruger.

You've discussed elsewhere what you've drawn from industrial engineers and modern architects—John and Washington Roebling, Robert Maillart, Mies van der Rohe . . .

Hans Scharoun too. When I first went to Berlin in 1977, I visited his library and philharmonic hall. He became important when I had to deal with volume, in an open field, in relation to a curve. Scharoun was a big influence, as was Frank Lloyd Wright's Guggenheim Museum. Not much had been done with curves in modernism. In fact, when *Tilted Arc* went up, the most startling thing about it was not that it took over the plaza but that it was a big curve. One

St. John's Rotary Arc, 1980. Weatherproof steel. 12 x 180 feet x 2 ½ inches.
Installation at Holland Tunnel exit, New York, 1980–88.

reason to build *Tilted Arc* in the Federal Plaza and *Rotary Arc* at the
Holland Tunnel was that I wanted to see and understand the differ-
ence between a concavity and a convexity. When you face a concave
shape, the whole breadth of the curvilinear volume opens up in front
of you; but once you walk around the edge it changes to an opaque
convexity that reveals itself only through walking—you can't see the
openness of the field or how the volume sucks into it. Just turning
the corner opens up another world: that interested me, and it didn't
appear to be critical in architecture. Maybe there was a concern with
curves in the 1930s, but in design more than in architecture . . .

*Was this when you became interested in Baroque architects like
Borromini?*

No, that's later; that happened just before the ellipses. On a trip in
1991 I saw Romanesque churches in France; that was important.

Another crucial experience—I have notebooks full of drawings—was Le Corbusier's Ronchamp, which I first visited in the same year. The solid and the void really are one there. You understand that the space is holding the walls and vice versa, that it's one field; you're in a volume unlike any you've been in before, and it affects you physiologically and psychologically in a way that nothing else has. I thought if architecture could do that, so could sculpture. But that was the first architecture I'd ever experienced that achieved it in terms of volume. Ronchamp is small, but you don't sense it or remember it as small. It has enormous volumetric presence, which comes in part from the pierced walls and the way they let the light in. When I was in Europe in 1966, I hitchhiked from Athens to Istanbul, where I saw the Hagia Sophia. There was a physicality to the light in the space; it was so palpable you could almost touch it. I didn't experience that sensation again until Ronchamp.

I made another trip in the mid-1980s to see the Mozarabic architecture around Madrid. It's built of ponderous stone with small openings letting the light in to illuminate the volume in very directed ways. The space of that architecture, its compression, the way the light holds the field, all that is there, too, in Ronchamp. You get a whiff of these things, and you want to stay on the trail because it's feeding you in a way that nothing has before.

What's the relation between the industrial model you brought into sculpture and your interest in these other traditions of building— the Hagia Sofia, the Romanesque churches, the structures in Spain, Ronchamp? Is it all about different tectonic principles?

You have the principles, and then you have their effects. What is the effect of a structure whose wall is punctured in a way that illuminates the volume so it can hold as palpable space? It might be how the light comes in, it might be scale or how the walls curve. There are many formal aspects that articulate space. A lot of things come into play; it's not only tectonics. Basically, what I've always done is ask, "What is it that I'm looking at that I don't understand, and why don't I understand it?" Often I'm very slow to read work, my own and everybody else's. I have to go back and look again and again.

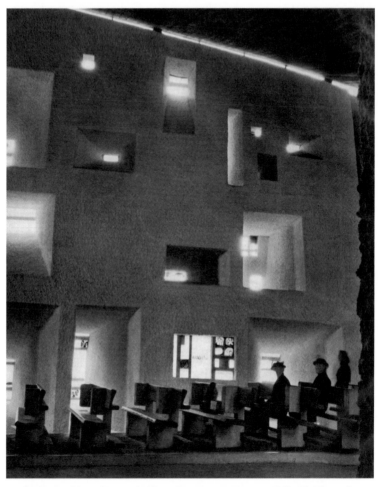

Le Corbusier, Notre-Dame-du-Haut, Ronchamp, France, 1950–54. Photo ©
FLC/ARS.

It's true of language, too. Often I don't trust my initial grasp: the
immediacy of that grasp doesn't allow you to penetrate what you
don't already know.

What about the frame of your work as it has changed over time?
When you, along with others, brought an industrial scale into art, that

tested the architectural parameters of the gallery and the museum. Yet, as we move toward the present, museums have trumped that scale, and there are many spaces, like Dia:Beacon, that are renovated factories or warehouses, where the fit between industrial-strength art and architecture becomes almost too perfect. How do you feel about that development?

Most of that work was built in loft spaces to begin with; then galleries opened in industrial warehouses as surrogates of the loft spaces; then collectors like Count Panza realized you could take that entire container, package it, and put it up somewhere else. So by refining the container you ended up with another container that was transportable and marketable. They found a way of defusing our first thrust, and as a result it was no longer as vital. Are places like Dia:Beacon a cooption of the 1960s in that way? Yes and no. For if those spaces didn't exist, the work wouldn't be seen.

Here's another way to view the relation. Your generation came along to contest an artisanal idea of art with industrial materials and methods, just at the moment when the industrial order had begun to rust, at least in the United States. Later your industrial work is positioned in old warehouses refitted as art galleries and museums, just at the moment when postindustrial economies become more important. So, if your work once broke with the old craft order with its industrial means, those very means might now be understood to question the new electronic regime. How do your industrial commitments jibe with your use of computer-aided design?

We still make models; then they are generated in the computer; and then it's back to the models. We seldom work directly out of the computer. Inventing forms is not dependent on software. In any case, the computer is just another tool, and it has become part of the industrial process, too.

Your recent work also speaks to a different kind of spatiality, less rectilinear, more immersive—a spatiality distinct from the clarity of

most industrial structures or the transparency of some modernist buildings.

Industrial space was largely defined by the frame and the grid. Contemporary space is much looser, smoother, faster—about movement rather than framing.

How faster?

It's more related to skin, to surface, to extension. Our first relation to a lot of new architecture is to its skin. That's a big difference.

Spectacular tectonics? Today, as you suggest, there's a fetishization of the abstract skin. That's what "Minimalist" seems to mean to many people today, which is almost the opposite of what it once meant.

Yes, whereas I'm still interested in the skin turning into the volume, in the skin returning you to the space of the void. I want to hold the field by using the speed of the skin. I still want to have the weight, but not as the first manifestation of the piece. The best example—and it might be a step back to go forward—is *Wake*, now in Seattle. Each module is identical and comprised of two S-sections which are inverted in relationship to each other. As the S-sections lock together, the concavity and convexity of one side lock to the convexity and concavity of the other side. The only prior piece like it is *The Union of the Torus and the Sphere* at Dia:Beacon where sections of a sphere and a torus lock together to create a space that's concealed, not revealed, as you walk it.[2] I installed this piece tight in its room so you can't quite grasp the field as a whole and are forced against the surface of the sculpture. The five elements of *Wake*, on the other hand, are set in an open field. What's important is your moving between them, through them, and around them as they undulate; it's your body moving in relation to their surface that moves.

You can say that's a return to an old notion of the Baroque; but whatever it is it takes you into the field, into the interstices between

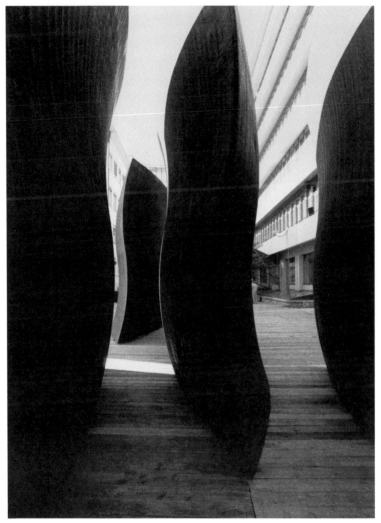

Wake, 2003. Weatherproof steel. Five parts, each made of two torus sections, ca. 14 x 48 ½ x 6 ½ feet by 2 inches. Sculpture Park, Seattle Art Museum.

the pieces, and allows for flow and movement, and it doesn't reduce to any imagistic awareness or Gestalt; you never know the configuration. That brackets my torqued pieces, most of which are still vessels.

So you have pushed your shapes in order to suggest a contemporary shift in space, but you still allow us to see how those spatial effects are produced.

In the industrial period space was mechanized, broken down into units of labor, and those units all had a function in production. When I brought the industrial process into my work, I brought in the effects of labor, not the image. When people think of industry they think of structures like the water towers photographed by the Bechers—the language of industry. I'm not involved with that language in that way; I'm involved with procedures of industry. And sometimes, in seeking to make what I want to make, the procedures have to be changed, or at least the tools. Occasionally the fabricators profit from those changes in that they enable them to contract for jobs they were not equipped to do before.

If the spatiality of your recent work isn't gridded, modular, and so on, you still don't plunge us into a fluid space either, as much installation art does; you don't rehearse that delirious spatiality. In a way you went back to the Baroque and other sources to understand what a non-classical, non-modern, non-transparent space is like in order to reflect on its return in the present. Yet you don't leave us there: you provide some distance for us to consider its effects.

I thought only a sculptural language could do that; certainly architecture wasn't doing it. My foundation is industrial process, but so is architecture's, though it is often hidden there. Buildings are often more interesting to me before they're clad. I'm not saying structural integrity *is* authenticity—that's not my polemic—but people can recognize when surface is not coming from structure: it looks superfluous, even frivolous. And I still believe that material imposes its form on form; that's why it's important for me to stick with materials I understand. That wasn't always true of the Minimalists.

I took the Minimalists too much at their own word.

You mean you believed the literalist dogma? I think we all did; we all read Minimalism through its language. But then it became important for my generation to find a way around it.

The literalist line remains very important: it allowed for a genealogy of work that opened out to actual space, as in your work, as well as to other notions of site—institutional, discursive, and so on. But what I always took to be a secondary line—an art of light-and-space phenomena à la Robert Irwin and James Turrell—has become dominant (and here perhaps Flavin returns as a problematic progenitor) as more and more art wants to create a condition of immersion, an experience of intensity. Your work also speaks to that tendency, but, again, at a critical remove.

To the optical tendency that engulfs us as heightened theater? The problem with those fluid spaces is you never feel grounded in them, whereas I'm still interested in grounding the viewer in an experience of place. A lot of those spaces just wash over you.

Can you say more about the development of the torqued pieces?

When I began the series of torqued ellipses in 1996 I was concerned less with making a definitive sculpture than with making a body of work. After I developed the first one I wasn't certain of the parameters. Then I built more, and saw the effects of different angles of incline, different lengths of passage, different closures, turnings, and so on. I could construct relationships between major and minor axes, and control the degree of differentiation I wanted to produce. The Bilbao commission gave me the opportunity to summarize how that language developed, and how it plays out.[3]

Did other factors guide this phase of your work?

Once solids and voids became equivocal in creating the sense of space in my work, time became more important, more so than in pieces like *Rotary Arc* and *Tilted Arc*. They had more of a real-time presence because their sites had other patterns, other contingencies, other

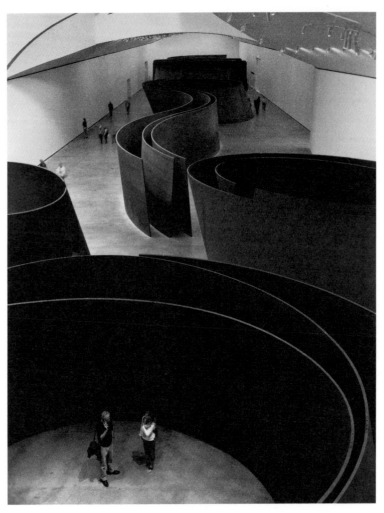

"The Matter of Time," 2005–. Ongoing installation. Guggenheim Bilbao.

realities. As the single torqued ellipses developed into the doubles and then into the spirals, there was more flux in the experience of time. Even as you follow a given path in the spirals, everything on both sides of you—right and left, up and down—changes as you walk, and that either condenses the time or protracts it, making you anxious or relaxed, as you anticipate what will happen next or remember what

Drawing of the installation for "The Matter of Time," 2005.

just did. Time is the focus more than in earlier pieces, which were more concerned with redefining the physical context. That's a big change. And as the pieces become more complex, so does the temporality they create: it's not time on the clock, not literal time. That different temporality—it's subliminal—differentiates the experience of the sculptures from daily experience.

But you once insisted on the continuity between artistic and everyday experience.

You're still grounded in the concrete place of that experience in the recent work; that hasn't changed.

Do you still want the viewer to figure out how the sculpture was made? Given this play with time-effects, doing so seems more difficult.

In the earlier work the structural language could be easily deduced; with the props, the cuts into space, and so on, the logic of the intervention was apparent. In the later pieces it's not as self-evident. I don't know what you can deduce from walking around inside a spiral—not the plan or the elevation, maybe not even the space. Yet the relationships don't seem to be arbitrary. They're just brought to bear psychologically on the viewer in a more intense way than in earlier pieces.

What has made you more open to this psychological dimension? Again, that once seemed to be viewed with suspicion.

You mean by me personally? I came up with Smithson, Bruce Nauman, and Eve Hesse, and we never bought into that part of the Minimalist dogma; I've also never written anything against those kinds of interpretations.

OK, but that dimension is much stronger now than ever before in your work.

Maybe it was always there, subliminally, but never much talked about. Is it there, for example, in *Delineator*, the piece with the steel plate beneath you on the floor and one above you on the ceiling?

Yes, but that is a physical threat more than a psychological effect; the affective dimension of the ellipses and spirals is very different.

Let's approach it another way. If you're throwing hot molten material into the juncture between a floor and a wall, couldn't one infer other things than a formal logic? No one ever has. It's not very far from Warhol having someone piss on oxidized canvas; it's another way of messing with the Pollock tradition.

I understand, but that, too, is very different from the effects of the recent work. In earlier pieces an emotive response was always kept in check by a rational reception—the will to work out the formal logic. Has that changed?

No. Finally, the work is more responsive to its form-making than to anything else. It has to be inventive as form first; if it's not, it's not going to function in any of these other ways, which are attributes. Let me give you an example. If the spirals had been Archimedean, where the spiral turns at a consistent rate outward from its center, they'd be uninteresting experientially, in terms of both space and time. I started out with logarithmic spirals that vary in intervals as they move outward. You have to find a way to transgress forms, to see forms anew. Here the forms are so unexpected you're not taken right back to their logic, to their structure. Did I set out with that goal in mind? Not at all.

Maybe the distinction is that you can still intuit the logic, if not know it.

If you see these pieces from overhead, as you are able to do at Bilbao, then you can read their structures.

You seem more open to the possibility of reading the work as image than before.

I'm still not interested in image. When you look at pieces from overhead you can read their plan and better understand their structure, but their elevation is always partially masked. For the Bilbao installation both the hollow spaces along the perimeter as well as the vault have been shored up, and that has allowed for greater freedom in placing the pieces, in organizing the space into different paths, trajectories, circulations.

So you treat the space as one field vectored in different ways.

Right. In organizing the sculptures in a space I'm more concerned with mapping and circulation than with image. Basically this whole group of work is generated by the first ellipse. When I was asked to do the Bilbao installation, I wanted to keep the language contained to one body of work.

Do you feel that you have exhausted this language of forms, or are there substantially different ones to test out?

There are no closed sequences. You go through many permutations of a problem to choose the solutions that point to the fullest exploration of the problem—at its most extreme, most abstract, and most consequential. This particular body of work spans only six or seven years. It is a cohesive language that anybody can follow.

A lot of people come to your work because they want to figure it out, to keep abreast of it, to see how it might develop further. Even as you challenge them, even overwhelm them, you also . . .

Bring them in on it.

Literally as part of the work, yet not just bodily but also . . .

Intellectually. But that can also sound like I'm becoming a pitch-man for my own narrative. I hope my private experience is not being imposed on them.

Part of it is your engagement with architecture; you provide a way to tease out some things about the built environment—structural principles, spatial effects. And as structure becomes more hidden in architecture, your sculpture still exposes it. You've talked about your relation to modern architecture. What about contemporary architecture?

One of the big problems I see in architecture now is the division between the structure, the more engineered part, and the skin, the more archi-tected part. The architect becomes the person who focuses a little on the layout and a lot on the ornament, whether it's glass, titanium that bends, or scenographic surface, while the structure is handed over to the engineer. That wasn't the case with, say, Jorn Utzon in his Sydney Opera House: there you still have the architect and the engineer of one mind, and there's a clarity to the building that takes everyone's breath away. But the division becomes problematic with postmodern archi-tecture, and more and more architects are limited to the design of the ornament as skin. (There are exceptions, such as Koolhaas's library in Seattle where the glass surface is tectonic.) The difference is that in my work the structure and the skin are one and the same.

Do you see your work reflected in contemporary design?

Sure. If anything, this century in architecture will be marked by the demise of the right angle; there will be more curvilinear, more open spaces that are swift, that float, that change velocity or other-wise nuance time. How will this proceed from my work, if at all? Probably by misinterpretation. Will some people take advantage of it in ways I can't foresee? I hope so. Do I think the work is open enough to allow people to deal with it in a lot of different ways? Again, I hope so. Architects and sculptors will figure it out;

performers, dancers, a lot of people will find it useful—or again that's my hope, anyway. Duchamp said that you're lucky if you get thirty or forty years (of course he's had a lot longer). Warhol said we all get fifteen minutes. Who knows? The fact is you can't know. But unless the work is inventive formally, it can't change anything. It has to be inventive formally to change one's perception, emotions and experience.

The Bilbao installation is not only an overview of a specific language you developed, but also a proposition about different relations between objects and passageways. What are the principal developments since?

In the recent work the paths have evolved into a circuitry where you have a choice, sometimes more than one. I have a piece in production that has four entrances and exits, where you have to choose between multiple directions. Without entering and exiting several times you will not experience the entirety of the work.

That sounds like the effect of the final pieces included in your 2007 retrospective at the Museum of Modern Art.

Yes, they evolve from *Sequence* [2006], *Band* [2006], and *Open Ended* [2007–08].

Do you feel you've reached a limit with the disconnection of inside and outside, elevation and plan?

No. I'm trying to stretch it further by focusing on a more complex, disorienting circulation. The path is driving the void. When you exit *Open Ended*, for example, you end up not knowing where you are in the room. You have to recalibrate where you entered the piece. In plan it's quite simple, but it's difficult (if not impossible) to reconstruct the configuration after you've walked it.

How did you get interested in this disorientation?

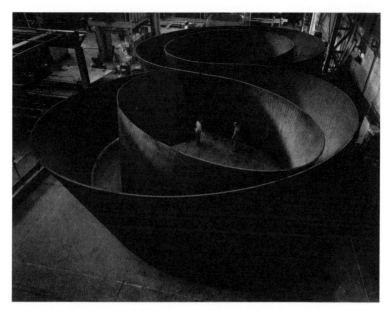

Sequence, 2006. Weatherproof steel. 12¾ x 40⅔ x 65⅙ feet x 2 inches.
Production at Pickham Umformtechnik GmbH, Siegen, Germany.

Being lost throws you back on yourself, and it might make you anxious to have to choose a direction without knowing where you'll end up. That's very different from urban spaces or buildings where your direction is prescribed. Decision-making in my sculptures means you have to make specific choices in the here-and-now.

Do they help you to understand, and maybe to meet, those moments in life more effectively?

You must trust your own experience. You're not in a trap—it's not that complex—but it does present you with different routes, like a cloverleaf without the signage.

With the development of GPS technologies, it's difficult to get lost today. We don't have to navigate much in our lives anymore; our

phones tell us where to go. That's fantastic, but one result might be a deskilling in planning, mapping, and traveling—in basic techniques of negotiating space and time, in being in the world.

You're pointed to your location, but GPS technology doesn't show you what the reality is outside the window or what's coming toward you around the next bend.

Let's go back to the pieces that develop from the torques.

Other than the work we just talked about with four entrances and exits, there is another piece in production coming directly out of *Sequence* that breaks into a Y. But I'm also working on constructions with flat plates that continue a series started with *Sight Point*. One is almost eighty feet high and made up of seven plates eight feet wide and almost four inches thick; it has three openings into a space that is ten feet wide on the ground and narrows to a nine-foot opening framing the sky at its height. It's a vertical shaft. The volume will probably be more extreme than in any other piece in the series of vertical structures.

Promenade [2008], your piece of five plates fifty-six feet high positioned down the long axis of the Grand Palais in Paris, was closely connected to its site, to the industrial structure and immense space of that building. And it was pretty extreme.

It engages the architectural history of a very different context. What comes to mind when you think of a structure that's tight and high but you can still walk into?

Well, various towers. And when you think of towers, you think of military and civic functions, but sometimes religious ones, too.

It will definitely have a civic function; it will be a point of gathering, hopefully a place of contemplation as well.

So you play on these associations in an abstract manner?

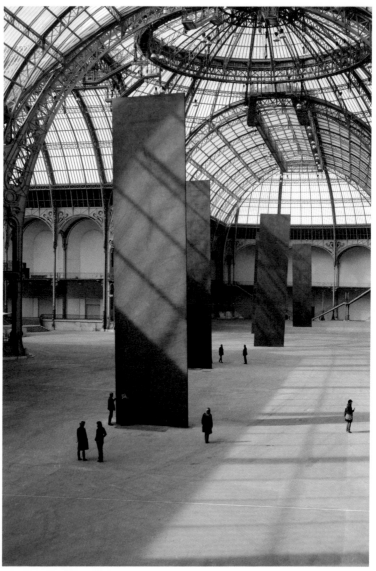

Promenade, 2008. Weatherproof steel. Five plates, each ca. 55 ¾ x 13 feet x 5 inches. Installation in the nave of the Grand Palais, Paris, 2008. Photo © Philippe Monsel.

Yes. To designate a place with a tight space of great height is to collect and to ground that environment.

How do you respond to criticism that such pieces might be monumental? This struck me in relation to Promenade *in particular: for some people it was a piece about looking, strolling, gathering, informally and freely, but others saw it as overbearing.*

That's not my sense of how people experience my work. Young people are often the first to explore a new piece, and I don't think they're overwhelmed by monumentality. One of the reasons I'm interested in the dislocation of paths is to create a more complex matrix for the viewer.

I like the notion that the new work invites viewers to consider, in a different register, the disorientations experienced in everyday life— not to cope with them exactly, but to see them differently somehow, to play with them maybe. Yours is not disorientation for its own sake.

No. You have to make choices; you have to decide, constantly, which direction to take.

Do you see the new works as a synthesis of the object pieces and the passageway pieces? Promenade *had elements of both.*

The new works are an extension of *Sequence* and *Band*; they're not as open and transparent as *Promenade*. They deal with curves in relation to paths.

The new vertical structure looks back to Sight Point, *as you say, which is a fundamental part of your language. With the torques we talked about the speed of the skin, which you related to contemporary architecture. Have you pulled back from that effect?*

No. The new pieces are even more involved with the speed of the skin.

But Promenade *wasn't. How and when do you decide what new part of your language to push, and what old part to reintroduce?*

Series are open and can be extended.

Can sequences intersect, or are they always discrete?

That's an interesting idea. I haven't found a way to bring them together, unless you consider the torquing of the vertical plates in pieces like *Vortex* in Fort Worth as combining two conceptual principles.

The art historian Alois Riegl once proposed a double spiral as a model of artistic development—that, as an artist spirals down into the history of his work to recover an old idea, he also spirals upward, elaborating the idea in new ways in the different circumstances of the present.

Brancusi did that constantly; so does Johns.

Do you feel an affinity with that process?

No. They saw their work as accumulative, and I don't see my work that way.

How do you see it then?

It develops by diverging. At times, though, I do go back to points where the work seems to split.

If only for a moment, Promenade *did call a halt to the speedy skins of the torqued pieces. It had an austerity, even an asperity, which is often associated with a "late style."*

The site was very suggestive. I was given a very powerful central axis to work with in the Grand Palais.

Over the last five years do you see a main thrust in the work?

What differs in the new work is that you have multiple choices—let's call them "intervals." With earlier pieces you enter and exit, and there's no real decision to make; you're propelled by where your footfalls take you. With the work I am developing now you arrive at an interval, a point of decision. I'm interested in what that means.

Architecture is made up of connections, of tissues between spaces, which sculpture can forgo. That suspension happens at the interval. It's not a joint because it's spatial; it's a break that connects. In architecture you're directed through connections that are predicated on function. This is exactly the opposite of the interval in my new work; there's no function, only decision.

The interval breaks your cadence. How you perceive depends on how you walk; if you change direction, your perception changes. If you have to make a choice about direction, it becomes a thought.

An interval is a moment of arrest, then, whereas the passage pieces keep you moving. There is arrest in previous pieces, too, such as Gravity [1993] *in the Holocaust Museum in DC.*

But the arrest here is heightened by anxiety, by not knowing which choice to make. Neither *Sequence* nor *Band* has intervals.

Are its effects different from the disorientation we just discussed?

You're still being projected forward, and the curves are opening or closing and leaning to the right or to the left. That remains the same.

Is this a new kind of "thinking on your feet"?

Yes, only it's more complex.

Are your navigational skills sharpened? Defamiliarized? Appreciated differently somehow? What exactly is the relation between the new sculptures and everyday experience?

Walking down the street or rushing through the subway you often experience a momentary lapse, and you feel lost. People are usually

not conscious of those moments. The intervals make you conscious of these lapses. You realize the lapse is not simply a blind spot, but a moment that asks for a decision. In any case, it brings you back to yourself and to the reality of the moment. The interval breaks your stride, which gives you pause.

Is there any relation to the interval in temporal arts—in music, say?

I don't know. I think in music the interval is the space between two tones sounded simultaneously or successively. Steve Reich's music elaborates on that space.

Is this thinking on your feet more in your head or in your body?

It's in the rhythm of your body first and your head second. I'm not sure how a reflex reaction becomes cognitive.

But if it's about decision, it must be cognitive. Maybe the interval is when the cognitive cuts into the perceptual, reflecting on it.

That's right. The interval is a cognitive pause. But it's not a centering moment. That makes it different from most architectural spaces.

It's a differential relation, which is how I see the rapport among the various mediums in the art-architecture complex at large during the last few decades. Your work is very important to the development of that complex. It's been made under various conditions over the last fifty years—different arrangements, spatial and economic, among artist, gallery, museum, patrons, and viewers. Can you talk about how your work has inflected, and been inflected by, those arrangements?

A lot of it has to do with just wanting it to happen and being tenacious. That probably goes back to the Constructivists—how they projected ideas, which they couldn't accomplish, as the very engine of their practice.

I understand how you've tested the limits of production, but what about the other side of the apparatus, the parameters of exhibition and consumption?

You have to deal with contradictions as they come up, which is to say continuously. It's rare to have patronage without strings attached.

You mentioned how Minimalism was contained. I'm uneasy about terms like "cooption" and "recuperation," but do you have any misgivings about your own part in the expanded field of art since Minimalism? What about the expansion of museums, in particular of museums that compete with sculpture as objects? What about the space war between art and architecture?

Give me an example.

How about the one between the sculptor Serra and the architect Gehry at Bilbao?

That's a misrepresentation. There never was a struggle other than in the press after the fact. I had an exhibition there in 1999 and was invited back a few years later to conceive a permanent installation.

What about other museums that are taken to be massive works of sculpture in their own right? Might that turn artists into installation-makers almost by default? My question is about the other side of the differential relation of sculpture and architecture, the rivalrous side, whereby sculpture and architecture pressure each other in terms both of image-making and space-claiming.

That's buying into the belief that no artist's work can override the context of spectacular architecture; we heard that a lot after Bilbao was opened. One can't anticipate what artists will do in relation to architecture. Art has always found ways to intervene, to critique architecture, to transform and to transgress space. Artists will continue to do that. They understand the contradictions. Can they find a way not to serve its interests completely, and even to override those interests

through the intensity of what they project? For sure they can: that's why they're called artists. Museums want that, too, or at least they should; they can't simply collect collectors. They have to accept work that foregrounds contradictions, that uses them to transgress given limits. That's what counts in the end.

ENDNOTES

Preface

1 The landmark "International Style" exhibition of modern architecture at the Museum of Modern Art in 1932 was much criticized for its emphasis on style over function. Yet style came to be a primary function of much of that design, and this is even more the case with "global styles" today.

2 This book consists of case studies, which are hardly complete analyses; I might have chosen other figures, too, but these are the most telling ones for me. On the reordering of art after Minimalism see Rosalind Krauss, "Sculpture in the Expanded Field," in Hal Foster, ed., *The Anti-Aesthetic: Essays on Postmodern Culture* (Seattle: Bay Press, 1983). Anthony Vidler offers his own map of "Architecture's Expanded Field" in Vidler, ed., *Architecture Between Spectacle and Use* (Williamstown: Clark Art Institute, 2008). In *Nothing Less Than Literal: Architecture after Minimalism* (Cambridge, MA: MIT Press, 2005), Michael Linder focuses on the role of architecture in the discourse of Minimalism. And in "Minimalism: Sculpture and Architecture" (in a special issue of *Art and Design* of 1997), Stan Allen suggests that "what lies between the arts" is not "theater," as Michael Fried claimed in "Art and Objecthood" (1967), but "architecture"—i.e. that the expanded field of art after Minimalism was an opening to space as much as to time.

3 See, among other texts, Ulrich Beck, *Risk Society: Towards a New Modernity*, transl. Mark Ritter (London: Sage Publications, 1992), and Johannes Willms, *Conversations with Ulrich Beck*, transl. Michael Pollack (Cambridge: Polity Press, 2002). I also adapt the term "banal cosmopolitanism" from Beck. As for skepticism, I agree with T.J. Clark that "modernity" is largely mythical in its promise of mobility, and I agree with Fredric Jameson that it tends to aestheticize whatever it touches. See T. J. Clark, *The Painter of Modern Life: Paris in the Art of Manet and His Followers* (New York: Alfred A. Knopf, 1985), and Fredric Jameson, *A Singular Modernity: Essay on the Ontology of the Present* (London: Verso, 2002).

4 See B. Joseph Pine II and James H. Gilmore, *The Experience Economy: Work Is Theater & Theater a Stage* (Boston: Harvard Business Press, 1999). Eric Schmidt, CEO of Google, speaks of an "attention economy" in which corporations compete for "eyeballs."

5 See Anthony Vidler, "The Third Typology," *Oppositions* 1 (1977).

6 So defined, a medium cannot be wholly invented, as some suggest today, or rather, to the extent that it is so made up, it can have only little purchase on the present, let alone on history. Even as modernist art aspired to specificity (e.g. "purity"), it was also tempted by hybridity (e.g. the *Gesamtkunstwerk*), so this difference does not distinguish it adequately from postmodernist art. However, they do have different proclivities, and, by analogy with "object-choice" in Freud, we might see modernist art as "narcissistic," as it cathects its own image first and foremost, and postmodernist art as "anaclitic," as it is often "propped" on other forms. This propping of art on architecture and vice versa is a central dynamic of the complex in question here.

In 1978 Rosalind Krauss opened her crucial essay "Sculpture in the Expanded Field" with a description of *Perimeters/Pavilions/Decoys* by Mary Miss: "Toward the center of the field there is a slight mound, a swelling on the earth, which is the only warning given for the presence of the work. Closer to it, the large square face of the pit can be seen, as can the ends of the ladder that is needed to descend into the excavation . . ." Krauss located "site-constructions" such as this one between "architecture" and "landscape," and thus unfolded her structuralist map of practices, beyond sculpture proper, located vis-à-vis other oppositions such as "landscape" and "not-landscape," "architecture" and "not-architecture," and so on. In 1910, in an essay simply titled "Architecture," Adolf Loos presented a similar scene with a different moral: "If we were to come across a mound in the woods, six foot long by three foot wide, with the soil piled up in a pyramid, a somber mood

would come over us and a voice inside us would say, 'There is some-one buried there.' *That is architecture"* (Adolf Loos, *On Architecture*, transl. Michael Mitchell [Riverside, CA: Ariadne Press, 2002]: 84). An origin-myth of architecture, it can also serve as such for the primordial marking that is sculpture: architecture and sculpture might be said to fight over that burial mound. This speaks to my sense of medium-differentiality, which assumes a field less of conceptual oppositions and negations *à la* Krauss than of similarities and differences that are material, formal, functional, conventional, above all historical.

7 For more on how some artists have responded to this aspect of the "experience economy," see Tim Griffin, "Compression," *October* 135 (Winter 2010).

8 Here, "complex" returns us to the structuralist field of recent art mapped by Krauss. The theorist A.J. Greimas pioneered the semiotic configuration also known by this name, but it has a different valence in his work: as Fredric Jameson writes, "it constitutes a virtual map of conceptual closure, or better still of the closure of ideology itself, that is, as a mechanism which while seeming to generate a rich variety of possible concepts and positions remains in fact locked into some initial aporia or double bind that it cannot transform from the inside by its own means" (A.J. Greimas, *On Meaning: Selected Writings in Semiotic Theory*, transl. Paul J. Perron and Frank H. Collins [Minneapolis: University of Minnesota Press, 1987]: xv). In short, expansion can harden into constriction.

9 This term has a specific meaning in architectural circles, where it is used to draw a line in the sand after the reflexivity of such archi-tects as Peter Eisenman, yet it also bears on a general dissatisfaction with critique. See, for example, Bruno Latour and Peter Galison, eds, *Iconoclash* (Karlsruhe: ZKM/Center for Art and Media, 2002).

1: Image-Building

1 Of course, architecture as sign or advertising precedes World War II, as in the *Reklame Architektur* of the 1920s. For a helpful account see Janet Ward, *Weimar Surfaces: Urban Visual Culture in 1920s Germany* (Berkeley: University of California Press, 2001).

2 On Pop vis-à-vis this changed semblance, see my *The First Pop Age: Painting and Subjectivity in the Art of Hamilton, Lichtenstein, Warhol, Richter and Ruscha* (Princeton: Princeton University Press, 2012).

3 See Reyner Banham, *Theory and Design in the First Machine Age* (London: Architectural Press, 1960).

4 See Robert Venturi, Denise Scott Brown, and Steven Izenour, *Learning from Las Vegas* (Cambridge, MA: MIT Press, 1972). The book began as a studio conducted in fall 1968 at Yale and Las Vegas; its historical argument was prepared by Venturi in his *Complexity and Contradiction in Architecture* (New York: Museum of Modern Art, 1966). For a recent review of the postmodernism debate, see Reinhold Martin, *Utopia's Ghost: Architecture and Postmodernism, Again* (Minneapolis: University of Minnesota, 2010).

5 Alison and Peter Smithson, "But Today We Collect Ads," *Ark* 18 (November 1956): 50. This paragraph and the next are adapted from Chapter 1 of *The First Pop Age*, where more can be found on the Independent Group and "This is Tomorrow."

6 Ibid.

7 Banham, *Theory and Design*: 11.

8 Banham, "Vehicles of Desire," *Art* 1 (September 1, 1955): 3.

9 As the Smithsons suggested, this move was in keeping with a shift in influence away from the architect as a consultant in industrial production to the ad-man as an instigator of consumerist desire. "The foundation stone of the previous intellectual structure of Design Theory has crumbled," Banham wrote in 1961; "there is no longer universal acceptance of Architecture as the universal analogy of design." ("Design by Choice," *Architectural Review* 130 [July 1961]: 44). On this point see Nigel Whiteley, *Reyner Banham: Historian of the Immediate Future* (Cambridge, MA: MIT Press, 2002).

10 Banham in 1960, cited in Whiteley, *Reyner Banham*: 163.

11 Alison and Peter Smithson, "Thoughts in Progress," *Architectural Design* (April 1957): 113.

12 Banham, "A Clip-On Architecture," *Design Quarterly* 63 (1963): 30. John McHale, a fellow IG member, was an important advocate of Archigram as well.

13 Banham in Peter Cook, ed., *Archigram* (London: Studio Vista, 1972): 5. Like Tom Wolfe, his enemy-twin in gonzo journalism, Banham developed a prose that is also a key Pop form, for it mimics linguistically the consumerist landscape of image-overload and commodity-glut; it, too, is plug-in and clip-on in character.

14 Banham, "Clip-On Architecture": 30.

15 At least in part, this difference stems from their formations. Venturi was trained in the Beaux Arts tradition at Princeton in the late 1940s, and spent an influential year at the American Academy in Rome, while Scott Brown, though schooled at the Architectural Association in London in the early 1950s, departed early on for the United States,

where she eventually partnered with Venturi. Banham came to the States, too, in 1976, but his Pop concerns were always inflected in other ways, as a comparison of *Learning from Las Vegas* with his *Los Angeles: The Architecture of Four Ecologies* (New York: Harper & Row, 1971) reveals.

16 Venturi et al., *Learning from Las Vegas*: 101.

17 Ibid.: 87.

18 Ibid.

19 Ibid.: 90.

20 Ibid.: 13.

21 Ibid.: 52. One might argue that this conflation of corporate trademark and public sign was another lesson of Pop art, yet it was rarely affirmed there: for example, the "Monuments" of Claes Oldenburg—his giant baseball bats, Mickey Mouses, hamburgers, and the like—do not champion this substitution so much as they underscore its inadequacy.

22 Ibid.: 9.

23 Ibid.: 75.

24 Ibid.: 74. This is actually a quotation from Donald Appleyard, Kevin Lynch, and John R. Myer, *The View from the Road* (Cambridge, MA: MIT Press, 1964): 5.

25 Venturi et al., *Learning from Las Vegas*: 139. Despite their critique of modern masters, the Venturis drew their strategy from Le Corbusier. In *Vers une architecture* (1923) Corb juxtaposed classical structures and industrial commodities, such as the Parthenon and a Delage sports car, in order to argue for the classical monumentality of Machine Age object-types. The Venturis adjusted these ideological analogies to a commercial idiom: "Las Vegas is to the Strip what Rome is to the Piazza"; billboards punctuate Las Vegas as triumphal arches punctuated ancient Rome; signs mark the Strip as towers mark San Gimignano; and so on (Ibid.: 18, 106, 107, 117). If Corb moved to classicize the machine (and vice versa) in the First Machine Age, the Venturis moved to classicize the commodity-image (and vice versa) in the First Pop Age. Sometimes the association between Las Vegas and Rome became an equation: the Strip *is* our version of the Piazza, and so the "agoraphobic" autoscape must be accepted (on which more follows).

26 Their studio visited Ruscha at the time, but in the end the Venturis might share less with Ruscha on Los Angeles than with Tom Wolfe on Las Vegas, especially his version of Pop language (see note 13) as practiced, for example, in his "Las Vegas (What?) Las Vegas (Can't hear you! Too noisy) Las Vegas!!!" in *The Kandy-Kolored*

Tangerine-Flake Streamlined Baby (New York: Farrar, Straus & Giroux, 1965). Previously, Venturi made the connection to Pop in "A Justification for a Pop Architecture" in *Arts and Architecture* 82 (April 1965), as did Scott Brown in "Learning from Pop" in *Casabella* 359/360 (December 1971). Aron Vinegar touches on this topic in *I Am a Monument: On "Learning from Las Vegas"* (Cambridge, MA: MIT Press, 2008).

27 On both Warhol and Ruscha, see (among many other texts) chapters 3 and 5 of *The First Pop Age*.

28 Venturi et al., *Learning from Las Vegas*: 80. The Venturi take is only slightly different: "Americans feel uncomfortable sitting in a square . . . they should be working at the office or home with the family looking at television" (*Complexity and Contradiction in Architecture*: 131).

29 Richard Hamilton, *Collected Words: 1953–1982* (London and New York: Thames & Hudson, 1983): 233, 78; Venturi et al., *Learning from Las Vegas*: 161.

30 Kenneth Frampton, *Modern Architecture: A Critical History* (London and New York: Thames & Hudson, 1980): 281. This dystopian shadow is also present, for instance, in the New Babylon project (1958–62) of the Situationist Constant Nieuwenhuys, who re-imagines select cities in Europe as liberated spaces for play—yet such is the ambiguity of his diagrams that these spaces can sometimes be read as constrictive enclosures.

31 Rem Koolhaas, *Delirious New York* (New York: Oxford University Press, 1978): 46 et passim. This phrase can also be reversed: the fantasy of the technological.

32 Koolhaas has defined his Office for Metropolitan Architecture (OMA) in Dalíesque terms as a "machine to fabricate fantasy," but some of the OMA "fantasies" have come true at a Corbusierian scale (Rem Koolhaas and Bruce Mau, *S, M, L, XL* [New York: Monacelli Press, 1995]: 644). Koolhaas also has a Corbusierian knack for catchy concepts (possessed by Banham and the Venturis, too), which, in good Pop fashion, he has presented as if copyrighted. In a sense the Corb-Dalí combination is not as singular as it might seem: a Constructivist-Surrealist dialectic was at the heart of the historical avant-garde, and its (impossible) resolution was a partial project of several neo-avant-gardes—from the Imaginist Bauhaus and the Situationists, through Archigram and Price, to Koolhaas and OMA.

33 Koolhaas, *Delirious New York*: 203.

34 Rem Koolhaas and OMA, *Content* (Cologne: Taschen, 2003): 489.

35 Ibid.

36 Just to be clear: the critique here is not that Gehry violates the (semi-) mythical principle of structural transparency, but that this disconnection often produces null spaces that deaden the architecture and disorient its subjects.

37 Already in his 1989 project for the Sea Terminal in Zeebrugge, Koolhaas posed this effect as an architectural question/ambition: "How to inject a new sign into the landscape that—through scale and atmosphere alone—renders any object both arbitrary and inevitable?" (Koolhaas et al., *S, M, L, XL*: 582). I return to the transformation of image into "atmosphere" in Chapter 7.

38 Michael Hays writes of this phenomenon:

> It is as if the surface of the modern envelope [his example is the Seagram Building of Mies], which already traced the forces of reification and commodification in its very abstraction, has been further neutralized, reappropriated, and then attenuated and animated at a higher level . . . This new surface [his example is the Seattle library by Koolhaas] is not made up of semiotic material appropriated from popular culture (as with Venturi and Scott Brown) but, nevertheless, is often modulated through procedures that trace certain external programmatic, sociological, or technological facts (what designers refer to as "datascapes").

See Hays, "The Envelope as Mediator," in Bernard Tschumi and Irene Chang, eds, *The State of Architecture at the Beginning of the 21st Century* (New York: Monacelli Press, 2003): 66–7.

39 A further twist on Pop architecture has become apparent. If in the 1960s there was talk of "meta-forms," and in the 1970s of "mega-structures," today one might speak of "hyper-buildings." Ironically, such architecture has returned the engineer, that old hero of modern architecture, to the fore. One such figure is the Sri Lankan engineer, Cecil Balmond, without whom some hyper-buildings could not have been conceived, let alone executed (he has collaborated with Koolhaas since 1985, and with other celebrated designers more recently). Another is Santiago Calatrava, the Spanish artist-designer also in great demand for his emblematic structures, and we will meet others in subsequent chapters. Such engineering-as-architecture might signal a return to tectonics, but, if so, tectonics are here transformed into Pop image-making as well. Consider the transit hub designed by Calatrava at the World Trade Center site in lower Manhattan: he intends its roof of ribbed arcs to

evoke the wings of a released dove, no less. If Daniel Libeskind proposed a design for "Ground Zero" that would have turned a site of personal trauma into a field of national triumphalism, Calatrava proposes a post-9/11 Prometheanism in which humanist spirit and imperial technology are also difficult to distinguish—and this phenomenon is hardly confined to Manhattan. In such (post-9/11) instances, advanced engineering is placed in the service not only of corporate logo-making but also of mass moral-uplift, and it will likely serve in this way wherever the next mega-spectacle (e.g. the 2012 Olympics in London) lands.

2: Pop Civics

1 Kenneth Powell, *Richard Rogers: Architecture of the Future* (Basel: Birkhäuser, 2006): 241. All other page references given in the text are to this volume.

2 So it goes, a pragmatist would say (perhaps too quickly), for any successful practice in this neoliberal era; the test is what one can accomplish given these conditions.

3 Reyner Banham, "A Clip-On Architecture," *Design Quarterly* 63 (1965): 30.

4 Reyner Banham, *Megastructure: Urban Futures of the Recent Past* (London: Thames & Hudson, 1976): 17.

5 Rogers was born in Florence to Anglo-Italian parents who left for England just prior to World War II; his older cousin was the important Italian architect Ernesto Rogers (1909–69).

6 See Siegfried Kracauer, "The Mass Ornament," in *The Mass Ornament*, ed. and transl. Thomas Y. Levin (Cambridge, MA: Harvard University Press, 1995). That such participation is not opposed to spectacle is a possibility I explore in Chapter 10.

7 Most recently, in 2010 Prince Charles intervened to squash the redevelopment of Chelsea Barracks in Belgravia, which the Qatari royal family had commissioned RRP to do (its scheme called for 548 apartments, half of which would be affordable, spread over fourteen glass-and-steel buildings). This was done in utter disdain for the planning process (the design had won support from council officers).

3: Crystal Palaces

1 See Norman Foster, "Introduction," in *Catalogue: Foster and Partners* (Munich: Prestel Verlag, 2005): 6–15. All other page references given in the text are to this volume.

2 This was as of 2005; there are far more today.

3 Its value is comparable to that of some clients, too. In 2007 the private equity firm 3i acquired Foster + Partners for circa £350 million; at the time Foster was reported to have owned more than 90 percent of the business.

4 The dream of total design is a recurrent one over the last century— from Art Nouveau and the Werkbund through design teams of the 1950s and 1960s such as the Eameses—but none of these instances matches the technical capacity of "Foster."

5 They are also often in conflict: for example, glass walls offer transparency but not sustainability, and so must be shaded with expensive devices—fret patterns, louvers, and the like. On another topic, the talk of a reinvention of types seems immodest, but, as I suggested in the Preface, "Foster" might be involved in the invention of a new typology altogether.

6 For Freud the exhibitionist is the double of the voyeur. If this double position is our desired one as social subjects today (that is, if we love to look and be looked at), does this mean we are beyond the paranoia about the gaze that informs the accounts to which I refer here, namely the panopticon of Foucault and the spectacle of Debord? This question recurs in Chapter 6.

7 See Mark Wigley, *White Walls, Designer Dresses: The Fashioning of Modern Architecture* (Cambridge, MA: MIT Press, 1995).

8 In prior affirmations of modernity, too, there was sometimes a theological dimension; think, for example, of how Hart Crane and Joseph Stella celebrated the Brooklyn Bridge as a cathedral (Rockefeller Center asks to be seen as one as well).

9 See Rem Koolhaas, *Delirious New York* (New York: Rizzoli, 1978).

4: Light Modernity

1 Its website (as of 2010) opens with a picture of an atelier filled with the old tools of the trade.

2 This firm remains very active, often represented in grand projects by the Sri Lankan engineer Cecil Balmond, who, as noted in Chapter 1, has worked closely with Rem Koolhaas, among others.

3 Patrick Buchanan, *Renzo Piano*, vol. 1 (London: Phaidon, 1993): 28.

4 This suggests that the piece is scale-dependent, and the diagrid of Foster is indeed more effective in smaller buildings. At the same time the piece has shifted somewhat from an objective element to a signature sign.

5 Philip Jodidio, *Renzo Piano Workshop 1966–2005* (Cologne: Taschen, 2005): 10; Buchanan, *Renzo Piano*, vol. 1: 16.

6 I return to this ambiguous third way—of structure as decoration and/ or atmosphere—in Chapter 7.

7 Buchanan, *Renzo Piano*, vol. 1: 27.

8 Buchanan, *Renzo Piano*, vol. 2 (London: Phaidon, 1995): 13.

9 Buchanan, *Renzo Piano*, vol. 1: 28, 19.

10 Le Corbusier, *The Decorative Art of Today* (1925), transl. James Dunnett (Cambridge, MA: MIT Press, 1987): 103.

11 Jodidio, *Renzo Piano Workshop*: 293.

12 A skeptic would say that the Center is a gesture of apology from a French government that gives back to the New Caledonians a simplistic version of their own Kanak culture, for which they are then asked to be grateful.

13 Piano quoted in Jodidio, *Renzo Piano Workshop*: 6.

14 Ibid.

15 Such lightness is exemplified in the 2004 redesign of MoMA by Yoshio Taniguchi, on which more in Chapter 7.

16 Italo Calvino, *Six Memos for the Next Millennium* (New York: Vintage Books, 1993): 8.

17 I return to this topic in Chapter 10.

18 Milan Kundera, *The Unbearable Lightness of Being*, transl. Michael Henry Heim (New York: Harper & Row, 1984); Peter Sloterdijk, *Critique of Cynical Reason*, transl. Michael Eldred (Minneapolis: University of Minnesota Press, 1987).

19 Buchanan, *Renzo Piano*, vol. 1: 33. The assumptions and projections, though condensed in this passage, are apparent enough not to require unpacking here.

20 Piano quoted in Jodidio, *Renzo Piano Workshop*: 9.

21 On the familiar trope of classicism within modernism, see Chapter 1, note 25.

22 See, among other texts, Zygmunt Bauman, *Liquid Modernity* (Cambridge: Blackwell, 2000).

23 See, among other texts, Ulrich Beck, *Risk Society: Towards a New Modernity*, transl. Mark Ritter (London: Sage Publications, 1992).

24 Reyner Banham, *Theory and Design in the First Machine Age* (London: Architectural Press, 1960): 193.

25 The classic text is Kenneth Frampton, "Towards a Critical Regionalism: Six Points for an Architecture of Resistance," in Hal Foster, ed., *The Anti-Aesthetic: Essays on Postmodern Culture* (Seattle: Bay Press, 1983); but also see his *Studies in Tectonic Culture* (Cambridge, MA: MIT Press, 1995).

5: Neo-Avant-Garde Gestures

1 Zaha Hadid quoted in *Zaha Hadid: The Complete Buildings and Projects* (New York: Rizzoli, 1998): 24. The catalogue for her 2006 show at the Guggenheim (also titled *Zaha Hadid*) contains useful essays by Germano Celant, Joseph Giovannini, Detlef Mertins, and Patrik Schumacher.

2 See Reyner Banham, *Theory and Design in the First Machine Age* (London: The Architectural Press, 1960). As for the reception of Constructivism in architecture at this time, see Stan Allen and Hal Foster, "A Conversation with Kenneth Frampton," *October* 106 (Fall 2003); for the corollary reception in art see Chapter 10. Suprematism was not as occluded historically: for example, an extensive sampling of Malevich paintings remained in Western Europe after they were exhibited in Berlin in 1927, and El Lissitzky was active in the West as a writer, editor, and lecturer.

3 Whether this connection is borne out is a question to take up in what follows. I allude here to an old distinction between kinds of postmodernism first proposed in Hal Foster, ed., *The Anti-Aesthetic: Essays on Postmodern Culture* (Seattle: Bay Press, 1983).

4 Kasimir Malevich, "Non-Objective Art and Suprematism" (1919). There are various translations; I have used the one in Larissa Zhadova, *Malevich: Suprematism and Revolution in Russian Art 1910–1920* (London: Thames & Hudson, 1982).

5 Hadid in *Zaha Hadid* (1998): 68, 24.

6 Aaron Betsky, "Beyond 89 Degrees," in *Zaha Hadid* (1998): 9.

7 Patrik Schumacher, *Digital Hadid* (Basel: Birkhäuser, 2004): 5.

8 Hadid in *Zaha Hadid* (1998): 19, 20.

9 Ibid.: 82.

10 Ibid.: 20.

11 Ibid.: 130, 126.

12 Schumacher, *Digital Hadid*: 17. As Schumacher points out, these distortions can also unify space. In this respect, too, Hadid is part of a neo-Baroque turn in contemporary architecture, which I take up briefly in Chapter 8.

13 Hadid in *Zaha Hadid* (1998): 135.

14 Ibid.: 74.

15 As projects brought to Hadid have increased in scale, her attention has turned to the skyscraper (which certainly complicates her prior privileging of the horizontal axis). For a discussion of this direction in her office, see Patrik Schumacher, "The Skyscraper Revitalized:

Differentiation, Interface, Navigation," in *Zaha Hadid* (New York: Solomon R. Guggenheim Museum, 2006): 39–44.

16 If Eisenman updated this operation, Greg Lynn made it semi-automatic through the digital generation of designs. In Chapter 6, I explore a different relation to field work proposed by Diller Scofidio + Renfro.

17 Ibid.: 64, 133. "Frozen motion" is a play on the famous definition of architecture as "frozen music," usually credited to Goethe in *Conversations with Eckerman* (published 1836), though Schelling used it previously in *Philosophy of Art* (published 1802–03).

18 Umberto Boccioni, "Technical Manifesto of Futurist Sculpture," in Umbro Apollonio, ed., *Futurist Manifestos* (London: Thames & Hudson, 1973): 63. Here Boccioni points to what a truly Futurist architecture might be more persuasively than does Antonio Sant'Elia (who was largely dragooned into the movement). Boccioni also used axonometric projections in his sculptural practice.

19 For example, her Pau media complex and London aquatic center resemble giant seats or mammoth mollusks (in keeping with the fascination with biomorphology among digital designers). Her recent emphasis on image (especially in projects in the Middle and Far East) often overrides her commitment to abstraction, and aligns her practice with the sculptural architecture of Gehry.

20 This rethinking of architecture in terms of temporality points to the possible influence on Hadid of another young teacher at the AA during her years there, Bernard Tschumi. As we will see in Chapter 8, Richard Serra introduced temporality and mobility into sculpture precisely to disrupt its status as an image-object.

21 Hadid has designed not only exhibitions and displays but also sets (for opera and other performances).

22 One need not refer to Minimalism; this tension is already active in modern architecture, as in the Villa Savoye (1929) described here by Le Corbusier: "In this house, we are dealing with a true architectural promenade, offering constantly varied, unexpected, sometimes astonishing aspects. It is interesting to obtain so much diversity when one has, for example, allowed from the standpoint of construction an absolutely rigorous pattern of posts and beams" (*Oeuvres Complètes*, vol. 2 [Basel: Birkhäuser, 2006]: 24).

23 Sol LeWitt, "Paragraphs on Conceptual Art," *Artforum* (Summer 1967): 80. See also Peter Eisenman, "Notes on Conceptual Architecture" (1971), in *Inside Out: Selected Writings, 1963–1984* (New Haven: Yale University Press, 2004). On matters of translation see Robin Evans, *Translations from Drawing to Building and*

Other Essays (London: Architectural Association, 1997), and Stan Allen, *Practice: Architecture Technique + Representation* (New York: Routledge, second edn, 2009).

24 Peter Burger, *Theory of the Avant-Garde* (1974), transl. Michael Shaw (Minneapolis: University of Minnesota Press, 1984). Although I critique his model in *The Return of the Real* (Cambridge, MA: MIT Press, 1996), it seems appropriate in this case.

25 Schumacher, *Digital Hadid*: 7.

26 Like Gehry, Hadid is attracted to total design, which in her case includes a "Z" line of silverware, furniture, and jewelry as well as a prototype for a futuristic car. The iconography of the Second Machine Age was self-evident (grain elevators, skyscrapers, bridges, ocean liners, and so on); that of the Third is uncertain: how to make visible, let alone iconic, contemporary technologies? The Hadid swooshes already look dated; in some ways we are back to the past of the House of Future mentioned in Chapter 1.

27 Schumacher, "The Skyscraper Revitalized": 44. This suggests that design is fated to be little more than a disciplinary diagram (on which more in Chapter 11).

28 Betsky, "Beyond 89 Degrees": 13. On montage within the computer, see Lev Manovich, *The Language of New Media* (Cambridge, MA: MIT Press, 2001).

29 Schumacher, *Digital Hadid*: 20. Jürgen Habermas first used this phrase in the early 1980s, and, following Hadid (see her first quotation in this text), her supporters have adapted it to describe her practice as well. Yet the Habermas term is "modernity," not "modernism." This slippage may seem slight, but it suggests a detachment of modernism from the greater project of modernity, a detachment that tends to reduce it to a repertoire of styles less able to engage the values of modernity, let alone the processes of modernization, critically.

6: Postmodernist Machines

1 Elizabeth Diller and Ricardo Scofidio founded Diller + Scofidio in 1979, and Charles Renfro joined as a partner in 2004; for the sake of simplicity I refer to the studio as DS+R throughout.

2 Although the ICA avoids excessive iconicity (it also turns away from the city toward the harbor), it is still intended by Boston authorities to be an economic attractor. The "Fan Pier" of which it is a part is under development by the Fallon Company as a link between the harbor front and the business district.

3 Nicholas Baume, "It's Still Fun to Have Architecture: An Interview with Elizabeth Diller, Ricardo Scofidio, and Charles Renfro," in Baume, ed., *Super Vision* (Cambridge, MA: MIT Press, 2006): 186.

4 Ibid.: 187.

5 Nearly ten years later DS+R used a shallower arc to generate the scheme for Slither Building (2000), a 105-unit housing project in Gifu, Japan. Here each of the fifteen stacks of units is shifted 1.5 degrees from the one before it. As in the Eyebeam scheme two years later, tropes of seeing and snaking are combined—as if architecture might incarnate sight as live and mobile.

6 Diller in Baume, ed., *Super Vision*: 186.

7 Renfro in ibid.: 183.

8 Scofidio in ibid.: 186. DS+R are also "creative partners" in two prominent art museums to come, one for financier Eli Broad in downtown Los Angeles, another for the University of California at Berkeley.

9 As even a great proponent of this mode, the curator Hans Ulrich Obrist, has commented, "Collaboration is the answer, but what is the question?" (Hans Ulrich Obrist, *Interviews*, vol. 1 [Milan: Charta, 2003]: 410).

10 DS+R press release, n.d.

11 DS+R project note in Aaron Betsky and K. Michael Hays, eds, *Scanning: The Aberrant Architectures of Diller + Scofidio* (New York: Whitney Museum, 2003): 51.

12 Project note in Betsky and Hays, eds, *Scanning*: 56. Of course, interdisciplinarity is (or was) a function of theory, too; here the theorists in question are Georges Canguilhem and Michel Foucault.

13 Diller in Baume, ed., *Super Vision*: 179.

14 There is a relation here, too, to one segment of *Interim* (1984–89) by Mary Kelly, which shows images of black leather jackets twisted in the hysterical positions as typed by Charcot.

15 With allusions to Duchamp and Surrealism, some DS+R projects also disclose a neo-avant-garde aspect, but again it is in the register of art.

16 See Luc Boltanski and Eve Chiapello, *The New Spirit of Capitalism*, transl. Gregory Elliot (London: Verso, 2005).

17 Betsky, "Display Engineers," in Betsky and Hays, eds, *Scanning*: 23; note the appellation "artists." To frustrate and to surf at the same time is an unlikely trick.

18 Hays, "Scanners," in ibid.: 130, 133.

19 As suggested, there are a few models of interdisciplinarity in DS+R: on the one hand, a "fusion" of art and architecture; on the other, the sense that architecture is always already present in any art arrangement; on

the one hand, a hybrid practice of installation, performance, and dance; on the other, design as a "creative partner." In general, I will suggest below, there is a movement from the former to the latter in each pair, but sometimes they contradict one another in their discourse.

20 Edward Dimmendberg argues as much in his essay "Blurred Genres" in Betsky and Hays, eds, *Scanning*.

21 However media-savvy, DS+R design is not digitally driven. "We could have drawn this building completely by hand," Renfro insists of the ICA (Baume, ed., *Super Vision*: 191).

22 DS+R, "Project," in Thomas Y. Levin, Ursula Frohne, and Peter Weibel, eds, *CTRL Space: Rhetorics of Surveillance from Bentham to Big Brother* (Cambridge, MA: MIT Press, 2002): 354.

23 Ibid.: 355.

24 Ibid.

25 Diller in Baume, ed., *Super Vision*: 182.

26 On the other hand, the people can seem almost irrelevant here. The lush design and the video display above the bar are so attention-grabbing that hardly anyone seems to watch the actual arrivals.

27 Diller in Baume, ed., *Super Vision*: 183.

28 I return to this problem in Chapter 7.

29 This is not to suggest that site conditions (or, for that matter, program dictates) are the alpha-and-omega of good design; it is to say that I find the DS+R approach to site more persuasive than the Hadid approach. For more on this topic see Stan Allen, "From Object to Field: Field Conditions in Architecture + Urbanism," in *Practice: Architecture, Technique + Representation* (New York: Routledge, second edn, 2009).

30 The plan did have its opponents. Extending Juilliard and Alice Tully changed both, and fans of Pietro Belluschi, the architect of Juilliard (1969), took umbrage. Moreover, the restaurant altered the North Plaza pool, the work of the beloved landscape architect Dan Kiley, which also ruffled feathers. Yet in general DS+R are respectful of the late modernist styles of such Center architects as Eero Saarinen (Vivian Beaumont, 1965), whose signature curves are echoed in their restaurant, Max Abramovitz (Philharmonic Hall, 1962), Wallace Harrison (Metropolitan Opera House, 1966), Philip Johnson (New York State Theater, 1964), and Gordon Bunshaft (Library and Museum of the Performing Arts, 1965). Indeed DS+R seem devoted to this period style; for example, with details like stone patio flooring and white leather chairs, the Brasserie anticipated the retro fashion of *Mad Men*.

31 Diller in Baume, ed., *Super Vision*: 190. This is not to say that DS+R

shy away from media images; on the contrary, there are five screens scrolling text in front of Alice Tully Hall, and thirteen four-by-eight-foot LED screens (with thirty-seven different video sequences) on West Sixty-Fifth Street between Columbus and Amsterdam Avenues.

32 I return to this opposition in Chapter 8. Hopefully, similar benefits will accrue from Governor's Island, a 172-acre former military base in Upper New York Bay that DS+R will refashion as a parkland in collaboration with West 8 landscape designers and Roger Marvel Architects.

7: Minimalist Museums

1 Le Corbusier borrowed two photographs of grain elevators from Gropius, who had published them in *Jarhbuch des Deutschen Werkbundes* in 1913.

2 See Reyner Banham, *A Concrete Atlantis: US Industrial Building and European Modern Architecture* (Cambridge: MIT Press, 1986).

3 See Beatriz Colomina, *Privacy and Publicity: Modern Architecture as Mass Media* (Cambridge, MA: MIT Press, 1994). Structure plays a dual role here: on the one hand, its materiality aligns it with mass (if not always volume); on the other, its clarity aligns it with transparency.

4 Sigfried Giedion, *Building in France, Building in Iron, Building in Ferro-Concrete* (1928), transl. J. Duncan Berry (Santa Monica: Getty Center, 1995): 153. As Giedion states here, in the nineteenth century transparency was evident in engineered buildings, but not in archi-tected ones. For an overview of the principle of transparency see Adrian Forty, *Words and Buildings: A Vocabulary of Modern Architecture* (London: Thames & Hudson, 2000): 286–8. On later reinterpreta-tions see Anthony Vidler, *The Architectural Uncanny* (Cambridge, MA: MIT Press, 1992), and Terence Riley, *Light Construction* (New York: Museum of Modern Art, 1995).

5 See László Moholy-Nagy, *The New Vision* (New York: Dover, 1938), and Chapter 9. Even more than Giedion, Moholy celebrated "dematerialization."

6 Colin Rowe and Robert Slutzky, "Transparency: Literal and Phenomenal," *Perspecta* 8 (1963): 46. "[I]nterpenetrate without an optical destruction of each other" is a quotation from György Képes, *Language of Vision* (Chicago: Paul Theobold, 1944): 77. A second part of the "Transparency" essay was published in *Perspecta* 13/14 (1971).

7 I return to this tension in Chapter 10, where I address the ambiguous

afterlife of Minimalism in recent art. One could also argue that Rowe and Slutzky represent a sophisticated understanding of *both* structure and surface, and thus are equally aligned with Minimalism; certainly other Rowe texts, such as "Mathematics of the Ideal Villa," are concerned with the Minimalist tension between objective form and perceived shape.

8 On this point see Robert Morris, "Notes on Sculpture, Parts 1 and 2," in *Continuous Project Altered Daily* (Cambridge, MA: MIT Press, 1993), my "The Crux of Minimalism," in *The Return of the Real* (Cambridge, MA: MIT Press, 1996), and Stan Allen, "Minimalism: Sculpture and Architecture," *Art and Design* (1997).

9 For some people this is what Minimalism signified all along. See Clement Greenberg, "Recentness of Sculpture," in Maurice Tuchman, *American Sculpture of the Sixties* (Los Angeles: LACMA, 1967), and James Meyer, *Minimalism: Art and Polemics in the Sixties* (New Haven: Yale University Press, 2001): 211-21. In a sense "Minimalism" is to recent architecture what "Cubism" was to modern architecture; elastic in its adaptation, it can be taken to support either the literal or the phenomenal.

10 This Constructivism is very different from the deconstructivist version, which is concerned with the disturbance of structure more than the transparency of construction.

11 Again, see my "The Crux of Minimalism."

12 "Dia" means "through" in Greek. The modest word implies that the original foundation was a facilitator only, but many complained that Dia was courtly in its operation and elitist in its taste. Wright brought a new openness to the operation.

13 In a similar way a commitment to Minimalism also helped other architects emergent at the time, such as Herzog and de Meuron.

14 This space was closed in 2004, as funds were diverted to support the expensive Dia:Beacon project, on which more follows. Dia bucked the trend, which started in the early 1980s (at the dawn of neoliberalism), of lavish new museums of modern and contemporary art (for example, the Staatsgalerie designed by James Stirling in Stuttgart, the Museum für Moderne Kunst designed by Hans Hollein in Frankfurt). So did the Hallen für Neue Kunst in Schaffhausen, which was founded in 1982-83 by Urs and Christel Raussmüller for "the new art" also supported by Dia, in the converted Schoeller textile factory (c. 1912) on the Rhine, one of the first ferro-concrete buildings in Switzerland.

15 On this score Dia:Beacon is a disappointment: Govan anticipated 100,000 visitors a year, a number not met.

16 See Michael Fried, "Art and Objecthood," *Artforum* (Summer 1967).

17 This empowerment cannot help but be illusory, that is to say, compensatory for the actual diminishment of individual agency in advanced capitalism. I return to this Minimalist sublime in Chapter 10.

18 Again, the prime determinant here is a greater culture given over to experiential intensity. What relation might this art have to such experience? Does its intensity counter the other one—or aestheticize it and cover for it somehow? I return to these questions in Chapter 10.

19 See Hal Foster, "On the Hudson," *London Review of Books*, July 24, 2003. Dia:Beacon might risk status as a period piece not in spite of this insistence on "a continuous present" but because of it.

20 See Nicholas Serota, *Experience or Interpretation: The Dilemma of Museums of Modern Art* (London: Thames & Hudson, 2000), and Rosalind Krauss, "The Cultural Logic of the Late Capitalist Museum," *October* 54 (Fall 1990).

21 In this silence it is still as though the recovery of modernist art in the form of the "Triumph of American Painting" were offered up as a cultural compensation for the actual devastation of Europe. The strong version of this story, developed by Clement Greenberg, was affirmed by William Rubin, who was curator of Painting and Sculpture at MoMA from 1967 to 1988. For Greenberg, advanced abstraction did not break with the artistic past but preserved its greatest qualities through self-critique. Such "modernist painting" served, then, not only to bracket other avant-garde practices, which indeed posited a break with tradition (the readymade, constructed sculpture, the found image, collage, photomontage), but also to paper over historical rupture as such: in effect, this account concentrated history on one medium, abstract painting, which provided a sense of continuity not to be had elsewhere. This salve also involved a sublimation of political energies into aesthetic ones, as Greenberg proudly admitted in the early 1950s: "Some day it will have to be told how 'anti-Stalinism,' which started out more or less as 'Trotskyism,' turned into 'art for art's sake,' and thereby cleared the way, heroically, for what was to come" ("The Late Thirties in New York" [1957], in *Art and Culture* [Boston: Beacon Press, 1961]: 230). Although the new account is less Francocentric in the prewar and far less Americocentric in the postwar than previous presentations, MoMA still uses the arc of "modernist painting"—as testament to liberal democracy as well as to historical continuity—to bridge the mid-century cataclysm. As a result some practices in the late 1940s and early 1950s that address this cataclysm (for example, New Brutalism) but do not fit the MoMA story are given short shrift. See

my "Museum Tales of Twentieth-Century Art," in Therese O'Malley, ed., *Dialogues in Art History* (Washington: National Gallery of Art, 2009).

22 The presentations of such departments as Architecture and Design, Drawings, and Photography, occur on the third floor.

23 On the founding of MoMA in 1929 there was no divide between modernist and contemporary, and as late as 1949 MoMA agreed to sell to the Metropolitan Museum of Art all work that had become established, to keep its focus on the new and the now; but that agreement was voided only four years later.

24 This effect underscores the pictorial bias of a collection governed by the trajectory of "modernist painting," as noted in note 21.

25 Riley curated "Light Construction" at MoMA in 1995; Taniguchi was hired in 1997.

26 Widely reported at the time, this statement sounds apocryphal, but it still suits the refinement of the design. Is that what money wants— to disappear? Or is this only, or especially, true in an age of finance capitalism?

27 Rem Koolhaas, "Junkspace," in *Content* (Cologne: Taschen, 2004): 170. This comment plays on the notorious text "Ornament and Crime" (1908), by Adolf Loos.

28 This sublimation is also techno-scientific. As we saw in Chapter 4, Riley concurs with Calvino in his *Six Memos for the Next Millenium*, whom he quotes here: " 'I look to science to nourish my vision in which all heaviness disappears'; and further, 'the iron machines still exist, but they obey the orders of weightlessness' " (*Light Construction*: 21).

29 Jacques Herzog and Pierre de Meuron in Wilfried Wang, *Herzog & de Meuron* (Basel: Birkhäuser Verlag, 1992): 193, 187.

30 Herzog and de Meuron, "Essays and Lectures," in Wilfried Wang, *Herzog & de Meuron* (Zürich: Artemis, 1994): 142.

31 Jean Nouvel, "The Cartier Bldg," n.d.; Riley, *Light Construction*: 11.

32 Herzog and de Meuron, "Essays and Lectures": 145. "Glass isn't glass anymore," they comment elsewhere; "it's as solid and stable as stone or concrete. Conversely, by printing on concrete, it suddenly becomes porous or shiny like glass" (*Herzog & de Meuron* [1992]: 194).

33 "The cloud is the appropriate symbol for the new definition of transparency," Riley writes in *Light Construction*, as if in anticipation of the Blur Building; "translucent but dense, substantial but without definite form, eternally positioned between the viewer and the distant horizon" (15). Here "atmosphere" begins to emerge as a soft version of the sublime (on which more in Chapter 10).

34 Recently the enigmatic was advocated as such by Charles Jencks, for whom a wide range of monumental buildings—from the Guggenheim Bilbao to the Swiss Re in London to the CCTV in Beijing—answer to this "injunction": "You must design an extraordinary landmark [in his revision of Horace it must "have the power to amaze and delight"], but it must not look like anything seen before and refer to no known religion, ideology, or set of conventions" (*Hunch* 6/7 [Amsterdam: Berlage Institute, 2003]: 257). For Jencks the epitome here is the Guggenheim Bilbao: only Gehry, he writes, had the "courage [to] confront a major problem of the moment: the spiritual crisis, and the loss of a shared metaphysics." Talk of spiritual crisis and metaphysical lack is always ideological, but at least Jencks is more forthright than others in this respect. Finally, however, such "enigmatic" architecture is another form of spectacular effect. ("Enigmatic" has a very different valence in psychoanalysis. For Jean Laplanche it describes the messages that as young subjects we receive, traumatically, from a world that we cannot understand. They are enigmas to us because they are signifiers of the unfathomed desires of the unfathomable others in our lives; as a result they lock us in a state of fascination, often paranoid in character. This effect of the "enigmatic signifier" is not too distant from the effect of some of the monumental buildings championed by Jencks.)

35 Herzog and de Meuron, "Essays and Lectures": 145.

36 "The architectural project is, as its name denotes, a projection" (ibid.: 146).

37 Vidler, *The Architectural Uncanny*: 221. Vidler refers here to the Paris library project of Koolhaas, but this description is appropriate to some buildings by Herzog and de Meuron, and others, too. Riley advocates such "a vertigo of delay, blockage, and slowness" (*Light Construction*: 29), and he alludes to the *Large Glass* (1915–23) of Duchamp as a model of light construction that creates enigmatic surfaces and ambiguous spaces. But who wants an architecture based on the cold seduction of the "bachelor machine"?

38 "This is precisely the level we want to reach," Herzog and de Meuron comment, "to incorporate in our architecture: the mental level of perception" (Wang, *Herzog & de Meuron* [1992]: 186). This Pop collapse of the phenomenological into the imaginary is what I mean by "faux phenomenology," which I address again in Chapter 10 (where we will encounter artistic equivalents of this architectural position).

39 Peter Sloterdijk, *Critique of Cynical Reason*, transl. Michael Eldred (Minneapolis: University of Minnesota Press, 1987). As in Chapter 4, note the fetishistic structure here ("I know but nevertheless. . .").

8: Sculpture Remade

1 Richard Serra, *Writings/Interviews* (Chicago: University of Chicago Press, 1994): 35.

2 In other words, even as Serra is committed to the internal necessity of (his) sculpture in a modernist manner, it has driven him to transform the medium beyond modernist recognition.

3 Donald Judd, "Specific Objects," in *Complete Writings* (Halifax: Press of the Nova Scotia School of Art and Design, 1975): 184.

4 Tony Smith as quoted by Robert Morris in the epigraph to his "Notes on Sculpture, Part 2," *Artforum* (October 1966), reprinted in *Continuous Project Altered Daily* (Cambridge, MA: MIT Press, 1993): 11.

5 Tony Smith in Samuel Wagstaff, "Talking with Tony Smith," *Artforum* (December 1966), reprinted in Gregory Battcock, ed., *Minimal Art* (New York: Dutton, 1968): 386. For more on these transformations see my "The Crux of Minimalism" (1987) in *The Return of the Real* (Cambridge, MA: MIT Press, 1996), and Chapter 10.

6 For artists such as Judd, Frank Stella, Robert Morris, and Serra, pictorial conventions of figure and ground underwrote a model of art that is not only residually representational but also implicitly analogous to a private interiority of artistic conception that they wanted to bracket. For this generation meaning is public, performative, a matter of open research. See Rosalind Krauss, "Sense and Sensibility," *Artforum* (November 1973). As we will see below, Serra revises this position in work of the late 1980s and later; see also Chapter 11.

7 See Serra, *Writings*: 3–4. This is the first text included in this volume, which suggests its importance to Serra. On this logic of materials in the late 1960s, Serra commented in 1980: "What was interesting about this group [he mentions Robert Smithson, Eva Hesse, Bruce Nauman, Michael Heizer, Philip Glass, Joan Jonas, and Michael Snow] was that we did not have any shared stylistic premises, but what was also true was that everybody was investigating the logic of material and its potential for personal extension—be it sound, lead, film, body, whatever" (112).

8 See "Richard Serra in Conversation with Hal Foster," in Carmen Giménz, ed., *The Matter of Time* (Bilbao: Guggenheim Museum, 2005). On prime objects see George Kubler, *The Shape of Time: Remarks on the History of Things* (New Haven: Yale University Press, 1962): 33–9.

9 Not all prime objects came early. The first torqued ellipse appeared in

1996, and in 2000 Serra added to this list with new pieces that consist of spherical sections and toruses. To understand these forms, imagine a doughnut: its outside edge describes a spheroid section, while its inside edge describes a torus. Each has the same radius; yet Serra bends the inner edge of his toruses back around, so that, when put together with the spheroid sections, the two lock together like the nonsymmetrical shells of a collapsed clam or the warped sides of a wing, as they do in *Union of the Torus and the Sphere* (2000). Serra had never made a sculpture that cannot be entered bodily or visually somehow, and its closure troubled him, so in subsequent pieces he separated the sections and oriented them in different ways, as in *Between the Torus and the Sphere* (2003–05), which consists of four toruses and four spherical sections put together in an ensemble that produces seven passageways over a length of fifty-four feet, with entrances that range from six feet to thirty inches wide. One intuits that the modules of *Between the Torus and the Sphere* are the same as in *Union of the Torus and the Sphere*, and each work does appear as the obverse of the other: while *Union* foregrounds the surface qualities of the torus-sphere units—for it is all exterior that cannot be penetrated—*Between* elaborates its spatial possibilities—for its complex of corridors is all exterior. This play between object and passage continues in his work (on which more follows).

10 Serra, *Writings*: 7. For Serra, the line of painting that Minimalism diverted into object-making passed through Newman more than Pollock. Serra claims a lineage from Pollock, but a different one from the "legacy of Pollock" claimed by Kaprow ("the mystique of loosening up remains no more than a justification for Alan Kaprow" [7]).

11 Ibid.: 98.

12 Ibid. On the first, "phenomenological" move see Rosalind Krauss, "Richard Serra: A Translation," in *The Originality of the Avant-Garde and Other Modernist Myths* (Cambridge, MA: MIT Press, 1984); on the second, "picturesque" move see Yve-Alain Bois, "A Picturesque Stroll Around Clara-Clara," *October* 29 (September 1984). For a time the Minimalist fixation on the object obscured the very shift to the subject that it otherwise inaugurated.

13 Bois, "A Picturesque Stroll": 15; Serra as quoted in Bois, 34.

14 Rosalind Krauss, "Richard Serra/Sculpture," in *Richard Serra: Props* (Duisberg: Wilhelm Lehmbruck Museum, 1994): 102. This essay was originally published in *Richard Serra: Sculpture* (New York: MOMA, 1986).

15 On these concepts see Christina Lodder, *Russian Constructivism*

(New Haven: Yale University Press, 1983), and Maria Gough, *The Artist as Producer: Russian Constructivism in Revolution* (Berkeley: University of California Press, 2005). As I suggest below, in such projects as the *Monument to the Third International* (1919–20) Tatlin had already combined architecture and sculpture, which is to say that Constructivism served as an architectural precedent as well as a sculptural one.

16 Serra, *Writings*: 45.

17 Michael Govan and Lynne Cook, "Interview with Richard Serra," *Torqued Ellipses* (New York: Dia Center for the Arts, 1997): 26. I do not discuss these different types at length as there are individual catalogues devoted to most of them.

18 "Despite what he says about it," Bois remarked in 1984, "all of Serra's work is based on the deconstruction of such a notion as 'sculpture itself' " ("A Picturesque Stroll": 36).

19 Serra, *Writings*: 141.

20 On the becoming-siteless of sculpture in Brancusi, see Rosalind Krauss, "Sculpture in the Expanded Field," in Hal Foster, ed., *The Anti-Aesthetic* (Seattle: Bay Press, 1983).

21 See Foster, "The Crux of Minimalism."

22 Benjamin H.D. Buchloh, "Michael Asher and the Conclusion of Sculpture," in Chantal Pontbriand, ed., *Performance, Text(e)s & Documents* (Montreal: Parachute, 1981): 55.

23 Ibid.: 56. Serra might agree—up to the last phrase "as sculpture".

24 This critique of modernist sculpture as a compromise-formation between art and industry is anticipated, in elliptical form, in this "excursus on Art Nouveau" by Walter Benjamin in "Paris, Capital of the Nineteenth Century" (1935): "The transfiguration of the solitary soul appears its goal. Individualism is its theory . . . The real meaning of *art nouveau* is not expressed in this ideology. It represents art's last attempt to escape from its ivory tower, which is besieged by technology" (Benjamin, *Reflections*, ed. Peter Demetz, transl. Edmund Jephcott [New York: Harcourt Brace Jovanovich, 1978]: 154–5).

25 Buchloh, "Michael Asher": 59. Serra opted for Tatlin, as it were, over Duchamp, for the (un)making of sculpture over its (un)naming. He was wary of the emphasis in the readymade on consumption, at least in its neo-avant-garde reception. Indeed his credo remains productivist— "not a manipulator of a 'found' industrial product, not a consumer" (Serra, *Writings*: 168).

26 As suggested here, I differ from Buchloh in that, in my view, the effect

of these paradigms was not immediate or total; see "Who's Afraid of the Neo-Avant-Garde" in Foster, *The Return of the Real.*

27 Serra, *Writings*: 169. The text in question is titled "Extended Notes from Sight Point Road."

28 See, for example, Buchloh, "Michael Asher": 59. This insistence on material and structural self-evidence might also appear regressive in relation to architecture today, where such values can only seem old-fashioned, but the statement was made in 1985, with postmodern design in mind.

29 Charles Baudelaire, "The Salon of 1846," in *The Mirror of Art*, transl. and ed. Jonathan Mayne (New York: Doubleday, 1956): 119.

30 Ibid.: 119–20.

31 On Diderot see Michael Fried, *Absorption and Theatricality: Painting and Beholder in the Age of Diderot* (Berkeley: University of California Press, 1980). The Diderotian *tableau* underwrites the "modernist painting" advocated by Clement Greenberg as well as Fried.

32 This is how Fried glosses this passage in his brilliant essay "Painting Memories: On the Containment of the Past in Baudelaire and Manet": "I take this to mean that having irrevocably lost contact with its origins, the art of sculpture is unable to mobilize its past at all and so will forever lack a viable present" (*Critical Inquiry* [March 1984]: 521).

33 Baudelaire, "The Salon of 1846": 120.

34 See G.W.F. Hegel, *Introductory Lectures on Aesthetics* (1820s), transl. Bernard Bosanquet (London: Penguin, 1993): 76–97. Hegel understands architecture in a very peculiar way (his prime examples are almost sculptural, the obelisk and the pyramid) in part because he wants architecture to represent a "symbolic" modality in which material is inadequate to idea; hence its low position in his hierarchy.

35 In other words, Serra proposes first a reversal of the old Hegelian hierarchy (as with the Constructivists, the critique of painting pushes him toward architecture) and then a release from this hierarchy. Of course, this pressure from the middle is also a way to expand the adjacent categories.

36 Serra, *Writings*: 146. He returns to this principle at several points in this volume. I have aligned Serra with the different approach of deconstruction, which works within a given language in order to critique it.

37 As Bois noted in 1984, Serra betrays an ambivalence regarding the picturesque as it suggests a static, optical imaging of a site as well as a peripatetic, parallactic framing. He also seems to have regarded it as a discursive field already occupied by Smithson.

38 Serra, *Writings*: 171.
39 Bois, "A Picturesque Stroll": 45. No one photograph will deliver the sculpture either, which is why a diagram is often required to comprehend the layout of a piece.
40 Serra, *Writings*: 163, 142.
41 See Kenneth Frampton, "Rappel à l'Ordre, The Case for the Tectonic," *Architectural Design* 60: 3–4 (1990), reprinted in Kate Nesbitt, ed., *Theorizing a New Agenda for Architecture Theory 1965–1995* (New York: Princeton Architectural Press, 1996). In particular Frampton bemoans "the universal triumph of Robert Venturi's decorated shed ... in which shelter is packaged like a giant commodity" (518). Frampton develops his position in his masterly *Studies in Tectonic Culture* (Cambridge, MA: MIT Press, 1995).
42 Ibid.: 519. "We intend," Frampton continues, "not only the structural component *in se* but also the formal amplification of its presence in relation to the assembly of which it is a part" (520). It might seem obvious that construction is fundamental to architecture—but it was not, say, to the Le Corbusier of *Toward An Architecture* (1923), who nominated surface, volume, and plane. Moreover, the tectonic is not, as it may sound, a technocratic notion; on the contrary, Frampton insists on the "poetic manifestation of structure in the original Greek sense of *poesis* as an act of making and revealing" (519).
43 Ibid.: 522. "Stereotomic," Frampton tells us, is derived from the Greek for solid (*stereotos*) and cutting (*tomia*). The joint, he also reminds us, was primordial for Semper as well.
44 Ibid. To say that this apposition is universal is not to say that it is uniform: for Frampton cultural differences are marked in the different inflections given to the joint. Nonetheless, he lets the phenomenological slip into the ontological in a way that sometimes detracts from the specificity of his argument.
45 Serra, *Writings*: 180. In a sense Serra goes beyond Adolf Loos: not only is ornament a crime but imaging is taboo. And here he participates in an important iconoclastic (sometimes Protestant, sometimes Judaic) genealogy within modernism that gathers disparate practitioners like Loos, Le Corbusier, and Mondrian, as well as theorists like Greenberg and Fried.
46 Perhaps this sharing is also primordial. As Frampton tells us, *tekton* means, etymologically, carpenter or builder, a vocation that might be taken to precede and support architecture and sculpture alike.
47 Serra, *Writings*: 169.
48 See Marcel Duchamp, "The Richard Mutt Case," *The Blind Man 2*

(1917). Especially in work after *Tilted Arc*, Serra referred to literary figures—from Herman Melville, cited in *Call Me Ishmael* (1986), to Charles Olson, cited in *Olson* (1986)—who were central to this American tradition of making as self-making. For its importance to Serra, see "Richard Serra in Conversation with Hal Foster": 23.

49 T.S. Eliot made this phrase famous in his essay "The Metaphysical Poets" (1921), in which he claims that a dissociation of thought and feeling has bedeviled English poetry since the seventeenth century.

50 Or, more precisely, it reveals an inconsistency in this structural logic, as Serra details in his description of the piece in *Richard Serra: Sculpture 1985–1998* (Los Angeles: Los Angeles Museum of Contemporary Art, 1998): 77.

51 Serra, *Writings*: 67.

52 The Constructivists worked in anticipation of a new industrial communist order, while Serra emerged amid the rusting of an old industrial-capitalist order. His position, then, is not as a futurist celebrant of the industrial tectonic but as an interested investigator of its structures. "We cannot repeal the industrial revolution, which is the cause of the urban glut," he stated in 1986. "We can only work with the junk pile" (ibid.: 175). For Buchloh in 1981 this position appeared ideological; in figures like Smith and Chamberlain he saw "the image of the proletarian producer" combined "with that of the melancholic stroller in the junk yards of capitalist technology" (Buchloh, "Michael Asher": 58).

53 To assist in the torqued ellipses, Serra employed the CATIA program used by Frank Gehry in the design of the Bilbao Guggenheim, but the ellipses provide an instructive contrast, "the total opposite of the construction of the Guggenheim Museum in Bilbao, which is built like a traditional nineteenth-century sculpture" (Govan and Cook, "Interview with Richard Serra": 27).

54 In "Surrealism: The Last Snapshot of the Intelligentsia" (1929), Benjamin suggests that the Surrealists were "the first to perceive the revolutionary energies that appear in the 'outmoded,' in the first iron constructions, the first factory buildings, the earliest photos, the objects that have begun to be extinct, grand pianos, the dresses of five years ago, fashionable restaurants when the vogue has begun to ebb from them" (*Reflections*: 181). Here Benjamin looks back to the products of the Industrial Age circa eighty years before his moment; this same outmoded status has now overtaken the products of the Machine Age circa eighty years ago, and it is this status that might render this material more critical than nostalgic.

55 For a useful counter-proposal see Jesse Reiser, *Atlas of Novel Tectonics* (New York: Princeton Architectural Press, 2006). As we saw in Chapter 5, the logic of Hadid designs is more representational than tectonic.

56 In this sense the principle Serra stated in 1980—they "do not relate to the history of monuments. They do not memorialize anything. They relate to sculpture and nothing more" (*Writings*: 170)—is adapted but not violated. Rather than a disguised return to the monumental, there is an innovative recovery of the commemorative. Whereas the monument usually serves the authority of the state, the memorial sometimes bespeaks a different kind of collective remembering and marking.

57 See note 6. Important though they are, phenomenological readings of Serra *à la* Krauss and Bois cannot account for this psychological dimension.

58 Krauss, "Sculpture in the Expanded Field": 38.

59 Serra, *Writings*: 69.

60 Ibid.: 7.

61 In a 1988 meditation titled "Weight," Serra writes of "the weight of history" threatened by "the flicker of the image," by the dissolution of memory in media, which he seeks to counter through an evocation of "the weight of experience" (Serra, *Writings*: 185).

62 There is a "presentness" here, but in the sense less of Fried in "Art and Objecthood" (1967) than of Benjamin in "Theses on the Philosophy of History" (1940): "Thinking involves not only a flow of thoughts, but their arrest as well. Where thinking suddenly stops in a configuration pregnant with tensions, it gives that configuration a shock, by which it crystallizes into a monad. A historical materialist approaches a historical subject only where he encounters it as a monad. In this structure he recognizes the sign of a Messianic cessation of happening, or, put differently, a revolutionary chance in the fight for the oppressed past" (Benjamin, *Illuminations* [New York: Schocken Books, 1969]: 262–3).

63 This refusal of representation is also political—a refusal of populist gestures, a refusal to represent a public that no longer exists as such (as figurative public sculpture imagines it still to exist). By virtue of this same abstraction, the spiritual meanings of *The Drowned and the Saved* and *Gravity* do not constitute a secret or second-order symbolism. However, such pieces do insist on significance—as opposed to the lack thereof flaunted by most spectacular sculpture (for example, Jeff Koons) and most affective architecture (discussed in Chapter 7); at the same time, they also ground this significance in actual bodies and spaces—as opposed to most installation art (discussed in Chapter 10).

64 Over the last two decades experience and spirituality were often set in the register of trauma, with the Shoah turned into the paragon of history. *Gravity* commemorates the Holocaust but not in this manner. Its arrest is also different from the suspension discussed in Chapter 7.

65 Serra, *Writings*: 184.

66 See Chapter 11. As noted above, Minimalism conceived the body of the viewer in phenomenological terms as "preobjectival," abstract, not disturbed by an unconscious. Feminist art subjected this phenomenological body to critique—it agreed that no one exists without a body but added that no body exists without an unconscious—and subsequent artists influenced by feminism (for example, Rachel Whiteread) have looked to a Minimalist idiom to draw out its psychological implications, which also suggests that they were there all along.

67 Serra, *Writings*: 112–14.

68 Krauss, "Richard Serra/Sculpture": 56.

69 Peter Eisenman captures this relation in a 1983 conversation with Serra: "You are interested in self-referentiality, but not in a modernist sense . . . The context invariably returns the work to its sculptural necessities. The work may be critical of the context, but it always returns to sculpture as sculpture" (Serra, *Writings*: 150).

70 Gilles Deleuze, *The Fold: Leibniz and the Baroque*, transl. Tom Conley (Minneapolis: University of Minnesota Press, 1992): 28.

71 Ibid.: 29.

72 Govan and Cook, "Interview with Richard Serra": 22.

73 His own description of these pieces summons attributes of the Baroque: "When you walk inside the piece, you become caught up in the movement of the surface and your movement in relation to its movement . . ." Or, "You become implicated in the tremendous centrifugal force in the pieces . . ." Ibid.: 17, 22.

74 Ibid.: 16.

75 This Constructivist/Surrealist dialectic is not an historical artifact, for it continued, say, in the opposition between deconstructivist and blob architectures in the 1990s.

76 See Anthony Vidler, *Warped Space* (Cambridge, MA: MIT Press, 2001). Elsewhere Vidler explains:

> Ostensibly, there is as little to distinguish Alberti's [perspectival] window from a computer screen as there is to differentiate an eighteenth-century axonometric by Gaspard Monge from a wire frame dinosaur generated by Industrial Light and Magic. What has changed, however, is the technique of simulation, and, even more

importantly, the place, or position, of the subject or traditional "viewer" of the representation. Between contemporary virtual space and modernist space there lies an aporia formed by the auto-generative nature of the computer program and its real blindness to the viewer's presence. In this sense, the screen is not a picture, and certainly not a surrogate window, but rather an ambiguous and unfixed location for a subject.

See Vidler, "Warped Space: Architectural Anxiety in Digital Culture," in Terry Smith, ed., *Impossible Presence: Surface and Screen in the Photogenic Era* (Chicago: University of Chicago Press, 2001): 291.

9: Film Stripped Bare

1 We can enter at other moments in the loop, and recognize it as "a line describing a cone" at any point. Although the film seems to invite us to accompany it, it is, of course, oblivious to our presence. In the days of grungy venues McCall relied on ambient dust and smoke to articulate the light; now he introduces mist.

In this chapter I focus on "the solid-light films," especially the vertical ones, but McCall has produced other kinds of works, too, including pieces involving fire set in landscape, a photo sequence, a slide installation, as well as pieces that involve light without film per se, one of which he describes here:

Room with Altered Window was the first solid-light piece, made in 1973, a few months before *Line Describing a Cone*. I masked off my studio window using black paper with a vertical slit cut into it. The room was left dark, and light could only enter through the one vertical slit. Facing south, the blade of sunlight was projected through the aperture into my studio, and it traveled slowly around the room as the sun moved across the sky.

Lauren Ross, "Interview with Anthony McCall," *Museo* (June 2010): n.p. On structural film see in particular P. Adams Sitney, *Visionary Film: The American Avant-Garde 1943–1978* (London: Oxford University Press, 1979).

2 For an excellent account of the intervening work see Branden Joseph, "Sparring with the Spectacle," in Christopher Eamon, ed., *Anthony McCall: The Solid-Light Films and Related Works* (Evanston: North-western University Pres, 2005). Attention was returned to McCall with the

exhibition "Into the Light: The Projected Image in American Art, 1964–1977," curated by Chrissie Isles at the Whitney Museum in fall 2001.

3 Tyler Coburn, "Interview," in Serena Cattaneo Adorno, *Breath [the vertical works]* (Milan: Hangar Bicocco, 2009): 81.

4 In an email communication McCall comments on the ambiguity of the word "film" as follows:

> I personally still use the word "film" as a convenient, descriptive short-hand for a "work," even though "film' is, strictly speaking, the word for the medium. Yet "film" is a simple, modest, familiar word, and it correctly connects the recent pieces to their material-ist film-practice roots, even though they have in some way grown beyond them. And other terms are cumbersome ("projected sculp-ture," "time-based light installations," etc.).

5 McCall in Coburn, "Interview": 76.

6 McCall: "From the start the films were intended to be shown in empty spaces, without a projection room, a screen or rows of seats. Just a large empty space" (ibid).

7 Anthony McCall, "*Line Describing a Cone* and Related Films," *October* 103 (Winter 2003): 41.

8 This shift also has to do with a shift in venue and audience; see ibid.: 56–64. George Baker probes the relation of the films to sculpture incisively in "Film Beyond its Limits," in Helen Legg, ed., *Anthony McCall: Film Installations* (Coventry: Warwick Arts Centre, 2004).

9 One might also mention the correspondence to dance. On this connec-tion see McCall, "*Line Describing a Cone*": 59–60.

10 Chrissie Isles makes this point in "Round Table: The Projected Image in Contemporary Art," in *October* 104 (Spring 2003): 80. Three works that follow *Line* are essentially installations: *Long Film for Four Projectors* (1974), *Four Projected Movements* (1975), and *Long Film for Ambient Light* (1975). See McCall, "*Line Describing a Cone*": 51–6.

11 *Line* in particular evokes classical origin-stories of representation, such as the shadows on the cave wall in Plato and "the Corinthian maid" tracing the silhouette of her lover in Pliny.

12 See McCall, "*Line Describing a Cone*": 57–62, and Joseph, "Sparring with the Spectacle."

13 McCall:

> I try to set the speed of motion at a threshold between no movement and movement. You recognize that change is underway, but you can

tell that it is going to take a while. It reduces the anxiety about what may happen next. And it enables you to really watch change, which is actually a rather rare experience. You, the watcher, become the fastest thing in the room.

See Graham Ellard and Stephen Johnstone, "Anthony McCall," *Bomb Magazine* (2006): 75.

14 In an email communication McCall elaborates on another crucial difference as follows:

> People commonly attribute [the emotions they experience in the projections] to the magic of the veils of light, but I am not so certain that this reported pleasure would work if they were walking into or around projected slides of similar forms. I suspect that it is the slow motion—or the slow disclosure of structure—embodied, of course, as veils of light, that is the key to this. So I don't think it is just the permeability of light that separates my pieces from those made of Corten steel. Rather, it is the fact that there is an additional element in play: in a Serra torqued ellipse the motion (and therefore the arrival at disclosure) is offered by the walking visitor. The same is true with my projected installations, except that the forms themselves are on the move as well. So there is a dynamic between the disclosure being offered by the mutation of the projected work and the disclosure as a product of a visitor's walking exploration. This is roughly what you get when you fuse cinema and sculpture!

15 Michael Baxandall, *Painting and Experience in Fifteenth-Century Italy* (Oxford: Oxford University Press, 1972): 34.

16 A title like *Line Describing a Cone* cannot but recall a text like *From Point to Line to Plane* by Wassily Kandinsky, one of the great treatises in modernist training. (Also suggestive here is the famous definition of drawing offered by his Bauhaus colleague Paul Klee: "a line going out for a walk.")

17 I consider these effects in recent installation art in Chapter 10.

18 See Martin Heidegger, "The Age of the World Picture" (1938); Jean-Paul Sartre, *Being and Nothingness* (1943); and Jacques Lacan, *The Four Fundamental Principles of Psych-Analysis* (1973), transl. Alan Sheridan (New York: W.W. Norton, 1978): 96, 106. For a rich account of this skepticism regarding the visual, see Martin Jay, *Downcast Eyes: The Denigration of Vision in Twentieth-Century French Thought* (Berkeley: University of California Press, 1993).

19 McCall in Ellard and Johnstone, "Anthony McCall": 71. McCall
 again: "Our whole experience of our corporeal selves is in relation
 to others. So representation sort of got it wrong, because it thinks the
 body is an object, which it isn't. Cybernetically speaking, you have
 a circuit of communication, the bodies being two nodes within the
 circuit" (McCall in Coburn, "Interview": 83–4). This ethics, perhaps
 evocative of Martin Buber or Emmanuel Levinas, is also intimated by
 the titles of such recent projections as *You and I*, *Between You and I*,
 Meeting You Halfway, and *Coupling*. For a provocative intervention
 in this philosophy of affective analogies see Kaja Silverman, *Flesh of
 My Flesh* (Palo Alto: Stanford University Press, 2009). And yet, as we
 will see, not every element of the projections is benign.

20 McCall uses these terms frequently in the two interviews cited above.

21 In addition, we tend not to be as interruptive of the light as we are
 with the horizontal pieces. This double connection to body and archi-
 tecture is also remarked in the titles of two works-in-progress—*Skin*
 and *Skirt*.

22 In an email communication McCall distinguishes the floating wipe as
 follows:

> The wipe used in *Between You and I* simply enters the frame from
> the left, passes through the frame, and exits right. As a result, the
> elliptical form begins complete and whole; then it is very slowly
> replaced by the traveling wave form, which produces a shifting
> combination of the two figures. By the time the wipe has exited, the
> ellipse has vanished, replaced by the traveling wave form, complete
> and whole. The "floating" wipe, on the other hand, never leaves the
> frame, but floats back and forth within the frame in a continuous
> liquid motion with both figures always in play.

23 For Serra's discussion of these effects of his own recent work, see
 Chapter 11.

24 McCall:

> I suppose that it is necessary to start with the reminder that these
> solid-light works exist in the dark, and that the dark holds all kinds of
> terrors. Even if we as adults have forgotten, every child understands
> this. Fire and light have traditionally been the protection against this
> void. In this context, a projected beam of light is at once an acknowl-
> edgement of the existence of the void, and at the same time an offer
> of safety (like the light-house beam was once for the sailor at sea).

See Bertrand Rougé and Charlotte Beaufort, "Interview with Anthony McCall," *Figures de l'Art* 17 (2009).

25 McCall in Ellard and Johnstone, "Anthony McCall": 73. This interview focuses on *Between You and I*, which was first shown at the decommissioned Round Chapel in London. As noted in Chapter 7, there is a modernist version of this spiritual light, too, as advanced by such visionary writers and designers as Paul Scheerbart and Bruno Taut, for whom light, transformed into a social medium by glass architecture, was to conduct us toward a utopian way of life.

26 László Moholy-Nagy, "From Pigment to Light," in *Moholy-Nagy: An Anthology*, ed. Richard Kostelanetz (New York: Da Capo, 1970): 31.

27 See László Moholy-Nagy, *Painting, Photography, Film*, transl. Janet Seligman (Cambridge, MA: MIT Press, 1969), and *The New Vision* (New York: Dover, 1938). See also my "The Bauhaus Idea in America," in Achim Borchardt-Hume, ed., *Albers and Moholy-Nagy: From the Bauhaus to the New World* (London: Tate Publishing, 2006).

28 In this respect his neo-avant-garde move is not the stylistic gesture discussed in Chapter 5.

29 Broached in Chapter 8, this topic is central to Chapter 10.

30 McCall:

> I have certainly been looking with considerable interest at the time-based work [in film and video installation] over the past few years. Obviously, this interest has not been dispassionate. What has often struck me, I think, is less what I have seen than what seems to be absent from what I have seen, namely, a focus on the physical here and now ("Round Table": 96).

His aesthetic is also relational in a manner more profound than is usual with practices grouped under that rubric.

10: Painting Unbound

1 I refer to Donald Judd, "Specific Objects," *Arts Yearbook* 8 (1965), reprinted in *Donald Judd: Complete Writings 1959–1975* (Halifax: Press of the Nova Scotia School of Art and Design, 1975). What I mean by "illusionism" is simple enough; it is captured here by Clement Greenberg in his summa "Modernist Painting" (1960): "The Old Masters created an illusion of space in depth that one could imagine oneself, but the analogous illusion created by the Modernist painter can only be seen into; can be traveled through, literally or

figuratively, only with the eye" (*The Collected Essays and Criticism, volume 4*, ed. John O'Brian [Chicago: University of Chicago Press, 1993]: 90). Illusionism, it might be argued, is all the more pure when all the more optical.

2 See my "The Crux of Minimalism" (1987) in *The Return of the Real* (Cambridge, MA: MIT Press, 1996). Almost all of these peers (Carl Andre is one exception) began as painters. Sculpture was not as discursively charged as painting, and Flavin insisted on his difference from it—really his indifference to it—even more than did Judd. "Please do not refer to my effort as sculpture and to me as sculptor," Flavin wrote the curator Jan van der Marck on June 17, 1967, "I do not handle and fashion three-dimensioned still works, even as to Barbara Rose's Juddianed 'specific objects.' I feel apart from problems of sculpture and painting." See *Dan Flavin: three installations in fluorescent light* (Cologne: Kunsthalle Köln, 1973): 95. All other page references given in the text are to this volume.

3 Illusionism was also retained, indeed heightened, in much Pop art, especially in contemporaneous silk-screens by Andy Warhol. In "The Crux of Minimalism" I proposed a kind of dialectic of Minimalism and Pop in this regard—between the specific and the simulacral, the embodied and the disembodied, perceptual presence and mass-mediated representation—with the Pop terms not simply opposed to the Minimalist ones but also internal to them. However, as suggested in Chapter 7, this dialectic has reached a new level, with the Pop term now dominant.

4 Rosalind Krauss, "Allusion and Illusion in Donald Judd," *Artforum* (May 1966): 24. See also Yve-Alain Bois, *Donald Judd: New Sculpture* (New York: Pace Gallery, 1991). On the early reception of Judd see James Meyer, *Minimalism: Art and Polemics in the Sixties* (New Haven: Yale University Press, 2001): 45–61, 134–41.

5 Krauss, "Allusion and Illusion": 24. Here the twenty-four-year-old Krauss is still under the sway of the Greenbergian reading of Smith. In his condemnation of Minimalism Greenberg related its objects to the pictorial rectangle and the Cubist grid. See "The Recentness of Sculpture" (1967), in Gregory Battcock, ed., *Minimal Art: A Critical Anthology* (New York: Dutton, 1968).

6 The very seriality of much of his art sometimes seems to virtualize it as well.

7 Judd, "Specific Objects," in *Complete Writings* (Halifax: Press of the Nova Scotia School of Art and Design, 1975). For another account of "polarity" in Judd, see Richard Schiff, "Donald Judd, Safe from

Birds," in Nicholas Serota, ed., *Donald Judd* (London: Tate Publishing, 2004).

8 "All that art is based on systems built beforehand, *a priori* systems; they express a certain type of thinking and logic that is pretty much discredited now as a way of finding out what the world's like"; see Judd in Bruce Glaser, "Questions to Stella and Judd" (1966), in Battcock, ed., *Minimal Art*: 151. (Flavin participated in this radio conversation, which aired in February 1964, but edited his remarks out of the transcript.)

9 Judd, *Complete Writings*: 124, 200 (my emphasis).

10 In 1965 Robert Smithson wrote incisively of the "uncanny materiality" of Judd boxes made of Plexiglas and stainless steel, and suggested that it sometimes "engulf[s] the basic structure" (*Robert Smithson: The Collected Writings*, ed. Jack Flam [Berkeley: University of California Press, 1996]: 22). See also Meyer, *Minimalism*: 134–8.

11 As suggested, the Flavin lights are in fact more complicated than "image-object"; key here, though, is that Flavin held the two terms together, even as other artists were prompted (in part by Flavin) to let them fly apart—the image to move outside the frame of a picture, the object to pass beyond the limit of a sculpture (on which more below).

12 On this irony see Alex Potts, "Dan Favin: 'in ... cool white' and 'infected with a blank magic,' " in Jeffrey Weiss, *Dan Flavin: New Light* (New Haven: Yale University Press, 2006). Of course, irony is a central device of modernist authors, and Flavin was a keen reader of James Joyce, among others. A preliminary version of the present chapter appeared in the Weiss volume as well.

13 "They lack the look of history," Flavin wrote of his early fluorescent works. "I sense no stylistic or structural development" (90). I say "undecideable" because this relation between illusionism and anti-illusion has the aporetic structure of allegory as defined by Paul de Man: "The two readings have to engage each other in direct confrontation, for the one reading is precisely the error denounced by the other and has to be undone by it. Nor can we in any way make a valid decision as to which of the readings can be given priority over the other (*Allegories of Reading* [New Haven: Yale University Press, 1979]: 12).

14 Peter Bürger develops the notion of "the neo-avant-garde" in *Theory of the Avant-Garde*, published in German in 1974. The glider was not reproduced in Gray, but *The Bottle*, corner reliefs, and the *Monument* model were.

15 On such ideological antinomies see Georg Lukács, "Reification and the Consciousness of the Proletariat," in *History and Class Consciousness* (1923), transl. Rodney Livingstone (Cambridge, MA: MIT Press,

1986). Michel Foucault also writes of an "empirico-transcendental doublet" deep in modern thought in *The Order of Things* (New York: Vintage Books, 1970 [1966]): 318–22.

16 See Allan Kaprow, "The Legacy of Jackson Pollock," *Art News* 57: 6 (1958), and Robert Morris, "Notes on Sculpture, Part 4," *Artforum* (April 1969).

17 "I smiled when I recognized it": this suggests that Flavin might have looked through the book before his visit, though the icon in the Gray is not the one in the Met (the one illustrated here is my best guess as to the specific icon Flavin saw there). It seems that, even before this visit to the Met, Flavin had begun to title his early series "icons" (the first one is dated 1961–62, and a note dated March 1962 refers to them as such). In the history of modern art, such museum visits are often staged as retrospective epiphanies; the most famous instance is the transformative visit of Picasso to the Trocadéro Museum in Paris, in June 1907, during the painting of *Les Demoiselles d'Avignon*.

18 As we will see momentarily, Tatlin was more interested in the material aspects of the icon. Flavin also did a drawing of an arrangement of his first four icons "with an overt reference to an iconostasis (the screen, adorned with icons, that separates the sanctuary from the nave in a Greek Orthodox church)"; see Michael Govan, "Irony and Light," in Michael Govan and Tiffany Bell, *Dan Flavin: A Retrospective* (New Haven: Yale University Press, 2004): 29.

19 Vladimir Markov (pseudonym of Waldemars Matvejs), *Printsipy tvorchestva v plasticheskikh iskusstvakh. Faktura* (St Petersburg, 1914): 54, as translated by Christina Lodder in her *Russian Constructivism* (New Haven: Yale University Press, 1983): 13. Markov is not mentioned by Gray, and it is highly unlikely Flavin knew of his work, yet he also highlights the facticity of his icons: "I use the word 'icon' as descriptive, not of a strictly religious object, but of one that is based on a hierarchical relationship of electric light over, under, against and with a square-fronted structure full of paint 'light' " (88).

20 Markov in Lodder, *Russian Constructivism*: 13.

21 Vladimir Markov, *Iskusstvo negrov* (St Petersburg, 1919 [1913]): 36; transl. as "Negro Sculpture" in Jack Flam with Miriam Deutsch, ed., *Primitivism and Twentieth-Century Art: A Documentary History* (Berkeley: University of California Press, 2003): 63.

22 This lack of mediation was a scandal for Europeans, who placed fetishism at the bottom of all hierarchies of religion and society for this reason. Such was its place in the writings of Charles de Brosses, David Hume, Kant, Hegel, and others, and Marx and Freud assumed

this pejorative connotation, too, only to turn it round on us moderns: sometimes in our commercial and sexual activity, they suggest, *we* are the fetishists. See William Pietz, "The Problem of the Fetish," in *Res* 9, 13, and 16 (Spring 1985, Spring 1987, Autumn 1988), and my "The Art of Fetishism," in Emily Apter and William Pietz, eds, *Fetishism as Cultural Discourse* (Ithaca: Cornell University Press, 1993). The European projection of the "fetish" on to West African practice was a fetishization in its own right.

23 Flavin in "Dan Flavin Interviewed by Phyllis Tuchman" (1972) in Govan and Bell, *Dan Flavin: A Retrospective*: 194.

24 Ibid.

25 Mel Bochner, "Art in Process: Structures," *Arts Magazine* (September/October, 1966): 39.

26 Michael Govan quotes Joyce on "the epiphany," which is indeed pertinent to Flavin: "The soul of the commonest object, the structure of which is so adjusted, seems to us radiant" (Govan and Bell, *Dan Flavin: A Retrospective*: 32). Yet, in Flavin as in Joyce, epiphanic states are sometimes undercut by humorous humiliations. At his most Minimalist, Flavin separated and opposed the terms of his "ironies." For example, *the nominal three (to William of Ockham)* (1963) commemorates the fourteenth-century English scholastic philosopher, who wrote: "Principles (entities) should not be multiplied unnecessarily." Flavin glossed his nominalism in this way: "Reality exists solely in individual things and universals are merely abstract signs. This view led [Ockham] to exclude questions such as the existence of God from intellectual knowledge, referring them to faith alone" (83–4). Yet for the most part Flavin does not oppose "individual things" and "abstract signs." Again, like the icon and the fetish, his lights work to hold such polarities together.

27 This shift in his work was remarked in the 2005 Flavin retrospective at its National Gallery venue when one moved from the first floor, where the work remained mostly on the walls, to the second floor, where it irradiated the rooms. In a sense Flavin was "graphic" from the start—long interested in drawing, especially Hudson School landscape studies (which he collected), he drew throughout his career—and the shift noted here is only in the nature of the ground to be marked—from the rectangle of a paper sheet, say, to the volume of a room, with the fluorescent tubes understood as graphic devices. With "expanded field" I allude to Rosalind Krauss, "Sculpture in the Expanded Field" (1979), in Hal Foster, *The Anti-Aesthetic: Essays on Postmodern Culture* (Seattle: Bay Press, 1983). Her map has no place for painting; however, my suggestion here is that the expanded field is now shot through with the pictorial.

28 Dan Graham, "Art as Design/Design as Art," in *Rock My Religion: Writings and Projects 1965–1990* (Cambridge, MA: MIT Press, 1993): 211. In this respect Flavin might be affined less with the Constructivist project of Tatlin than with the color-plane decors of de Stijl.

29 Rosalind Krauss, untitled review, *Artforum* (January 1969): 53–4. Some spaces are set apart from the viewer by the fixtures in a way that marks them as pictorial in the sense suggested by Krauss.

30 Perhaps Smithson had this effect in mind when he wrote in 1966, "Flavin's destruction of classical time and space is based on an entirely new notion of the structure of matter" (*Collected Writings*: 10).

31 Judd, *Complete Writings*: 184.

32 I trust it is clear that a related "catastrophe" is also at work in the architecture discussed in Chapter 7, especially the refashioning of space as illusion.

33 In the 1960s the distinctions between these practices were not always clear—though Flavin refused any association with painters like Olitski (cf. 109). In a sense Flavin split the difference between punctual "presentness" and durational "presence" (to borrow an opposition used by Michael Fried in "Art and Objecthood" [*Artforum*, June 1967]).

34 Flavin continues in his acerbic way: "No one should bother to pay to concede his perception to the pointless audio-visual 'entertaining' punishment haphazardly projected by some of the so-called self-determined multi-media techno-totalitarians, especially since, at home, on any evening, he is already compelled to absorb an 'overload' of much of the same seemingly arbitrary, jarring, messageless mistreatment from television commercials and programs" (93). Perhaps Flavin is sensitive here because his work was sometimes viewed as "passive" before its own technology: "It is a kind of '1984' passivity," Emily Wasserman wrote, "a lyricizing of basically uninventive, unprofound forms" (*Artforum* [December 1967]: 60). "Environment," we might say today, was on the side of spectacle, as Flavin signaled in 1982: "I don't want to make a cathedral. I really don't. I think that's the subject of business now" (197).

35 In the 1960s pictorial space was extruded into actual space in a number of ways. Think, for example, of the scatter pieces by Robert Morris and others. In a work such as *Threadwaste* (1968) Morris sought to move "beyond objects" altogether—but neither into pure idea (as in much Conceptual art) nor into sheer material (as in other process art). He sought the creation of a "field effect" in which the object was often fractured if not dissolved, and the vision of the viewer often

disturbed if not deranged. In his own words, Morris wanted "to take the conditions of the visual field" as the "structural basis" of the work and not merely its physical limit. In so doing he attempted to shift the viewer from a focal gaze (as one looks at a painting or a sculpture or indeed a Minimalist object) to a "vacant stare" on a visual array; and it was to this end that he arranged materials in a way that could hardly be grasped, in profile or in plan, as an image at all. In works like *Threadwaste* it is as if vision were decentered from the subject, thrown out into the world. See Morris, "Notes on Sculpture, Part 4." On a related derangement of vision in Flavin see Briony Fer, "Nocturama: Flavin's Light Diagrams," in Weiss, ed., *Dan Flavin: New Light.*

36 Already in this moment Harold Rosenberg wrote, "de-aestheticized art goes hand in hand with aestheticized events, with the increasing injection into actual situations of the ambiguity, illusoriness, and emotional detachment of art" ("De-aestheticization," in *The De-definition of Art* [New York: Collier Books, 1972]: 37).

37 Robert Irwin, "The Hidden Structures of Art," in Russell Ferguson, ed., *Robert Irwin* (Los Angeles: MOCA, 1993): 23.

38 Ibid., 33.

39 Ibid., 21, 23 (emphasis in the original). His move was thus less that from specific medium to general art, as often in Conceptualism, than from specific object to spatial environment, as often after Minimalism.

40 Irwin as quoted in Lawrence Weschler, *Seeing is Forgetting the Name of the Thing One Sees* (Berkeley: University of California Press, 1982): 61; Irwin, "The Hidden Structures of Art": 29.

41 Irwin, "The Hidden Structures of Art": 25 (emphasis in the original). This stress on the viewer is more extreme than any Duchampian shift in "the creative act" forced by the readymade (see Marcel Duchamp, "The Creative Act" (1957), in Michel Sanouillet and Elmer Peterson, ed., *The Essential Writings of Marcel Duchamp* [London: Thames & Hudson, 1975]).

42 Philip Leider, *Robert Irwin, Kenneth Price* (Los Angeles: Los Angeles County Museum of Art, 1966): n.p.

43 Richard Andrews and Chris Bruce, "Interview with James Turrell," in *James Turrell* (Seattle: Henry Art Gallery, 1992): 47.

44 Alexander Baumgarten, *Aesthetica* (Frankfurt, 1750/58), § I.

45 See Krauss, "Cultural Logic": 12. Paradoxically, the overemphasis on the viewer can render him or her almost null and void, as Anne Wagner suggests vis-à-vis a Flavin note on a drawing for a 1972 installation, "to beset and to abuse the complete room": "Whatever he is

suggesting—for surely his phrase presents a set of specific intentions, however cryptically—the formula seems to leave the viewer out. An abused room evaporates the viewer; place yields to placelessness" ("Flavin's Limited Light," in Weiss, *Dan Flavin*: 127).

46 Julia Brown, "Interview with James Turrell," in *Occluded Front: James Turrell* (Los Angeles: Museum of Contemporary Art, 1985): 22, 25. If Minimalism wanted to eject the work of art from the private space of consciousness, so to speak (see note 8), Turrell installations seek to inject that private space into space at large: "I want it to be like the light that illuminates the mind" (44).

47 Andrews and Bruce, "Interview with James Turrell": 51, 47, 50. For more on these matters see Hal Foster, "Polemics, Postmodernism, Immersion, Militarized Space," *Journal of Visual Culture* 3: 3 (December 2004). Turrell's controlling of experience through his pieces extends to permission to publish images of them, which his studio has denied me.

48 Benjamin, "On Some Motifs in Baudelaire" (1940), in Howard Eiland and Michael W. Jennings, eds, *Selected Writings, Volume 4: 1938– 1940* (Cambridge, MA: Harvard University Press, 2003): 314.

49 During the time that Irwin and Turrell developed this work, such phenomenological immediacy was subject to critique not only in theory (for example, Jacques Derrida published his *Speech and Phenomena* in 1967) but also in art (for example, the early performances and videos of Dan Graham effectively question the phenomenological assumptions of Minimalism).

50 Samuel K. Wagstaff, Jr, "Talking with Tony Smith," *Artforum* (December 1966), reprinted in Battcock, ed., *Minimal Art*: 58.

51 Ibid.

52 Other critics have made similar points about installation art; see especially Alex Potts, "Installation and Sculpture," and Briony Fer, "The Somnambulist's Story: Installation and the Tableau," in Oxford Art Journal 24: 2 (2001). "It's almost as if the thingness of the traditional sculptural object has been turned inside out," Potts writes, "so it resides in the framing that encloses and focuses the viewer's looking" (17). Johanna Burton has also suggested to me that, in much recent practice, the two art-historical moments that concerned Krauss in the middle 1970s—the expanded field of culture and the collapsed present of video—have merged.

53 We also saw this operation at work in Chapter 7. The concept of the sublime was prominent in the discourse of postwar American art, where it was deployed by Newman among others. Significantly, in " '. . . daylight or in white.' an autobiographical sketch," Flavin cites Kant: "The

Sublime is to be found in a formless object, so far as in it, or by occasion of it, boundlessness is represented" (*Artforum* [December 1965]: 24). However, as Wagner notes, Flavin cut this reference when the essay was reprinted in 1969 ("Flavin's Limited Light": 128). Perhaps he became leery of the effect. Not so Turrell: "I am working for pure visual delight and sensation. And when I say delight I mean in the sense of the sublime" (Andrews and Bruce, "Interview with James Turrell": 51).

54 "What is most interesting," the literary critic Herman Rappaport writes about such images as the cave in *The Republic* of Plato, "is the way a prop such as the cave wall can suddenly turn into a stage, how an image, itself framed, can suddenly stage itself as stage and in that way absent itself or disappear from the viewer's consciousness as image, object, or prop" ("Staging: Mont Blanc," in Mark Krupnick, ed., *Displacement: Derrida and After* [Bloomington: University of Indiana Press, 1983]: 59). As Victor Burgin notes, this operation is similar to that of fantasy, in which the subject seems to be within the scene of his or her own viewing, the frames of which tend to dissolve as a consequence (see "Diderot, Barthes, *Vertigo*," in *The End of Art Theory: Criticism & Postmodernity* [Atlantic Highlands, NJ: Humanities Press International, 1986]). Turrell often associates the space of his installations with that of the dream or daydream.

55 Sigmund Freud, *Civilization and its Discontents*, transl. James Strachey (New York: W.W. Norton, 1961): 20.

56 Wagstaff, "Talking with Tony Smith": 386. Ironically, the military base in Marfa, Texas adapted by Judd into an art complex once served as a POW camp for German soldiers. Not altogether ironically, Dan Graham has suggested that "Flavin tried to combine Tatlin and Speer" ("Interview with Dan Graham by Rodney Graham," in *Dan Graham: Beyond* [Los Angeles: Los Angeles Museum of Contemporary Art, 2009]: 92).

57 Walter Benjamin, "The Work of Art in the Age of Technical Reproducibility," in *Selected Writings, Volume 3: 1935–1938*, ed. Howard Eiland and Michael W. Jennings (Cambridge, MA: Harvard University Press, 2002): 122. Also germane here is Siegfried Kracauer, "The Mass Ornament," in *The Mass Ornament*, ed. and transl. Thomas Y. Levin (Cambridge, MA: Harvard University Press, 1995), and Susan Buck-Morss, "Aesthetics and Antiaesthetics: Walter Benjamin's Artwork Essay Reconsidered," *October* 62 (Autumn 1992).

58 Flavin glimpsed this prospect, too, when he referred to "the so-called self-determined multi-media techno-totalitarians" with their "concoctions of theatrical ritual, of easy, mindless, indiscriminate sensorial abuse" (93).

59 Benjamin, "The Work of Art": 115.

60 Ibid.; Benjamin, *Selected Writings, Volume 2: 1927–1934*, ed. Howard
 Eiland and Michael W. Jennings (Cambridge, MA: Harvard University
 Press, 1999): 3–5. The "blue flower" is the prime figure for the object
 of desire in the work of the German Romantic Novalis. This description
 in Benjamin is also apposite here: "What we used to call art begins at a
 distance of two meters from the body. But now, in kitsch, the world of
 things advances on the human being; it yields to his uncertain grasp and
 ultimately fashions its figures in his interior" (4–5). The best commen-
 tary on the blue-flower trope in Benjamin remains Miriam Hansen,
 "Benjamin, Cinema and Experience: 'The Blue Flower in the Land of
 Technology,' " *New German Critique* 40 (Winter 1987).

61 Eliasson also privileges the spectator ("the gaze of the viewer in a
 complex way constitutes or creates the piece") and does so again in
 phenomenological terms (the spectator "sees herself seeing"), but
 in the end a similar reversal occurs (this spectator is "a constructed
 third person"). See Eliasson in Hans Ulrich Obrist, *Interviews*, vol. 1
 (Milan: Charta, 2003): 203, 205–6.

62 This techno-aesthetic sublime might be troped productively, even crit-
 ically, but it is not so in such practices. For Benjamin and Kracauer
 the primary subject-effect of capitalist culture was a complex of atten-
 tion and distraction, of shock and absorption, and they argued that
 some modernist practices—especially abstract architecture, Dadaist
 collage, and filmic montage—might turn this sensorial complex to criti-
 cal advantage. At times, too, they suggested a "go-for-broke game"
 in which this complex might be exacerbated and somehow passed
 through: "The process," Kracauer writes in "The Mass Ornament,"
 "leads directly through the center of the mass ornament, not away from
 it" ("The Mass Ornament": 61, 86). It might be argued that this is what
 artists like Eliasson attempt to do again today—but to what other side?

11: Building *Contra* Image

1 The first two parts of this dialogue are extracted from Hal Foster, "A
 Conversation with Richard Serra," in *Richard Serra: The Matter of
 Time* (Bilbao: Guggenheim Museum, 2005); the third part was done
 in summer 2010.

2 For more on these sections see Chapter 8, note 9.

3 This installation consists of eight sculptures—two ellipses, three
 spirals, two pieces with torus and/or spherical sections, and one ribbon
 piece (*Snake*, 1994–97), which was *in situ* in the Fish Gallery since the
 opening of the Guggenheim Bilbao.

ILLUSTRATION CREDITS

All images in Chapter 2 are courtesy of Rogers Stirk Harbour + Partners. All images in Chapter 3 are courtesy of Nigel Young / Foster + Partners, except Commerzbank and Stansted (courtesy of Foster + Partners). All images in Chapter 4 are courtesy of Renzo Piano Building Workshop. All images in Chapter 5 are courtesy of Zaha Hadid Architects. All images in Chapter 6 are courtesy of Diller Scofidio + Renfro. All images in Chapter 8 (except Myoshin-ji and Brancusi) and Chapter 11 (except Le Corbusier) are courtesy of Richard Serra. All images in Chapter 9 (except Moholy-Nagy) are courtesy of Anthony McCall.

Every effort was made to contact the copyright holder for every illustration appearing in this book. Author and publisher apologize for any image used without accurate accreditation and, once informed, will emend in any future edition.

INDEX